MW00476190

Go Out and Live

A 27-year Journey of Courage

Doris and Ken Hall

Beaver's Pond Press, Inc.
Edina, Minnesota

GO OUT AND LIVE © copyright 2003 by Doris and Ken Hall. All rights reserved. No part of this book may be reproduced in any form whatsoever, by photography or xerography or by any other means, by broadcast or transmission, by translation into any kind of language, nor by recording electronically or otherwise, without permission in writing from the author, except by a reviewer, who may quote brief passages in critical articles or reviews.

ISBN 1-59298-011-2

Library of Congress Catalog Number: 2003110393

Book design and typesetting: Mori Studio
Cover design: Mori Studio

Printed in the United States of America

First Printing: September 2003

06 05 04 03 6 5 4 3 2 1

Beaver's Pond Press, Inc.

7104 Ohms Lane, Suite 216
Edina, MN 55439
(952) 829-8818
www.BeaversPondPress.com

to order, visit www.BookHouseFulfillment.com or call
1-800-901-3480. Reseller discounts available.

To
Kent and Allison

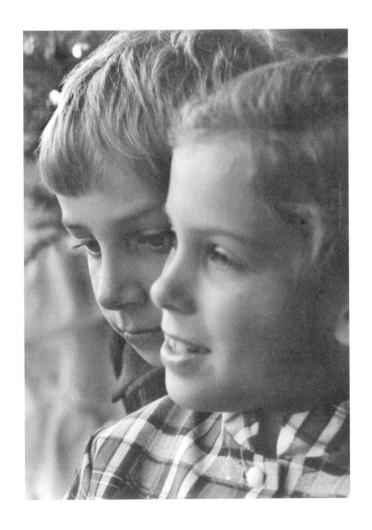

Contents

Acknowledgments

*I*n addition to those who appear in Allison's story, the following acknowledgments are made with our gratitude and affection.

To our patient teachers, Marion Landew and John Scarry.

To our editors, Lucille Enix and Cindy Rogers, for their love, understanding, and expertise.

To our treasured friends at the Santa Barbara Writers Conference who helped shape our story: Mary and Barnaby Conrad, Sue Gulbransen, Charles Champlin, Frances Weaver, Cork Millner, and Richard F.X. O'Connor.

Sam Fleishman for his help as a brilliant mentor and literary agent.

Rev. Lee Gartrell, who first suggested that Allison's story be told.

Milt Adams, our friend and publisher, for his guidance.

Birgit and Don Wise for their unwavering friendship and encouragement.

George Anderson, whose unique gift enabled us to find the true path of life again.

Rev. Charlotte Sommers for her pastoral support and understanding.

Dr. Arthur Reisel for his loyal guidance.

Most of all, birthmother Frances for Allison herself.

Hello

One thing is certain: We have created the reality we have so that we may learn. In the first moments of tragedy, people inevitably ask, 'Why did this have to happen?' We need to ask, 'What lesson am I fulfilling from learning from my life's spiritual course?' Bad things don't just happen to people.

Lessons from the Light
—George Anderson

"God, I hope we're doing the right thing," I whispered to my husband as we entered the unadorned room to meet with George Anderson.

Ken quietly murmured, "I'm sure we are, Doris, but let's keep all this to ourselves. Our friends'll think we're nuts!"

"I know. Who'd have ever thought that someday we'd be visiting a psychic medium hoping he could make contact with Allison on the other side," I marveled.

"Yeah, and remember, we wouldn't even be here if we hadn't read those books about him, dear. I'm convinced he's got a unique gift to communicate with the souls of those who've passed on. Least we can do is to see what happens. Anyway, if this meeting doesn't work out, nobody'll know the difference. Besides, George can't have found out anything about us. Remember, when we signed up to see him, we gave his staff only our name and we paid with an untraceable bank check. So if George comes up with anything connected to Allison, I figure it's been worth our effort."

"Well, I don't mind telling you, dearie, I'm scared stiff!" Ken's hopes had lessened my uncertainties; still I continued to fidget while he set up his tape recorder. I recalled that we'd been waiting for this day for what seemed an eternity. Seven years of ongoing grief over our daughter's passing had driven us to seek a meeting with George Anderson who many consider the world's greatest psychic medium. Now the moment was here.

Mr. Anderson calmly entered the room. This fortyish, neatly bearded man appeared to be dressed for tennis—casual attire and modest demeanor that helped put us more at ease. With an unusually direct gaze, he introduced himself, we shook hands, and he indicated where we should sit.

Sensing our anticipation, Anderson commented, "Keep in mind that the spirits are waiting for this meeting just as much as you are."

He went on to explain, "What I do here I call a discernment. I discern or pick up the souls that draw near to the family who has come to me, and I listen to the information the soul wants related to their loved ones. I do this by hearing faint voices and visualizing various images and symbols. The discernment is the soul's forum."

So far, so good, I said to myself, but was George preparing us to see ghosts, for heaven's sake? I'd never seen one, but there's always a first time. I sneaked a glance at Ken who understood that we wouldn't be hearing spirit voices ourselves, but George's interpretation of their messages through his mediumship.

George seemed very definite about this next part. "Well, we'll get started now. No matter what I say to you, don't respond with anything more than, 'Yes,' 'No,' or 'I understand.' Keep in mind that when the spirits are discerned, they will communicate about things they know you will understand. So listen carefully to what I'm saying because certain things can go right over my head, but it will have great meaning to you. I try my best to keep my own thoughts and feelings out of your session. So without further ado, let's begin."

George made the sign of the cross, and mentally I did too. Couldn't hurt—I needed all the help I could get at this point.

Then before I knew it, he said, "*Someone's here already. First a young male presence has come into the room, and there's a female*

presence also here. There's talk about the male—says he's a younger male who's passed on. There was the loss of a brother? Did either of you lose a brother, because the young man keeps saying, 'I'm the brother that passed on.' He passed on kinda young. He's the one that was coming to you, Ken. Does that made sense to you?"

"Yes, it does," a stunned Ken said.

Must be Charles, Jr., Ken's brother who died when he was five and Ken was two. Now, how in the name of time does George know all this? Oh, I forgot, Charles, Jr. just told him! But I want to hear from Allison. Is she all right?

"There's this talk about a young female who also passed on. Correct? Now the female claims to be the daughter that passed on."

"Oh, yes, yes!" we both chorus.

"She's saying, 'I'm the daughter that passed over.' He and your daughter have become good pals over there I'm being told. He passed on way before her—claims he knew what it was like to pass on young, so he was one of the first souls to help welcome her into the light."

How wonderful! I can just see that—like in the movies—our Allison all calm and happy. It's all happening so fast!

"Your parents, Ken, are gone over also? Because your brother is saying, 'Mom and Dad are here also and they're with your daughter as well.'"

I'm flabbergasted! That's Ken's Mom and Dad who also died when he was two. Hadn't even imagined we'd hear from them—the in-laws I'd always wanted to know!

"Your daughter claims she has come in dreams? Is this true? She states that this isn't the first time you're hearing from her—that she has visited in dreams."

"Oh, yes!" we both assure him. I'd always been big on dreams and trying to interpret them.

"For example, I know I dreamt last night, but I couldn't give you detail, even if they are vague memories. She insists she's right, and I won't argue with her. She says she has come in dreams and that's final, so I'll let it go."

Sounds like Allison, for sure, with that inner certitude I always loved in her.

But George is hearing more. *"Without telling me, your daughter keeps saying that her first name is short.* This is true?"

"No," we reply in unison.

"A nickname?"

"Yes," I murmur.

"Yeah, that's what I'm thinking. She's called by a shortened form of it. *Now she tells me she has a common first name.* Is this true?"

"Uh, well, it's more common now than it used to be," I explain.

"Well, I've heard it before?"

"You have."

"Maybe I should be more patient. Maybe this is why she has to do it this way, because if it's not an everyday name that I hear frequently, she has to build up to it in her own way. But she's called by a nickname or a shortened form of that name?"

"Yes." It's all I can do to keep from telling George about her friend Jennifer's daughter named Ally after our Allison. Some people even called her Al.

"She just showed me seven letters—must be seven then."

What's all this about establishing her name? Oh, I get it. She's got to prove her identity for us so there's no mistaking who she is. After all, I have to remember that George didn't know of her before. I sneak a look at Ken and he's cool as if he knows that George will get it sooner or later.

"Also I hear somebody say 'Allison.' Huh? Is that your daughter? Oh, thank you. Wait a minute. She spells it with two l's and she told me before I was spelling it wrong. But she's sometimes called Ally?"

"Yes."

"That's what I figure. Because *she shows me the actor Ally McGraw.* And now I know why she said before, *'You could take the name for a man's name.' But she's saying that her baptismal name is Allison.* The spirits have to do it their way to get it out."

I guess so, I muttered to myself. Allison opened lots of doors for us and for others by doing it her way.

4

"Not that she has to, but she says, *'I'm sorry this has happened to you, but there's nothing I can do about it.' Your daughter claims to have passed tragically. It came beyond her control. She just feels bad for the two of you because you're left holding the bag, as they say. And you have to suffer in the aftershock of it. 'Cause she's not only your daughter, she's also a good pal, yes?"*

"Yes!"

"Because the feeling of friendship is there as well. And she doesn't want you to feel that her life was snuffed out. She says her life is continuing, but somewhere else, much as if she's moved to a foreign country. You may think at times that she didn't get a chance at life or that she was in the height of her life, and then look at what happened. She says it's a health-related condition that eventually causes struggling with the breathing. She keeps saying you couldn't save her."

"True!" That's all I could say—just "True!" while my thoughts race around remembering how we'd tried to save her and, when we couldn't, tried to find purpose in it all.

"She says she goes to the hereafter fulfilled. And again, as much as you'd rather have her here than where she is, she says as an individual she had to fulfill her own life in her own direction. And she says that when she did, she moved on. Her health problem is like her passport to move on, a part of her fulfillment, her way of exiting. It's funny—it's almost like part of her knew she wouldn't live to a great age, like she's no more surprised that she's where she is than you should be."

I feel like crying out to her, "Oh, Allison, bless your sweet heart! Here you are still teaching the teacher! I love you so!"

"The illness is there for a period of time, yes? That's what she states. It has the suddenness of an accident where all of a sudden it's discovered, but it's there for a period of time and you don't know it. And, she says, it's almost like at times you feel as parents you should have known something was wrong. But, as she states, you're not infallible. She didn't know something was wrong, so how would you?

"You see, I'm no doctor, so I can't describe what I'm feeling medically, but she states it affects the muscle too. I feel like I'm losing

my muscle coordination because she kids me that she's becoming Jell-O. She admits she put up quite a fight, though, trying to get well again. But the most, the worst, was the leg though, yes! She keeps coming up with having this trouble walking.

"She says she had a short but fulfilling life."

Oh, yes, Allison, I thought, you telescoped so much living into those twenty-seven years. You've really taught us how to live.

Resurrection

*Resurrection: The act or fact of rising again from an
inferior state (as death, decay, disuse) into a superior
(one).*

—Webster's Dictionary

The doctors told us she was going to die—our beautiful twenty-seven-year-old daughter, Allison. We just weren't ready for the when. We had prayed and cried with both heart and mind for eleven years, always imploring God to spare her and us that final day. But it was not to be.

By that Friday in May of 1991, Allison's frail body ebbed away, dissolving as the now untreatable, uncontrollable disease ravaged her. In the last three days of her life, we witnessed a series of events that altered our lives forever. During her short life, Allison had taught us many lessons, and now she would give us insights into heaven itself.

The first hint of heaven came on Sunday afternoon, two days before Allison's death, when she lay in a semi-conscious state between sleep and wakefulness. Ken, the Hospice volunteer, and I had gathered in our first floor den where we had placed her bed. Suddenly the stillness was broken, and, as if from nowhere, a deep, mature voice we'd never before heard came from Allison, "I want you to come too... It's going to be a great time!" The timbre and aura were strong, definite, assertive. Her thoughts were entirely positive and focused on the future. Was this a foretaste of the confident, enhanced being Allison would become after her passing? We're sure those utterances were not of this world. At the time we were too stunned to reply, but the memory of that moment has never left us!

Within a minute's time, her animated comments faded almost as quickly as they began.

Later on that Sunday afternoon, Allison slipped in and out of semi-consciousness, emitting soft, indiscernible utterances. However, at one point her voice resumed its normal tones as if in an ordinary conversation. Then she coherently asked, "How do souls communicate?" Unfortunately, both for mankind and us, Allison did not answer her own question.

On the next day, Monday, Ken and I moved Allison out onto the back lawn, since it was a beautiful May day. She was sitting happily on the *chaise longue* when she unexpectedly started to convulse as if with an epileptic seizure. Later we learned that she suffered a dystonic reaction to medication and was also dehydrating from an inability to retain fluids.

When Allison began to shake, Ken grabbed her to prevent her from falling. As he held her frail body, she was still fully conscious, but rigid. Ken cried out to her, "Allison, soon you'll be with God!" to which she quickly replied, "Dad, I've already seen God!" Ken and I looked at each other dumbstruck, unable to respond. A type of veil enclosed our thought processes, preventing us from probing her revelation. Mercifully, the seizure subsided and Allison asked to return to bed.

Later we tried to understand these events by talking with the minister who visited Allison during her last days. He confided that she had asked, "Will I go to heaven?" To him, this signaled her deep, abiding faith. She demonstrated even more understanding by her description of seeing the image of an angel.

Why had Ken and I not shared in such joy and wisdom? The good minister gently explained his belief that we survivors have not yet earned the right to know what Allison and other souls experience during the transitional period from this life to the other side.

Allison was reaching out to this new existence with its limitless boundaries. Ken and I believe that we saw the beginning of her resurrection. The unusual phenomena that took place heralded the start of her transition to another state of being. We felt so anguished at the time that we could hardly fathom the meaning of what we had seen. yet those first spiritual experiences only prefaced the most profound one of all on Allison's final day of life.

For the last few nights Ken and I had taken turns sitting up with her, sleeping in a big chair next to her bed. Monday night was Ken's shift, and he observed an event that was beyond his comprehension. He relates the story in his own words:

"I awoke in our wingback leather chair shortly after 6 A.M. on Tuesday, the normal waking time for me. I looked over at Allison, now so thin but finally enjoying a peaceful sleep for a change. So I said to myself, 'Why not slip into the kitchen and grab my morning cereal before we face another difficult day?' The kitchen is in the adjoining room, so in a few steps I'd filled my bowl with sliced banana and cereal.

"As I reached for the milk from the refrigerator, I heard an unusual noise coming from the den. A couple of steps put me in view of Allison's headboard, but she was no longer in the bed comfortably lying with her head on the pillow. I entered the den and to my surprise found Allison standing at least eight feet from the end of the bed. By her own effort and for the first time in nine days, she was up and walking! As my eyes focused on her, I was stunned by her appearance. She was upright as a pillar and taller than I had ever seen her. She had not stood that erect for five years.

"Hearing me enter the room, she turned halfway around, revealing the most beautiful Allison I had ever seen. She was pure love! Her expression was radiant, as she smiled at me with a grace far greater than any I had been privileged to see. Then she explained, 'Dad, I thought I'd go upstairs and take a bath.' Unfortunately, I was powerless to answer, although I must have somehow conveyed a parental hesitance of 'No.' She seemed to wilt in muttering, 'I guess that's a silly idea,' and, with that, the lovely form returned to bed and slipped under the covers. She quickly became near comatose and her body lost its radiance as she regained her rapidly developing skeletal appearance.

"'My God,' I realized almost immediately. 'The greatest moment of our life was lost as I stood there paralyzed!' Had I seen what I would look back on as her resurrection? Had I seen her spiritual body? Perhaps this is how she will be on the next plane. Endlessly I have thought about those moments and asked myself what would have happened had I quickly smiled back at her and peacefully said, 'Yes, Allison, let's go get a bath, get dressed, and go out and live the

rest of your life.' Maybe that is something Jesus could have done in helping her to heal herself at that moment and sending her out to the life that she was entitled to.

"Allison's resurrection occurred on that Tuesday morning, and by midnight of that day she was gone in spirit. Perhaps Allison's and our experiences in those final days demonstrate the following Bible passage:

> *Beloved, now we are the sons of God,*
> *and it doth not yet appear*
> *What we shall be: but we know that*
> *when He shall appear, we shall be*
> *like Him, for we shall see Him as He is.*

We believe that the three of us glimpsed this truth before she left us."

Following Allison's passing, the full effects of this witness began to sink in. We again talked with our minister, describing the events of her last days, and he concluded that these experiences showed us her spirit preparing for death. He also told us about *The Road Less Traveled and Beyond* where M. Scott Peck wrote:

> {*The acceptance of death*} *is a stage of great spiritual calm and tranquillity, and even of light for many. People who have accepted death have a light in them. It's almost as if they had already died and were resurrected in some psycho spiritual sense. It's a very beautiful thing to see, but it is not very common.*

"You saw this glory in a most vivid fashion," he commented. "Why don't you tell her story to others? I'm sure it would be of great help on many levels."

A year later, Doris and I decided to write, describing the journey of the loving human being called Allison. Our purposes were to try to understand why such tragedy struck our family, to possibly lift emotional burdens from others facing life's struggles, and to lessen the abyss of desperation over a loved one's passing.

Let us introduce you to the earth angel who entered our lives on February 6, 1964.

The Adoption

Affection is responsible for nine-tenths of whatever solid and durable happiness there is in our lives.

The Four Lives
—C. S. Lewis

*L*ittle did I suspect the telephone call from our lawyer that February morning would contain such life-changing news. But afterwards I sprinted down the hall shouting to Ken, "It's a girl! John called and he said we're the parents of a 6-lb.7 oz. baby girl!" With one of the few physical advantages of a new adoptive over a new birth mother, I leaped into bed hugging and kissing my husband. Then I remembered he had the mumps. Oh, well, I simply couldn't catch them at a time like this. "We've got a brand new daughter to care for, Ken. She was born at 9:03 this morning, and she's doing fine."

Backing away from the sickbed, I tried not to overwhelm him with my joy and instead regain my senses. First, she'd need a name. I searched out the list of names we'd been compiling and, settling a safe distance from Ken on the bed, read off, "Cynthia. That's awfully romantic. Some kind of Greek nymph, I think." Sounded too highfalutin to Ken. "How about Camille? She was my best friend growing up here in Phoenix—so beautiful and smart and poised... No, too tragic—from that movie where the heroine dies a slow death... What do you think of Stephanie? Now that's pretty perky. I wonder if she's a Stephanie, Ken. No, too trendy...I know! Allison! She's an Allison."

"That's it, Doris! I love it. The name says it all. But how should we spell it?"

11

"With two l's. Hall has two l's. And how about Allison Marie after me? Allison Marie Hall."

Although she was now Allison Marie Hall to us, she was "Baby Sawyer" among the newborns in St. Joseph's Hospital nursery. On that Thursday, the birth mother's parents pressed against the nursery window to single out their first grandchild and to despair that soon they would have to give her up. Meanwhile, Baby Sawyer's existence crystallized in our hearts and minds: our giving her a beautiful name had helped to make her our very own.

Kent, now eleven months old and sensing the excitement, toddled into our bedroom, reminding us that we were already the parents of one adopted son. I swooped him up. "Kent, guess what! You've got a baby sister! You're going to have a beautiful little girl to play with. Her name is Allison, and she's going to be the most fun in all the world."

How could I get across to him that his father was in quarantine for a couple of more days? Never mind. Just get back to the challenge of keeping up with Kent's perpetual motion. Now we shall have two children. Other parents managed, and so will we. But I secretly wondered how mothers who had given birth mustered the physical and emotional reserves to accomplish right away all that needed to be done.

These days Ken wasn't eating very much, leaving me time for making formula, washing clothes, playing Legos with Kent. Inwardly I strove to understand my newfound status as the mother of two children. We'd been blessed beyond belief that God had given us a little girl. What a perfect family now with both a son and daughter to care for. Could the moment when John placed Kent in my arms just eleven months ago equal the one that was to come when I accepted Allison as my own? I cried for joy. Tears came readily to me these days.

Then my organizational habits surfaced and I turned to the next priority, calling Mother with the glorious news. We two were one spirit, so my ecstasy was also hers. She squealed uncharacteristically at the announcement. "Oh, sweetheart, you've made your father and me so happy. Just think, a little girl!" She must have been reliving her own delivery of me thirty-five years ago. That was one of the family legends: giving birth to me had counted even above her

own life that she would have sacrificed had it not been for the Cesarean delivery.

From the passionate to the practical, diapers for the new baby. I would not repeat my former *faux pas* of eleven months ago on the morning John had called announcing Kent's birth. Mother's presence had strengthened me then, too, when we'd dashed to town to enlist the help of a diaper service. After all, times had changed from Depression days when Mother had hand washed my diapers.

We'd entered the office that bright March morning with the sun blazing as it did most mornings in Phoenix. The receptionist, Miss Bailey, greeted us with Southwestern graciousness.

"Good morning, ladies. May I help you?"

"Yes, good morning. I'd like to sign up for your diaper service please."

"Oh, fine. Will this be for your baby or as a gift?"

"For my baby!" The wonder of that fact would not soon fade. My baby. My son. At last a stake in the future—a place for me in eternity.

"Your name and address?"

Still the glow remained.

"And the baby's name?"

"Kent Morlan Hall." We'd decided on that name early in our marriage, if we were to have a boy. Like Kenneth, only not a junior. And his middle name would carry on Ken's mother's maiden name.

Miss Bailey's questions brought me back to the business at hand, "Date of birth?"

"Today! This morning! March 11, 1963," I exalted.

Miss Bailey's head jerked up from her writing to stare at me in shock. Her eyes took in my healthy upright frame, conjecturing that certainly I did not appear to have just given birth that very morning. Perhaps I had mistaken the date.

"Uh, Mrs. Hall, don't you mean?" and her stammering penetrated my self-centered euphoria as I realized the source of her confusion.

"Oh, uh, you see, Miss Bailey, we're adopting the baby. He really was born this morning, and he's going to be ours. We're picking him up at the hospital on Thursday."

"Well, congratulations, Mrs. Hall. Now I understand. That's just wonderful." Her broad smile signaled that she too was caught up in my elation, and she assured me all the more that this baby and his befuddled mother deserved the diaper service more than most new families.

"Don't worry, Mrs. Hall. We'll start the service the same morning you bring him home. I'll see that they are ready and waiting on Thursday morning, the 14th, for sure. Now, for newborns we usually suggest seventy to eighty weekly. Just bag and set out the soiled ones each Thursday for pickup. We'll gradually increase the quantity and size as he grows. That'll be $9.95 for the first week payable in advance."

Tears rolled down my cheeks. Tears of relief and gratitude to God that He had given us a sign in the form of the kind Miss Bailey that He would guide us through this adoption. At long last these many blessings as evidenced by Kent himself were coming to us instead of being reserved for other people.

We ended the day of Kent's birth appropriately enough by painting Ken's father's fifty-year-old U.S. Army footlocker for our new son to use as a toy box. In this way we would prove to Kent that we would be good enough parents, at least by the time he was old enough to enjoy such a treasure. We would need time, experience, and God's grace to get it right.

In contrast, the second time we became adoptive parents, I placed a businesslike call to the diaper service increasing the weekly order to 175. Ordering birth announcements came easier too. The first page announced in pink script *Doris and Ken Hall* and continued on the inside:

> *Happily announce that on*
> *February 10, 1964,*
> *They were adopted by*
> *A small girl*
> *Allison Marie Hall*
> *Born February 6, 1964*

Ironically, one detail had escaped me in the excitement of receiving John's telephone call telling me of Allison's birth. When would we pick her up? He had volunteered the information that the nineteen-year-old birth mother and daughter were "doing fine," but he

had not said when she would actually be in our possession. The next morning came the heart-stopping call, this time with Ken well enough to be on the extension.

"Doris," John began. His assuring, avuncular tones did not at first alert me to the undercurrent of tension. "Oh, hi, Ken. I'm glad you're on too. How are you feeling? That's good. Anyway I wanted to tell you folks that there's going to be a slight delay this time in picking up the baby."

I stiffened in panic. "What's the matter, John? Is she okay?"

"Oh, sure, Doris. She's doing just fine. It's just that we've hit a little snag in the adoption proceedings... Uh, you see, it's all been cleared with the birth mother to give her up. But now it seems the maternal grandmother wants to take over and raise the child."

With the words "grandmother... raise the child" Ken burst in, the terror of it all gripping him.

"John, what's going on here? Now, you and I know that baby deserves a home with two parents—a loving, stable home. Of course, a sixty-something grandmother can raise a child—I'm not arguing against her personally—she's probably a fine woman. But it's just not fair to this little baby who has a chance to grow up with a brother and loving mother and father—which you know we are, John."

The prospect of the child who might have been ours being raised by a grandmother echoed Ken's own upbringing. His parents had died when he was two years old. His grandmother had not allowed him and his sister to be placed for adoption in separate homes. Instead she had raised the two of them, along with their four cousins. Understandably, the uncertainty now shook us both in almost irreparable ways.

"Ken, I know how you feel. It has surprised me too, but the good news is I don't believe she'll go through with her plan. I think the birth mother's convinced she can't give the baby much of a life herself and neither can her parents. My guess is that in the long run they'll consider the child's welfare and her future. Frankly, it could go either way, so I just had to let you two know the situation so you'd be prepared."

Prepared! I thought. How is a person ever *prepared* for times when the bottom drops out entirely, when all you've hoped, dreamed,

prayed for is within reach and then slips away with a single telephone call? How could I keep from going crazy after being told on Thursday I was a mother and now on Saturday being told I was not one after all? How could I undo all the plans—not merely the diapers and announcements ordered—but telling everyone I knew and met, decorating her room, buying her coming-home layette, her formula, her supplies. How could I stop enfolding with love this tiny being who had already begun to transform our lives? The physical and emotional preparations of the last forty-eight hours had meant the end of gestation for me. I had tried to compress what natural mothers experience over nine months' time. Most mothers had savored at least eight months of expectation and becoming accustomed to the entrance into their lives of another human being.

My hopes stirred briefly in recalling John's promise, "Now, both Dr. Schmidt (the trusted doctor who had cared for the birth mother and delivered the baby) and I are going to talk with everybody concerned and see if we can't get things back on track. It shouldn't take more than twenty-four hours for them to decide. So let's say I call you again tomorrow about this same time. Don't worry, folks. It's going to work out all right. Get a good night's sleep, both of you. You're going to need it when you have two babies around that house!"

We said we'd try, and then we fell into each other's arms, wordless, weeping, and anguished as never before. Still another worry entered the equation: Kent to whom we'd promised a baby sister. After all, hadn't we longed to adopt two children so they could become best friends? The four of us, having adopted each other, could then face the world together. We'd repeated to Kent so many times the word sister that now he babbled his own version of *seestar*. We couldn't shatter his dream now; perhaps our willing it would bring her to us.

The hours ticked by. If you were to ask me what were the longest twenty-four hours I have ever endured, I would cite those as the second most tortured of my life beyond hours waited in hospital rooms, beyond awaiting laboratory results, beyond hearing word of a child's whereabouts. At least friends and relatives interrupted our vigil with congratulations on an adoption we secretly feared would never take place.

On Sunday night, John's third call, as promised, instantaneously confirmed my intuitive hunch that we were the parents of a baby girl.

"Congratulations, you two! She's yours! The papers are all signed and sealed. You can pick her up at ten o'clock tomorrow morning in the main lobby of St. Joseph's Hospital. A nurse will be carrying her in the outfit and blanket you provided."

"That's wonderful news, John," Ken responded. "How did it work out? Did the grandmother change her mind? Are you sure they've all given her up?"

"Yes, Ken, I'm very certain about it now. Evidently the grandmother saw her daughter's wisdom and agreed that you two solid citizens with another adopted child were the best ones to have her. So it's all set. Remember, ten o'clock tomorrow at St. Joe's."

This time the three of us fell into each other's arms, dancing around and around in the joy and relief of it all. By this time tomorrow we would be four; a baby daughter would complete the Hall household.

In the morning came my ever-loyal parents to care for Kent while we drove to the hospital for Allison. Once again at the mercy of new-parent jitters, halfway there I demanded of Ken, "Where are you going, Ken?"

"To the hospital, of course."

"Which hospital?"

"Good Samaritan. That's where we got Kent."

"Heavens, no! She's at St. Joe's! Turn right here and we'll still be able to make it in time."

In 1964, a private adoption in Arizona was a confidential matter, and the state government, in an effort to protect the identities of all parties, maintained carefully sealed records. Although the law required public notification of the adoption, such notices were so obscurely placed in small newspapers that the item was as good as buried. Under no circumstances would the delivering doctor or attorney divulge information about either party or the child being adopted. In addition, hospital rules mandated that the birth mother was not to know the gender or the health status of the baby and was not allowed to contact or even see the child.

17

We believed in following rules and cast uneasy glances around the imposing hospital lobby with its tall Greek columns and polished marble floors. Then we noticed a nurse exiting the elevator carrying a pink bundle. She looked around the lobby and approached us. "Mrs. Hall?" she inquired and then ever so carefully placed Allison in my arms. The tenderness of that transfer exceeded any other of my lifetime. As we pushed back the little cap to better see her red face, blinking eyes, and shock of dark hair, we whispered in unison, "What a miracle! Oh, thank you! She's so precious!"

Our leap of faith now taken, we quickly reached the entrance, each painstaking step to the car bringing her closer to being truly ours. Only fleetingly did I ponder if from one of the hospital windows someone was watching her baby disappear with us or possibly recording our license plate number so as to contact us later. No, impossible. The anxiety of the past few days had taken its toll on us.

Ken, once again a new father, recalls those first magical days after we brought Allison to the room we had joyfully decorated on the chance that we would adopt a girl. He recalls how Allison affected him.

"From the start, Allison made me aware of the many contrasts between boy and girl babies in their body structure, habits, and needs. I couldn't touch those tiny fingers and toes nearly enough, all the while trying to convince Doris and me that Allison wasn't really so fragile as she appeared. We stared at her lying happily in her crib cooing and smiling, and realized how accustomed we'd become to Kent's constant wiggling and kicking.

"Allison's delicate feminine features so astounded me that I was happiest just being in her room studying her. The realization soon came over me that my life before her arrival had, with only a few exceptions, been barren of sensitive, feminine influence. The entrance of another woman into our household now demanded a new level of decorum from me. This vulnerable little person, this bundle of love and joy, soon taught respect I didn't know I could feel for her purity, her dependency, her helplessness. And then gradually my understanding of and appreciation for all that is female improved dramatically. Now I was blessed with the care and upbringing of this little being who would teach me new non-male values. Clearly, I idealized her, and Allison came to idealize me

too—a perfect unfolding of father-daughter love whose qualities I had so far in my life been denied.

"This heightened sensitivity to the feminine psyche naturally resulted in greater intimacy between Doris and me. I felt a kind of nobility toward women that I hadn't known before, and spontaneous kindness came more easily. At last I was permitting some of my own feminine qualities to emerge, a pattern that so many men carefully conceal behind their infinite varieties of barricades.

"The primary purpose in Allison's young life seemed to be to make me into a more complete person. This blessed child of God changed my life forever."

"And A Little Child Shall Lead Them"

Ever since there have been men, man has given him-
self over to too little joy. That alone, my brothers, is
our original sin. I should believe only in a God who
understood how to dance.

—Henri Matisse

"**K**itchee-kitchee-koo" accompanied my tickling Allison's tiny feet, gently squeezing her cheeks, or rubbing our noses together just to have fun with each other. Her smile stretched across her puffy cheeks, and at less than a month old she seemed to be observing as well as getting to know me. I'd not had the joy of carrying her within my body for nine months, so we had some catching up to do. Part of our bonding took the form of late-night talks, even while she slept. "Allison, how'd you ever get to be that dainty, that fragile and still have all systems working so perfectly? And you barely three weeks old! Only God knows how dearly I love you. Between us girls, you're showing me all over again what it means to be a woman!"

She'd awaken and I'd nudge that miracle of a tiny fist so that her fingers closed over just one of mine. Now that I had her attention, I'd launch into more important girl talk. "Just think, Allison, now there are two of us women in the family! It's you and me, baby, against the world. Life's gonna be a bowlful of cherries from now on."

By the time that third week ended, she'd slept through the night, an event inspiring another woman-to-woman chat, "Allison, I can't believe you let us have a full night's sleep last night. How'd you manage that one, pal? You're growing up too fast!" She cooed back

in delight. "Just do it again, will you? We're gonna have fantastic times ahead, I can tell you."

And indeed we did. With Allison's slim, agile, strong frame and unusually mature presence, the two babies and I ventured outside the neighborhood often. No more new mother fears; we'd only have great adventures ahead of us.

My late-night talks and lullabies generally induced sleep in Allison with one memorable exception. One night she'd taken her usual six ounces of milk when I decided to amuse us both with a song:

> Out in Arizona where the bad men are
> Only thing to guide you is the evening star.
> The roughest, toughest man I know
> Is Ragtime Cowboy Joe.

I'd just begun the refrain, "*He always sings, yes, he sings, jazzy music/ To his cattle while he swings, yes, he swings,*" when Allison's whole body started in an enormous shudder. Like one of those times when you're just dropping off to sleep, your nerves twitch your entire being, and you utter an involuntary cry so that even the bed and very room reverberate. Allison stiffened to the point I held onto her tighter than ever. She seemed to want to fly out of the room, but I cuddled her, enfolding her in my arms when she uttered a piercing, supernatural scream as if afraid, in pain, or in shock. So startled by a shriek a tiny baby seemed incapable of, my nighttime imaginings envisioned either physical pain or foreboding of terror. Then I theorized that perhaps Allison and her birth mother had touched one another in mutual longing. For years to come I pondered the reason for that outcry.

Images of Allison's early years became a foretaste of her adult qualities: a glimpse of her scooting crablike along the floor on elbows and knees with the determination of a Sherman tank. Later toddling independently down the sidewalk insisting on walking ahead of us. Next lingering behind, and when we urged her to catch up, she'd do so in a run. Delectable secret plots with Kent hiding in his toy box to elude Grandma's watchful babysitting. And outdoor hijinks in scaling our backyard six-foot block wall by piling up tricycles, wagons, and a small ladder to invade the neighbor's swim-

ming pool. Allison fearlessly executing the nursery school's parallel bars with "Catch me if you can" zeal to the amazement of peers and mothers alike.

Allison delighted in climbing the dozen grapefruit trees surrounding our house, and they required frequent irrigating, pruning, and seasonal harvesting. The novelty of our first house tugged at our energies and pocketbook. But our two charges so close in age that they resembled twins caused me to economize my energies to savor simpler pleasures of the moment with them.

One spring afternoon, five o'clock, our 'witching hour,' fast approached. The cocktail hour for many people, it signaled tensions at their zenith for us. After enjoying fifteen minutes of relative calm, I stopped sorting clothes. My motherly instinct told me the atmosphere was far too quiet. Those kids were up to something we'd all have to pay for. Unless they were asleep or within sight, I couldn't indulge in fifteen solitary minutes. Detective-like, I searched out their last known whereabouts, Kent's room. Rushing the door as if to raid the premises, my eyes fell on a sight worthy of a photograph. Together Kent and Allison had removed and emptied all of his nine dresser drawers and placed them on a twin bed to simulate a train. He happily played engineer in the front portion while she bounced along in back, the contented passenger.

I decided it was time to get us all out of the house. At this point I couldn't much vary their menu or mealtime, but I could alter its location. So I announced, "Okay, gang, we're going on a picnic. I'll throw some sandwiches together and get a blanket. We're going to climb partway up Camelback Mountain and watch the sunset. Get those shoes on so you'll be ready when I am." They caught the spirit even as I questioned was I nuts to get us all off schedule like this. Nope, it was time for some fun. I'd leave a note for Ken and we'd be off.

In those days, when seat belt laws had not yet been enacted, Kent and Allison contentedly jounced in the back seat of the car while I negotiated unfamiliar streets past the appropriately-named Camelhead district to rocky, but open desert. Shaded by a sturdy palo verde tree, I unpacked our dinner, ham and cheese sandwiches, apple juice, animal crackers, some forbidden potato chips, along with apples and carrots to salve my conscience on matters of nutri-

tion. As a native Arizonan, I scanned the area for rattlesnake holes, but found none and turned to glimpse the city of Phoenix spread out in the distance. Kent and Allison busily explored the camel's—actually the dromedary's—vast left nostril while I watched, liberated from routine. They had taught me in one afternoon to savor the moment.

If our toddlers appeared to be more active than other people's children, I chalked it up to their both being firstborns. If overwhelmed by their energy, I marveled at their curiosity that led them one day to play in an unguarded moment with a neglected broken strand of beads. The results surfaced weeks later with Allison's pediatrician during an otherwise routine physical checkup.

Dr. Wright's examination took in Allison's strong heart and lungs, her developing bones, sturdy muscle tone, nose, throat, and finally ears. Drawing to full stature, he reported confidently,

"Well, Mrs. Hall, everything about Allison checks out fine, except for the red bead in her ear."

"The red bead in her what?"

"That's right. There's a red bead quite far down in her left ear."

"But, but, how'd it get there? Allison, how ever did you do that?"

Her silent, steady gaze offered as much of an answer as we were ever to have. I was asking for the unanswerable. Although Allison didn't remember its getting there, the inescapable fact of its existence remained.

Dr. Wright plotted his strategy. Since the bead was too deeply embedded to be reached by ordinary instruments, he suggested that first we attempt to dislodge it through periodically dropping warm ointment in her ear. He warned that if this did not loosen it, then surgery would be necessary. "Surgery! What kind of surgery?"

"Oh, just minor surgery. It'll mean a general anesthetic and only overnight hospitalization. But for now you'd just better go home, try the ointment, and see if it doesn't come out within the next few days."

You guessed it: surgery became necessary. Earnest, apprehensive Doris and Ken determined to prepare their three-and-one-half year old for the event. We read her all the proper books; we reassured her in all the recommended ways; we waved and kissed her good-bye

approaching the operating room. But inwardly we felt downright flawed in allowing the whole thing to happen.

The mystery bead was quickly removed, and we gazed at Allison's small form returning on the gurney following surgery. Not yet realizing the limits of parental control in many such situations, we listened with dismay to her most vivid recollection of the entire episode. The morning following surgery, she'd heard a nurse's gruff voice shouting, "Allison, wake up! Do you hear me? You'd better come to in a hurry or I'll let you have it! You'll be sorry!" The red bead, specimen #0097, remains to this day in our memory box as a testimonial to Allison's courage.

What did we do to deserve such a graceful little girl who taught us the "dance of life?" Her early love of dancing not only drew others to her and into a celebration of life but it laid the groundwork for future happiness. Now in pre-school, she exhibited incredible style. Her wise teacher offered music that captured Allison's imagination to move in harmony with its rhythm.

Allison's natural inclinations also turned to costume, as I learned one day when she insisted on borrowing one of my skirts—vivid green, with flamboyant Mexican design and yards of flowing material. The next day, in pre-school, I watched her parade in step to the music, costumed in my skirt with its waistband draped on her shoulders—just the right length for a three-foot girl to twirl in. Our glimpses of her transcendent joy in movement made us receptive to advice expressed in that Shaker melody, "I Danced in the Morning:"

> Dance, then, wherever you may be:
> I am the Lord of the Dance, said he,
> And I'll lead you all wherever you may be,
> And I'll lead you all in the dance, said He.

What philosophy undergirded our approaches to rearing Kent and Allison? One of love as well as the simple realization that all four of us had initially come together as strangers to form a single, strong family unit.

Meanwhile, Ken was experiencing a restlessness that stemmed from a lack of job fulfillment and future growth potential. He recalled one of his early mentor's advice, "Ken, never let geography be a primary influence in determining your career goals." Following

that wisdom, he accepted a new sales position in marketing products in the industry he knew: heating, air conditioning, and refrigeration. The company, one of the largest in Denmark, transferred us back East, reversing the old adage of "Go west, young man."

I, an only child, was squarely divided between heart and head. My sorrow over putting a nation's distance between my parents and me warred with my common sense that told me we should go. Armed with a graduate degree to put to use, a family legacy of reaching out for opportunity, and my parents' selfless encouragement, I knew I must follow the biblical Ruth's wisdom that *Whither thou goest, I will go.* Besides, maybe I could even try teaching in high school there.

Bidding a sad good-bye to Grandma, Grandpa, and our dozen grapefruit trees, we moved to New Jersey on one steamy July day in 1968.

Questions

Bonding is more important than genes; love and affection, more important than DNA

—Dr. Laura Schlesinger

*T*hat July day we left Phoenix, the local Indians were probably doing an above average job for the tourists frying eggs sunny-side up on the sidewalks of downtown Washington Street. Boarding our flight, we assured Kent and Allison that it would be cooler in New Jersey.

"Where's New Jersey, Mom?"

"Oh, it's clear over on the other side of the country. Look at this map right here. See, it's that little state next to the Atlantic Ocean, and it's got more people per square mile than any other state!"

"Oh, yeah? Well, will I have a smaller room then?"

"No, Allison. Actually it's going to be bigger."

"Awright!" She uttered the expression that would become one of her hallmarks, "Awright!"

The stewardess awarded Kent and Allison special wings commemorating their first flight, and we found in New Jersey, "It isn't the heat, it's the humidity."

Unknowingly, we continued learning lessons from Kent and Allison as we concentrated on immediate issues, trusting that distant challenges would either take care of themselves or disappear. With a fix-it-up special of a house to renovate, four distinct seasons of the year, the super-charged New York metropolitan pace of life,

and new friendships to cultivate, we confronted frequent lessons in adaptation. Now my calendar was filled, as I received a call from the local high school accepting my application to teach.

Ken and I knew from the very start that Allison was a special child—how special we did not imagine, but we felt that God had given her to us and put her in the world to accomplish something important. In our new stimulating environment, we believed that if we flourished, so too would Kent and Allison. Although at times our new life taxed our ability to cope with change, both children inspired us to keep reaching beyond the norm. I marveled especially at Allison's intuitive, inter-personal strengths.

Second grade reading and writing nourished Allison's emerging personality. After a few months, however, some hindrance seemed to be blocking her progress. As a high school English teacher and as a mother, I had to know the reason for her poor reports. Allison had loved reading up to now, and we'd nurtured that inclination. Then came hints of physical difficulties, perhaps visual ones. Before long, a family talk ended in her confession that she needed glasses.

Getting her eyes examined became our first priority. Within days we appeared at the eye doctor's office for the feared results. Dr. Lee's mild manner and intricate test results only heightened my anxiety during a private doctor-to-mother huddle. "Mrs. Hall, Allison really doesn't need glasses. Her eyesight is actually quite normal."

"Then why the complaints, Dr. Lee? Why the poor grades?"

As soon as the questions left my lips, I recognized the ruse. "Oh, now I get it. Allison actually wants to wear glasses, whether she needs them or not. Of course, her friend Melanie recently got them. And Kent has worn them for three years now. It's some kind of status symbol. Whatever can I do, doctor? What do you suggest?"

No doubt this hadn't been the first time in Dr. Lee's career that patients had wanted glasses for reasons other than physical ones. "Well, Mrs. Hall, I can prescribe glasses with only a minimal correction in one lens. It certainly won't hurt her eyesight, and it really won't do much good either. She can wear the glasses whenever and wherever she wants. My guess is that after a while, she'll discard them."

"Do you really mean it, doctor?" For all intents and purposes, they'd just be clear glass, but they'd get her through whatever fad she's dealing with?"

"That's right. If you don't mind spending the money, Mrs. Hall, that's what I'd advise you to do."

Allison's one pair of glasses prescribed at the tender age of seven rounded out her wardrobe but did not elevate her to social prominence. For her lifetime, Allison remained both outside the pack and, in ways, ahead of her peers. With her incredible self-knowledge, she was a more authentic person than the rest of us, as seen by this revealing response to a third-grade assignment to describe herself:

> I am Allison or Alison or Allyson or Sonny for short because my name ends in 'son.' I would like this to be part of my diary. I have glasses. I guess that would be the first embarrassing thing to say. I love babies. I think they are very cute. I try to obey my mother. I like boys, but when I get up close, it gives me the funniest feeling that I'm a woman. I did promise to not be like other people, although I do still try but not really much. I also try to be very good in school and some of my friends are still copying over my paper.
>
> I am the youngest in my family. I have an older brother that is a year older than me. You might think it is very dumb, but I call my room my lullaby place because it is so quiet and seems like my real house and I do take care of it and I never thought of it before but don't think it has ever gotten messed up. I do act kind of babyish too. Oh, well, I just guess I can't be like a real person at all. Here are some compliments that some people say—I act too big for my age. I am very brave to go up and speak like I would normally to a friend but I do it to a teacher. One thing I enjoy the most is going out and FEELING FREE! Although you might think it is dumb, I have three pictures of my grandmother, grandfather, and mother in my room and whenever I feel lonesome or I am going to go somewhere I always tell them or talk to them!

We tried to give our children wings as well as roots, which led to frequent travel. No second home at the beach or mountains for us;

instead we voraciously covered the Eastern seaboard: Disney World at Christmas with Grandma and Grandpa when together Kent and Allison took round trip rides on the Monorail. Visits along the Hudson River and to the Vanderbilt Mansion when we wondered if Kent might not have visited too many restorations with his question, "Is this house for sale? Can we buy this house?" Another Christmas in Bermuda with Kent and Allison on motorbikes negotiating hilly roads and miraculously returning safely. Summer weeks at Cape Cod where Allison thrilled to dancing the Hokey Pokey around the Chatham Bandstand. They seemed to gain the greatest peace while visiting Grandma and Grandpa in their cottage nestled next to the red rocks of Sedona, Arizona. I recall our splashing in Oak Creek there many afternoons reveling in the wonder and enchantment of nature.

As Allison grew, so did my ambivalence over her independence. I both rejoiced at her new experiences and grieved over her being gone for two weeks at summer camp. Certainly winter schedules brought more sense of control with her piano and ballet lessons, joining the school band to play the oboe (her courageous choice!), in addition to Brownies followed by Girl Scouts. June brought year-end recitals where our pride spilled over at the poise and stage presence of this essentially private person. Throughout, Allison's guardian angels nurtured her in ways we did not realize, or so I surmise from these marginal sketches at nine years of age.

Ken and I labored under that common parental fallacy as to the power of our influence, largely unaware of the mothering and fathering taking place in her outside world of teachers, playmates, and, to some extent, television.

My earlier student-teacher days had shown me how to learn valuable lessons from students, but unfortunately some home lessons that Allison delivered escaped me and caused needless pain. Not all the insights our children can teach us are pleasurable and easy to grasp. For instance, I saw merely the charm rather than the underlying sadness of this note conveniently left so I would find it following a disagreement.

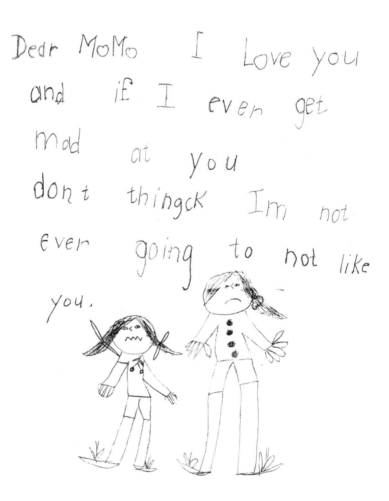

Questions

As communicators, Ken and I believed we knew how to deal with Kent and Allison above all, and we prided ourselves on conversations that were two-way streets. But I wondered at our success when I ran across more of Allison's writing.

> The Adopted family and The real Family
> My real mother was going to get maried, But then they desided not To. Then I was born and they couldn't keep me. So I had To be adopted. Then when I was 9 years old I met my real mother again, But when I found out she was deforced I wished she wa see it all happend when They got maried they had 5 children Then the Father was going on too many Trips so They got deforced. Then My Real Father had Two children But he didn't want Them so he gave Them to my Real mother. So then she got maried and just a little bit ago she had TripleTs.

I couldn't believe my eyes! It took me a while to realize that Allison had cooked up such a dream scenario! It was wishful thinking that she'd found her birth family. Shortly after that, I discovered a sketch of this dream family, complete with siblings and pets galore.

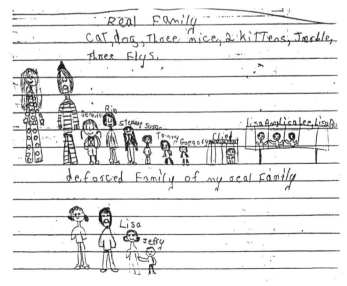

What to do? She'd certainly shot down our theory about adopting two children so they could help each other understand and accept the whys and wherefores of adoption. Better attend to it!

The following Saturday, Allison and I decided on a shopping trip, and over lunch and on neutral territory, I launched into some girl talk whose ring of sincerity belied my manipulative intent. "Just think, Allison, you're going to be ten years old next month. I'll never forget the day we brought you home from the hospital. It was about the happiest day of our lives! Grandma and Grandpa and Kent were beside themselves waiting to get a look at you. We took pictures and showed you off to all our friends. We'd fixed up your room just so. I'll never forget how darling you looked with your sweet little face peeping out from under that baby bonnet."

"Did I look like my birth mother, Mom?"

Uh-oh. I'd got the clue. Her curiosity had started up again. "Never saw her, Allison, no way to tell, but it's certainly natural to assume that you look like her. I do know that she must have been a really brave and loving young woman to have given you up."

"Maybe—I dunno, Mom."

"'Course she was, sweetheart. She knew she couldn't have raised you alone. Remember, we told you she was just nineteen when she had you."

"Yeah, I know, Mom. (Pause) Did I have any brothers or sisters?"

Allison was always one to ask the hard questions, but why now when I was ready to either burst out in tears or choke on my food? Instead, I replied, "Nope. That's one reason she decided we'd be a good family for you, Allison, 'cause you'd have a big brother. That's more than your father and I had."

"Yeah, I guess. Kent bugs me!"

Was she convinced? Was this the end of the questions or just a brief respite? What more could I do than to tell her the honest truth?

"Just remember, Allison, your father and I know we could never, never love even a birth daughter more than we love you. You know that, don't you, sweetheart?"

"And I love you guys, too. I know I probably bug you a lot. I'm sorry."

"Don't be, Allison. Really, it's okay. We'll just all try to do better. Gotta get these things talked out every once in a while." Whew! Guess that's over for now. It's like trying to explain about the birds and the bees, only worse. Certainly we'd always let them know they were adopted, but you just have to keep repeating things on their level. Guess you can't leave out anything or tell it enough times.

But why didn't Kent show interest in the whole subject of adoption? We'd tiptoed toward the birth parent morass to ferret out whether or not he had any latent questions or concerns like Allison. Well, he'd simply dismissed the matter with, "You guys are my parents! Forget about it!" Those two sentences had spelled out to me that he was secure in our love.

As it turned out, "explaining about the birds and the bees" was child's play compared to dealing with two more incidents in Allison's eventful tenth year. The first episode she later described:

> One night I saw a movie where a girl's life was ruined because she found out her father and mother had adopted her and she wasn't really their own daughter, as she had believed all her life. She found the adoption papers by accident during a big birthday party held for her on her sixteenth birthday. Ever since that movie, being adopted has bothered me.

One fall day, my friend of several years and mother of one of Allison's best girl friends, appeared at our door. "Hi, Doris, how are you? Can I come in?"

"Well, hi, Eleanor. So glad to see you. Yes, do come in. How about a cup of coffee?"

"Oh, no, thanks. I can't stay long."

Eleanor, always one to get right to the point, turned her dark eyes on me, and, savoring the pronouncement, said,

"I understand that you've found Allison's birth mother! So happy to hear the news, Doris. Sandy says Allison's also telling everybody she's got a whole lot of brothers and sisters too!"

My disbelief managed to still Eleanor's forward momentum until I could regroup and ask for more details.

"Eleanor, I'm sorry, but I just don't know what you're talking about. Now, once more, please tell me what you've been hearing from Allison. I've got to understand what's going on."

Fortunately, Allison's story had not circulated beyond a few friends. Her tale was simply that she'd contacted her birth mother in Phoenix and had been welcomed back into her family after a long separation. Soon Allison would be returning there for a memorable reunion to claim forevermore her true birthright.

If a mother can be blasted out of complacency into glimmerings of her daughter's pain and resulting fantasies, this was the moment. First I had to address poor Eleanor's confusion. The visit ended agreeably enough.

"Eleanor, I really do appreciate your telling me about this. Believe me, you're a true friend to do so. I'm going to try to straighten all this out as soon as I can. I'll let you know how things turn out."

"Sure, Doris. Actually, I had my doubts when I first heard, so I thought I'd better talk to you first. You've really got your hands full with that girl!"

Ken had also learned to expect the unexpected, so when I greeted him at the door with a hurried, whispered account of our latest challenge, by dinnertime we'd found the strength to realize we needed some professional advice to help us all. First, we seemed to be functioning differently from a biological family. Next, some healing surely had to begin. We could not appreciate the trauma of an adoptee being relinquished by the birth mother. But how were we to confess to our imaginative, needy, bright Allison that Ken and I were both unable and unwilling to locate her birth mother?

A forthcoming trip to Arizona at Christmas would provide what we believed would close the book on Allison's quandaries over her adoption. We would resolve her questions and enjoy the carefree vacation we'd hoped for. The plans were to meet with brisk, savvy, Dr. Schmidt who'd delivered her. Then we'd follow up with a visit to John, our family lawyer, who'd talk to both Kent and Allison like the proverbial Dutch uncle. Both children readily agreed. Their meetings would not take away from their usual visits, swimming, and horseback riding. The appointments were made and, in due time, came about.

Dr. Schmidt's practiced eyes took in all the family, and alerted to his intended mission, he greeted Allison with his usual breeziness.

"Well, hello there, Allison. My, but you're growing up to be a nice girl! You know, I was the very first person to ever set eyes on you! You were beautiful even then!"

Myriad pictures crowded his office bulletin board detailing the progress of the many children adopted through Dr. Schmidt. His pep talk continued with its ring of sincerity and compassion.

"I remember your mother was a real beauty, too. You guys are mighty lucky to have such great adoptive parents. What grade are you now in school?"

Dr. Schmidt doled out sound fatherly advice directed mostly at Allison until he sensed he'd both pre-empted and satisfied her curiosity.

Next came a meeting with John to whom the task proved more difficult, given his initial qualms about a private versus public agency adoption in the first place. But he rose to the occasion and might as well have been negotiating a contract considering his businesslike, orderly command of the proceedings.

Kent sat in a far corner of John's office, thumbing through a *Reader's Digest*, seemingly uninterested in this person we'd billed as such a friend. Allison posed the penetrating questions: "Did you know my mother? What was she like? Do you know what happened to her? Did you ever meet my birth father?"

Much to our relief, John answered forthrightly, sensitively, and with textbook insight. Yes, your birth mother came to me to handle the adoption papers. Yes, Allison, she was nineteen and very beautiful. No, he didn't know and couldn't find out her whereabouts. Frankly, if she'd like his personal opinion, it'd be useless to try to find her birth mother. No, he hadn't met her birth father. However, from acquaintance with your adoptive father and nearly lifelong knowledge of your adoptive mother, both you kids should get along fine with the parents you've got!

Again, a welcome ending to two remarkable interviews. As we left John's offices and crossed the art deco lobby to the street, we each felt heightened awareness that some important phase of our lives had closed. Entering the car, we knew we were a family bonded by

love. As Ken and I had withstood several of life's trials, so now Kent and Allison would find the strength and character to confront whatever came. I glanced back at Allison and saw that in the mist of the rear window in her lefty scrawl she'd printed:

I LOVE YOU.

Running

(Emily) "Do any human beings ever realize life while they live it—every, every minute?"

(Stage Manager) "No, the saints and the poets, maybe—they do some."

Our Town
—Thornton Wilder

At age eleven Allison began staying after school for running prac- tice and was soon invited to be on the track team. Next came her reports of meets and wins recounted with such confidence, pride, and spirit that we knew running had become an important part of her life.

Meanwhile, as with most teachers, I taught what I valued most, for instance, Thornton Wilder's *Our Town*, emphasizing young Emily's suggestion that we appreciate life more. Imagine my zest in teaching Sillitoe's short story *The Loneliness of the Long-Distance Runner* when Allison was breaking track records, achievements unfolding as a natural outcome of her passion and talent. My patter went like this: "Hey, guys, lookit that line where the protagonist says, *'Makes me think that every run like this is a life—a little life.'* That's called a metaphor." or "What do you think he means by saying, *'You see I never race at all; I just run'?"* or "See where he says, *'I knew what the loneliness of the long-distance runner felt like, realizing that as far as I was concerned this feeling was the only honesty and realness there was in the world.'* That practically sums up the point of the whole story, doesn't it?" And all the while, I'd been thinking of Allison, though unaware of the complexities of her inner life.

Then came Allison's increasing mention of her friend Debbie, another lover of running. For two years, Allison and Debbie led in fast walks, long jumps, hurdles, and sprints until the season neared its end with only the two of them from the school qualifying in the final 440-yard county race. They would compete as never before.

That race produced records that still remain. All fear, reticence, and hesitation left Allison for those supreme minutes, and she won the race. But seconds later she realized that she'd won over Debbie; she'd defeated her best friend; she'd bested someone she loved. Allison savored the joy of winning, but kept to herself and from us her bittersweet dilemma of winning over Debbie.

I watched well-wishers crowd around Allison, but also her turning away more in anger than in acceptance. Her sourness, petulance, and incongruous discouragement continued over dinner that evening. Only long afterwards did I find out her solution. She'd determined to make it up to Debbie and to confess her sorrow, conflicting emotions, and her pain. Ruled by her unique personal moral code, Allison could not rest without apologizing and reconciling their friendship.

That evening Allison sought Kent's help in going unannounced to Debbie's house to give her a bouquet of flowers purchased with accumulated savings. This token would assure Debbie that Allison understood her sadness and somehow wished that it could have been otherwise. We parents as well as Debbie grasped only superficially Allison's conviction to place friendship above winning and human relationships above sports competition.

To reward Allison for her many track victories, we finally granted her longstanding wish to have a dog. Ken took her to the last remaining farm in our town to look over a recent litter of adorable Golden Labrador puppies. As Ken and Allison peered over the partition in an old shed, they could see the puppies tumbling over one another in play, nuzzling their tired mother for attention, or eagerly eating. No sooner had they approached the enclosure than one puppy raised its head above the pack, spotted Allison, and ran to greet her. For Allison, it was love at first sight. She picked up the beige ball of happiness, and Ken swears the puppy smiled. Allison named him Ben.

Ben was an exceedingly fast runner, a trait that endeared him to Allison during her track days. She and Ken established a routine for

him: during the day, tethered outside on a long chain and in the doghouse built for him by Grandpa; at night, on the screened porch for safekeeping. The procedure worked well, except on those infrequent occasions when Ben broke loose and circumnavigated the entire house in about ten seconds flat. At times he resembled a Greyhound in exercising that strong frame in exhilarating, free romps. We did not want him in the house to chase Nasel, a stray cat that Kent, another animal lover, had brought home from summer camp.

At nine months of age, Ben was still in his childhood when, as was Ken's nightly habit, he brought him in from his dog run to the back screened porch. Despite the heavy chain attached to his collar, these days it took all of Ken's strength to control Ben's youthful energy. On one particular evening, as Ken led Ben to the porch, halfway in the door, he released the chain from his collar. Ben bolted and galloped off into the darkness. Momentarily Ken saw the lights of our neighbor's car flashing as they entered their adjoining driveway.

Ken set out to search throughout the neighborhood, but Ben did not respond to his calls. We could only assume that after Ben had completed his night's investigations he would return to our doorstep as one tired dog. Fortunately Allison retired for the night unaware of the problem.

Finding no Ben the next morning, we faced the unpleasant experience of telling Allison that Ben had run off. It occurred to me that perhaps those parents who never got around to finding pets for their children led simpler lives. Our assurances that we would keep looking for Ben did not lift her sadness as she and Kent walked to the corner of our property to wait for the school bus.

We heard the bus pick them up and turned to our own busy schedules when within minutes came a pounding on the front door and

Allison's screams that Ben was dead. Ken opened the door to see Allison in tears and, behind her, Kent holding Ben's still body. To her horror Allison had spotted him from the bus window and pleaded with the bus driver to let them off, which he did.

Apparently after bolting, Ben's body had glanced off the neighbor's front bumper and he had crawled to a low spot in their front yard, collapsed, and died of a broken neck. Ken seems to remember hearing Ben's tag faintly jiggling when he'd tried to raise his head in response to Ken's calls. However, on that dark, cloudy night, unable to see him, Ken had gone on.

We buried Ben in the backyard garden, as Allison wanted the remains of this, her first pet, to be close at hand. Ken offered a short prayer, and Allison later found solace in pouring out her grief in her journal:

> Ben, I love you. Can you hear me now? Why did you have to get hit by a car? Ben, I forgive you. Just please stay near me and wait for me to die. I'm scared now that you've gone, but when I die, I'll have you with me again. Now I know how Mom felt when Grandma died.
>
> I know you're crying, but soon we'll both get over it. Don't think it was you that hurt me. It's just that I love you so much. You were my very first dog, and I was very attached to you.
>
> If I get another puppy, don't be jealous. I'll always love you better. I'll come visit you by your grave. You must be very lonely.
>
> Maybe you're mad at me because I was scared to touch you and look at you that day, but I was just very upset. Please understand. It might take me a while to come to you. Please wait.
>
> If you see me now and you're barking at me, don't get upset that I can't hear you. All I want to do is scratch your ears and shake your paws just one more time. Good-bye, Ben.

Allison's reaching to Ben beyond the grave might well have comforted me in the recent death of my beloved Mother had we shared our grief. Certainly Allison's instincts rang true. Although her

favorite symbols, the unicorn and the rainbow, offered her solace, Allison's thinking was deepening even more as she completed her year's study of religion offered by our local Presbyterian church. With tears of joy and gratitude, we watched as the minister introduced Kent, Allison, and each member of the confirmation class to the congregation. His prayer for Allison went this way:

> Lord, bless this unique young woman who is Allison. We ask that You lead her in continued growth through those deep spiritual qualities that she has so lovingly shown. Amen.

Still another rite of passage, Allison's sixteenth birthday, drew near. No sooner had we asked that she plan the day than we received a detailed description of the proceedings, which we followed:

My Birthday. Feb. 6, 1980 on a Wednesday

In the morning, will have to get up early. Would like to have a huge breakfast w/ waffles, grapefruit, and those certain meat patty sausages you used to make, Mom. Would like to have One white rose wrapped in tin foil to carry around in school. At seven o'clock, would like to have dinner at Houlahan's at Riverside Mall. During this whole day will be taking Snap shots. After dinner, ride back home and have fire, with music. Eat my cake (small, lemon filling, white buttery frosting, with tiny pink, green, blue, and yellow flowers all over. No saying except two candles, a 1 and a 6.) Open presents and then go to bed. What a day!!!!

B-List
Portable radio, like your's Dad, but maybe no tape recorder.
the game "maniac"
light yellow sheets and pillow cases.
Carpeting
white curtains for room.
$50 to do with what I want! (too much?)

41

The Bus Trip

There is always inequity in life. Some men are killed in a war and some men are wounded, and some men never leave the country... Life is unfair.

Press conference, March 21, 1962
—President John F. Kennedy

The lushness of May mornings in northern New Jersey still quickened my juices, despite the daily emergency of seeing off two teens to school and preparing myself for teaching at the neighboring high school. Routes to our separate destinations wound past white blossoms of flowering pear trees, lawns so green they dilate the pupils, and delicate pink cherry blossoms blanketing the road.

On this particular May morning, I could see the big yellow school bus lumbering along and picking up Kent and Allison at our corner. Allison, now just sixteen, sat down a polite distance from Kent, and they were off. She confided later to sensing a heavier than usual group atmosphere among her peers on the bus that morning. Soon the reason became clear: a new bus driver and an inexperienced one at that. Too bad, she mused, already feeling below par. Perhaps the wrangling with me over eating breakfast and my sidelong glances at her faded jeans and Kent's borrowed plaid shirt had rankled. Following the unfamiliar blocks, the bus driver clumsily negotiated twists and turns, hills and dales. Still Allison held on tight, telling herself, "It'll be over soon. School's only twenty minutes away. Wish I hadn't sat over the back wheel of this thing!"

The truth of the refrain, "We all live in a yellow submarine" recurred as the school bus rounded a high curve, unexpectedly catching a back wheel on the curb. Without warning, all the chil-

dren swayed in their seats, and the motion pitched diminutive Allison out of her seat with a force strong enough to throw her across the aisle. Her back struck the opposite seat's frame and she fell to the floor, writhing in pain.

"Kent, help! What's happening to me?" she cried out to her brother. Her screams of agony brought the bus lurching to a stop, as her classmates stared paralyzed over what could be happening to the ordinarily self-contained Allison. Stabs of pain tore at her back as Kent leaped to her side, insisting, "Allison, stay right here, okay? Let me help you up. Does it hurt bad?"

"God, yes, Kent," she frantically replied. "It's intense! It just keeps coming!"

The distraught bus driver decided to take charge by shifting into reverse. "I'll drive you back home. Hold on. I'll just back up, turn around, and we'll be there in no time." His panic-stricken efforts jerked and jolted Allison until her pleas again silenced the group.

"Please, sir," interrupted Kent, "Can't you just let us off? I'll get us to a neighbor's and call home from there."

Gingerly helping his sister off the bus, Kent secured a neighbor's aid. Ken, working in his home office, quickly picked them up and pleaded for an early appointment with an orthopedist, one of eleven doctors Allison had seen for back pain in the last three years.

Until this day's visit, no two diagnoses had been the same. One doctor mentioned "growing pains." Another confided that it existed mostly in Allison's mind. Another doctor settled on a diagnosis of scoliosis and suggested that she practice standing up straighter. Most attributed her complaints to running, with resulting damaged ligaments and muscle strain. In fact, just two weeks before, Allison had excelled in a state amateur track meet at Rutgers University.

For two previous excruciating attacks, we'd taken Allison to the emergency room of the local hospital where medically naïve and hurried interns treated only the symptoms and awarded her a new packet of pain pills. Most of what confused us was that as quickly as her pains arose, within twenty-four hours they subsided.

Dr. Branigan, the orthopedist, had examined Allison three long years before for similar yet less severe symptoms, and he now carefully listened to her description of the new episode. Allison spoke

with almost scientific precision. The good doctor examined her back, carefully probed her stomach muscles, and determined exactly where it hurt the most—deep within her right abdomen. We studied his facial expression as his puzzlement evoked thoughtful "Hmmmm's" and "Uh,huh's."

Surely God's wisdom shown through Dr. Branigan on that day. After reviewing his past notes, he reported an "enlarged area of tenderness" this time, a palpable change from three years earlier. Knowing that Allison's complaints were genuine and persistent, he suggested, "Perhaps a sound scan might be the best bet, folks. . . We'll schedule one for you day after tomorrow." And from that moment forward, our lives changed forevermore.

Two days later Allison was wheeled into a laboratory specializing in diagnostic medicine. After a short time, she returned smiling to say that the expected ordeal had not been an ordeal after all. She had simply lain on a table while a doctor slowly waved a wand over her body. He'd explained that the wand was a sound device that sent out signals to a monitor and bounced them off her innards. If all the bounces patterned normally, then everything would be fine.

The doctor gave us no idea as to how the scan went, but advised that we would hear from Dr. Branigan. It was just that simple. Within two days we would get the call.

Those two days seemed suspended in time, and I felt suspended in space like one of those deep-sea divers you see in pictures moving with purpose but ever so slowly. Why couldn't I follow Allison's lead in just living life in the moment? She managed to sleep late, listen to her favorite tapes, and chat endlessly with her friends over the telephone. Until recently that harmless plastic instrument had happily brought me the outside world, but now I waged civil war with it. Whether our kitchen sentry or nightstand model, those telephones were keeping information from me! While Allison brightened in anticipation at its ring, I railed at its imprisoning me in my own home. With each call, whether telephone solicitation or friend, I answered in my best secretarial mode. Then, as with many of life's experiences, the doctor's call came when I least expected it.

The sound scan had revealed some type of "invasion," something amiss, but probably not all that serious. He was certain it could be taken care of through a surgeon's look-see. So he wanted the top

man in the area to study the findings and decide what to do. Simple as that.

The "top man" turned out to be a Dr. Todd, and plans accelerated until Allison and I found ourselves two days later waiting in a familiar group of doctors' offices. After three years of medical visits, I could tell you the floor plan of most all the doctors' offices in our area. Allison thumbed through their magazines with genuine interest, while I merely went through the motions. Here she took not only each day but each hour one at a time. Smart girl, that daughter of mine! I inquired about her recent final exams and she'd done okay in English, Biology, and Art, but wasn't so sure about Math and History. How was she so secure both inside and out while I felt shaken to the core? Better take my cue from her and get it all together.

When they called her name, she informed me that she wanted to meet and be examined by the doctor on her own, thank you very much. What was I—the transportation committee? But afterwards, Dr. Todd, a prematurely gray-haired man with large, piercing brown eyes and a broad smile, came out with her, both of them seemingly satisfied with a job well done.

He admitted that indeed there was a small mass near the back of Allison's stomach, and hospitalization was in order—say, next Thursday, the 18th, for surgery the next day. As my eyes widened in alarm, he quickly explained, "Nothing major, Mrs. Hall, I'll do a laparotomy—an exploratory procedure to merely investigate the area. She'll get through it fine, and at her age, she'll be home in no time at all!"

I sneaked a glance at Allison who'd taken the news calmly enough. This called for letting go, so I proposed, "Let's go out for lunch!" as impulsively as that day over a decade ago when we'd picnicked next to the nose of Camelback Mountain. Allison readily agreed if we could keep it simple and get one of her favorite subs— nothing fancy or drawn out. Were we bolstering each other, ourselves, or just savoring the relief of knowing that at last a doctor was taking action?

"Well, at least, Allison, we're both through with exams. Boy, is that a lucky break. I can check stuff out of your locker at school, can't I? And they won't miss me at the high school if I don't attend graduation this year."

As we reported to Ken, I searched his face for that slight wrinkling of his brow that signaled his doubts. Perhaps the fears were really my own and I should dismiss them. Besides, Allison was more active than ever, what with interminable telephone chats with Marla, church youth meetings, listening to tapes, and going to movies. Well, I'd just compartmentalize my life the way I'd learned in high school after reading all those self-help books. I'd concentrate on only one area at a time: children, husband, house, and self in that order. Rather an impossible task though.

Lurking in the inner recesses of my heart—except on Sundays—was the suspicion that I'd put God on the back burner. He wasn't in limbo, I was. I'd prayed hard enough for strength and help to get through these days. After all, didn't I wake up every morning to that saying on my nightstand, *"Lord, help me to remember that nothing is going to happen today that You and I together can't handle."*? But that part about turning everything over to Him was pretty extreme. Best not to press my luck any more than I have already by asking God to step in and help with all the details. Best to find some middle ground between my will and His. Time would tell.

Still I didn't want Allison to start out this sixteenth summer with even brief hospitalization. A girl's sixteenth summer should be once in a lifetime. I remembered mine, celebrated in Santa Fe, and hoped that the rest of Allison's summer brought on new adventures. Lately she'd been savoring the usual I've-got-the-world-by-the-tail existence of a sixteen-year-old, interrupted only when we seemed to get in her way.

I thanked God for Allison's running and the fact that she loved reading and writing more and more. I'd noticed she and Marla, another individual type person, had become even closer friends. If Allison missed having a sister, then even one good friend was the next best thing.

Guess I'd welcomed this summer more than most, since I didn't reckon months by the ordinary calendar. My year began in September with the chance to teach and learn new material. Then after December's respite, I had a second renewal in another semester's work. Next came that blip of a spring break followed by glorious June and the reward of two uninterrupted months with family. June was no ordinary month for me.

Maybe we could still rescue the summer that we all deserved and go on vacation: Kent and Allison and I could go back to Cape Cod. God knows we needed natural surroundings, not manmade ones, and relaxed closeness, not rushed schedules.

As Allison and I approached Valley Hospital that June day, I remembered our first trip to the emergency room with her. How could I get through it this time? Granted, I'd been hospitalized a couple of times since that emergency appendectomy when I was eleven, but now it was Allison being admitted. I'd just do it, that's all, because here was matter-of-fact Allison looking cool as a cucumber. I'd just march up to that Admitting Office, answer all their questions, and get a room. No need to get defensive when the admissions lady asked for a diagnosis. "A simple laparotomy," I replied evenly, and she waved us down the hall.

My resolve almost faltered when I sensed a volunteer's reaction, "But she's so beautiful!" And hadn't that nurse looked at us with an expression as if to say, "But she's so young!" No matter. I'd muster the stamina my beloved mother passed on. My daughter deserved the best of treatment and I'd see that she got it. Anyway, in three short days she'd be home as good as new.

Still another surprise surfaced when the volunteer delivered us to the children's ward. Certain that she'd made a mistake, I told myself to wait and see. She proudly called attention to the ward's many benefits: gaily-printed curtains, wall murals in solid primary colors, special play area. Come now, lady, you've gone too far! Allison eyed the building blocks, teddy bears, and climbing apparatus just waiting to be used, and they inspired the child in her, a quality we'd temporarily forgot. Even as the volunteer muttered, "I realize all this is far below your age level," I followed Allison's lead to a jack-in-the-box on a corner table.

The volunteer nattered on about how lucky Allison was to be in this ward with its relaxed rules. She didn't even have to get into a hospital gown, as the lab technician, due any minute, could draw blood just fine as is. Finding the small talk harder to keep up, I despaired that Ken couldn't be here. I was relinquishing our precious Allison to the care of these types! Then came a registered nurse who, before I knew it, eased that relinquishing. She too chattered on, "Bet you didn't know another advantage to being in this

ward, Allison. We can send out for any food we want. Tonight we've decided on pizza."

"Awright!" Allison quickly rejoined. "I'll have mine with pepperoni and mushrooms."

The nurse turned to me, "You're welcome to stay, Mrs. Hall. It shouldn't be too long."

Realizing that quick partings are best under such circumstances, I replied, "Oh, no, thank you. We'll be here in the morning, sweetheart. Get a good night's sleep. I love you," and I left.

Sweet Sixteen

Sometimes life breaks your heart.

—Senator Edward Kennedy

Returning to the hospital early the next morning offered a welcome alternative to the loneliness of our house without Allison. We hurried to her room where orderlies were lifting her onto a gurney. "Stop! It's too soon!" I wanted to yell. Life itself was moving too fast. Seeing her amazingly alert, we mumbled that we loved her, that I'd be here when she got back, and, for want of anything more profound, "Good luck, sweetheart!"

Ken wasted no time in telephoning his air conditioning customers who started early on summer mornings. Then he took off for his sales calls, reminding me of a planned dinner meeting that night with two out-of-town business friends. What awful timing, I thought to myself.

Nothing to do but return to that room in the children's ward. At least I'd be as physically close to Allison as could be. As I smoothed down the bed sheets and nestled Chastity, Allison's favorite doll, next to her pillow, I realized that I really didn't care what people thought about my sixteen-year-old bringing her doll with her. Didn't we all need a security blanket?

I knew I should have worn something more comfortable than a lavender cotton shirtwaist, but Allison liked it and that's what mattered. But why didn't I bring some needlepoint instead of a book? Can't concentrate, for some reason. At least I could take a quick lunch break of some soul food—say, a grilled cheese sandwich with bacon and a big thick chocolate malt. Maybe I could make the time go faster by postponing in half-hour segments when I go to lunch,

starting at 11:30 and holding out until 1:00. My concentration waned due to hunger, but I won the bet with myself.

Momentarily distracted by lunch and the change of pace, I crossed the hospital lobby and came face to face with none other than Dr. Todd, the very person in charge of our lives at this point. My senses went on alert to take in his tired eyes, the heat of the overhead lights, my own flushed cheeks, and most of all his words.

Dr. Todd's report began routinely enough, his mind proceeding in textbook order. The operation had gone well. Allison had tolerated it nicely. She would be going to Recovery right away. *Why these details, Dr. Todd? What are you keeping from me?* When they had opened her up, they'd investigated some hard-to-get areas. *What are you trying to tell me, Dr. Todd? What are you getting at?* They had discovered some unexplained masses that were being biopsied. *But, Dr. Todd, even I know that biopsies are commonly done while the patient is still on the operating table!*

He had decided to close her right back up again. Without a surgical assistant and the biopsy results, Dr. Todd had reasoned that he would not proceed on the basis of uncertain evidence. He knew that benign tumors could look awful while cancerous ones can sometimes appear harmless. In the meantime, don't worry. He'll report back to me this afternoon as soon as he knows the outcome. *Don't worry, Dr. Todd? This is my only daughter you're talking about! She is one of the four persons in this entire world that I love the most!*

The next two hours were blurred except for scattered images such as Allison's spare, sinewy body beneath the sheets. I yearned to awaken her and reestablish contact. Instead I ever so tentatively stroked the two peaks covering her feet, kissing them in gratitude to God that she had come through okay.

Napping next to Allison's bed, I was awakened by the awareness of two close friends in the hallway looking in through the open door. They signaled their hesitance to enter the room. The very sight of them told me that here were two people who genuinely cared. I joined them, explaining the horrible uncertainty of not knowing any real results yet, but that their appearing for even this brief time had taken away the loneliness.

At last Dr. Todd returned, and with practiced eyes took in both Allison's having gone to sleep and my state of mind before explaining,

"We've just confirmed the findings, Mrs. Hall. Sorry it's taken so long, but this hospital's exceptionally thorough. In Allison's case, they wanted to verify their findings with another lab. This pathology..." *What do you mean, "pathology"? Something's wrong! That means disease!*

I could hardly absorb the details as he continued, "This pathology's particularly rare, so several technicians pooled their expertise for a diagnosis, and they ran a second procedure to be certain of its nature."

Then with excruciating deliberateness, Dr. Todd took my hand, concluding, "Allison is stricken with leiomyo sarcoma... It's a rare type of cancer." My heart stopped at the word "cancer." Not my Allison. She couldn't have cancer! Not at sixteen! She hadn't done anything to deserve cancer!

From the mention of that word, I must have sunk into a dream-like trance with hospital personnel hovering around me asking when my husband was returning, assuring me that Allison would be sleeping the rest of the night, and urging me to do likewise. I only half-listened, both yearning to be cradled and to cradle Allison lying there so peacefully.

The End of Innocence

I also believe that things happen in life for reasons that sometimes you only figure out afterwards.

—Mayor Rudy Guiliani

Doris was three days from starting her summer vacation while my workdays now lasted ten to twelve hours. The New York metropolitan area's air conditioners hummed endlessly, but my customers still needed to have the parts and equipment I sold to keep those machines happily running. Seldom did I regret my decision to start my own sales agency that was now in its fifth year. The financial and personal rewards were beyond my fondest dreams. I was now an entrepreneur. The decisions I made directly affected my personal success and income, and now I had an incentive to charge into the daily fracas. However, I hadn't anticipated the eventual trade-off: with only twenty-four hours in the day, the real cost of running one's own business took away time from a wife and growing children.

I served many masters among the companies I represented to the point I was becoming the proverbial dog chasing its tail. The more I worked, the greater became my commitment to my principals—always at a greater loss of personal time. They wanted more sales, requiring me to devote more time and energy endlessly selling.

That June morning in the hospital, Doris and I had done our best to encourage Allison when the reality was that the two of us desperately needed support. Allison's innocent demeanor hid any fear or concern she might have had. My own innocence had blocked the possibility of a diagnosis of cancer. It never entered my mind that today could destroy our innocence.

Soon I left Doris in the hospital room with a heart heavier than usual, feeling guilty of downright abandonment of my wife and daughter when they needed me the most. But Doris released me, saying, "Ken, you might as well get to work. Sitting around here'll drive you up the wall!" I was out the door, reminding her that I'd be checking back with her during the day.

Driving between sales calls, my thoughts went back to barely nine months ago when Doris' mother, Grace, had been hospitalized for heart trouble. Both Doris' parents had come back to live with us in New Jersey, spending their last days with us, so to speak. But unfortunately Grace's condition had worsened and she'd succumbed to congestive heart failure. Now, at least, Doris' strong father, Ed, carried on, tending his garden and helping us in so many ways.

Here it was already five o'clock and I still hadn't been able to contact Doris. Nearing Newark Airport, I'd muttered, "Damn this business! It's going to be another sixteen-hour day!" Our business friends, Tom and Gloria Rainey, were due in at any time, and I chafed at the slow-moving escalator bringing me toward the gate area.

At least I could squeeze in a couple of minutes before the Raineys' arrival to call Doris again. Victorious in getting the last remaining receiver in the bank of telephones at the gate, I said a silent prayer asking that Allison's problem be minimal—just a benign tumor as Dr. Todd had hinted. I prayed to God to heal my precious Allison, telling myself, "She's going to be okay. She's always been so strong."

Luckily the hospital operator put me through to the nurses' station so I could finally talk to Doris outside the room and leave Allison to her much-deserved sleep. Doris' tentative "Hello" triggered a premonition in me, as I strained to hear her over the background conversations and flight announcements. Pushing back my guilt over not being at the hospital, a flash of fear came over me when Doris said there'd been a delay in reviewing the biopsy. Was that a signal or something?

"I'm at the airport and the Raineys should be here any time now." Doris' hesitation set off more mental alarms as I asked, "What's going on, dear? What're the biopsy results?"

More silence until she poured out the life-changing news in just two words. "It's cancer, Ken."

"What?" I screamed.

"The doctor says that the biopsy shows cancer."

"Oh, God, why her, Doris? Why Allison?"

"We just don't know enough yet, dear."

My thoughts whirled—How could Allison have cancer? How bad is it? What can we do about it?—as I heard Doris say, "She's comfortable and sleeping soundly. She's going to be well out of it until tomorrow morning, so I guess we can go ahead with the plans, Ken. After you pick them up, come by for me, we'll go to dinner, and then we'll deliver them to their hotel. That's about all we can do at this point. Allison's going to need all our help and strength later on, like tomorrow."

"God, it's so awful. God, I'm so sorry. Well, you're right, dear. I guess we'll just have to continue on as planned. We'll pick you up in less than an hour. G'bye, dear. We'll get through this somehow."

I turned and there were Tom and Gloria approaching. Their faces brightened as they saw me. I tried to return their smiles except that tears began streaming down my face. When Gloria hugged me, I sobbed uncontrollably, pouring out the still unreal news, "Allison's got cancer!"

Somehow we endured that longest of dinners on that longest of days. Over a dinner that they shall not forget, Tom and Gloria served more as grief counselors than business acquaintances.

"What is Cancer?"

Biologically, adults produce children. Spiritually, children produce adults. Most of us do not grow up until we have helped children do so. Thus do the generations form a braided cord.

—George F. Will
The Washington Post

The next morning I awoke with a start unusually early. It took a split second to register what deep emotion gripped me— intensely good like Christmas morning or intensely bad? Intensely bad, of course. Allison had cancer. My subconscious must have been active through the night because seemingly from nowhere came the question, "What is cancer?" Dr. Todd had explained briefly, but I needed to know more.

For years my trusted "doctor book" had helped me out with everything from Ken's poison ivy to Kent's asthma. Why not cancer? While Ken and Kent ate breakfast, I sought out safely secreted in my bedroom nightstand this friend who'd tell me in language I could understand what was wrong with Allison.

The dictionary had said a neoplasm is "a new growth of different or abnormal tissue; a tumor," but I had to know more. Shuffling over the pages, I lit on one paragraph seemingly meant only for me:

Malignant Neoplasms: (cancer)

In what appears to be increasing numbers, unruly members of the community of neoplasms rebel against the state of peaceful coexistence enjoyed by benign tumor and

host. Rejecting the policy of "live and let live," malignant mutineers embark on careers of murderous infamy. Unleashed by unknown forces, they infiltrate and destroy workaday tissue and cells; penetrate lymphatic and blood vascular channels; and set up fifth columns in distant areas of the body (metastases). Rapidly accommodating themselves to new surroundings and conditions, these remote metastases resume tactics of infiltration, sabotage and destruction. Unchecked, they replace established order with jungle anarchy. Sooner or later having exhausted the host's bounty, they initiate a death march whose terminus is a common grave into which they themselves inevitably sink after they have sapped the vitality of their hapless victims.

<div align="right">

The Complete Home Medical Encyclopedia
Harold T. Hyman

</div>

Now unsure whether my "doctor book" was friend or foe, I decided to keep the information to myself. Did it really mean that this type of cancer was fatal? Why did it use the language of warfare, as if we were entering some kind of battle? Maybe I'd better follow that axiom, "When in doubt, do nothing."

The "do nothing" notion was not working, so I mentally turned to Mother. She had been in heaven close to nine months now, and my little talks with her were becoming habitual. "What would you do, Mother? What am I going to do—share this terrible information or keep it to myself?" Clear as anything it came to me, "Don't look on it as terminal, Doris. Don't even discuss the possibility! That way it will increase her chances and pave the way to hope." For years later, I remained silent about the terminal nature of Allison's cancer.

The odor of anesthetics so assiduously kept to a minimum in hospitals carries me back to later that morning when we hurried to Allison's bedside, easing our loneliness for her. Allison's weak but cheerful, "Hi, Mom! Hi, Dad!" lulled me into the illusion that she just might as well have been recuperating from a bout with the flu. Her shiny hair I so admired fell into soft waves, and she allowed me to brush them ever so gently. I fussed around renewing her ice water, pinning up "Get Well" cards, and helping her into her own pink flowered nightgown instead of the hospital issue.

Leave it to Allison to focus our thinking on the here and now. She was hungry, of all things. It had been over a day since that pepperoni pizza with extra cheese, and in the meantime tea, soda, and ice chips had not sufficed. What would she like, a grilled cheese sandwich? I'd get one from the cafeteria!

I rushed out and here was Dr. Todd about to enter the room. Why were his eyes more penetrating than ever? Of course, the horn-rimmed glasses! But why did he seem almost a holy man to me?

"Doctor," I confessed, "I'm going to get her a grilled cheese sandwich. Is it okay for her to begin eating again?"

"Yes, she can tolerate solid food, but for now I'd like it to be from the hospital menu."

"Oh, all right. Doctor, is she recovering the way she should be? Is she all right?"

"Yes, Mrs. Hall. Her vitals are practically back to normal now. She has youth and a strong body on her side, you know. Also she seems to have a good attitude. I'd like to look in on her, and then I can tell you more."

Ken and I began the first of what would be many hospital hallway meetings and vigils. This one lasted only a few minutes before Dr. Todd drew us into a nearby waiting room. Did this signal her condition was worsening? Instead came Dr. Todd's reassurance that if the present recovery continued, she'd be out in a few days. He reflected on the surgery that had taken an unusual six hours and described that hated unnatural mass inside Allison as "ugly, in fact, like yellowish-brown muck, and large—the size of a grapefruit." He'd clenched his fist to show its proportions.

I'd felt like a fool asking, "Spell it again, would you please?"

"L e i o m y o sarcoma—a particularly rare form of cancer. No more than perhaps five or six cases that we know of in the world per year, but fortunately slow-growing. In Allison's case, the tumors have attached to portions of her stomach and spinal soft tissues instead of the lungs as they usually do." I wanted to lash out at whatever random selection had singled out our daughter against such odds.

Next the good doctor anticipated our "What now?" dilemma with mention of a surgeon-friend of his, J.B. Price, who'd be quite willing

and able to take over Allison's case. Now, we weren't to fear that he was giving her up. Far from it! Since "J.B." practiced at Columbia-Presbyterian Hospital, he'd talk with him and they'd plan to admit Allison there. Although Dr. Todd was taking a vacation soon, he'd be back to assist J.B. in surgery and generally see that all went as planned. The conversation was becoming more than we could absorb at this point, just as Dr. Todd led us to the next major hurdle in our thinking.

I reproached myself that I hadn't thought it out as to how to break the news to Allison herself. Dr. Todd suggested a couple of alternatives: did we want to talk with her, say, tomorrow when she was alert enough or did we want him to explain to her as much as he could right now. Ken and I read each other's minds as married couples often do and with one accord agreed that Dr. Todd was the best person to tell her. We would be in shortly afterwards to try to pick up the pieces. She'd be in good hands, as he'd know all the technical—and even philosophical—answers. Dr. Todd's solemn tones and careful planning should have, and in some measure did, alert us to the tragedy we were all living out, this ironic rite of passage: adolescent female learns she has cancer.

We never knew what they said when Dr. Todd in his expert handling managed to avoid pronouncing a death sentence and instead to leave the door open to hope. I doubt that he sidestepped any facts or issues, as he genuinely respected both the intellect and psyche of his young charge. Rather, I'm certain that he talked with Allison as he would have counseled with his own daughter over the facts of this essentially gloomy prognosis. He assured her that the doctors would do all they humanly could and that for now she most assuredly had youth, strength, and faith on her side. But Allison in her highly intuitive way asked that unanswerable question, "What now?" to which he advised, "Go out there, Allison, and live!"

Whatever transpired on that June afternoon, one final question caused Dr. Todd to emerge from her room pale as those hospital surroundings. Always one to pose pivotal, gut wrenching queries, she'd asked, "What is cancer?"

"That's one of the hardest questions I've ever faced." Dr. Todd confided. "She's such a beautiful, innocent young woman. I think I've fallen in love with my patient!"

Returning to Allison's room expecting the worst, we were instead greeted by the best of Allison, the miraculously matter-of-fact, life-loving teen eager to get on with the business of living. The questions directed at us tumbled out: "Will I have bad scars?—When can I get out of here?—When can I eat some real food?—When I get out, can we go shopping for a party dress?—Can we go eat at the Gasho Japanese Restaurant next weekend?" My agreement was quick, but my mind was elsewhere: "Take your cue from her, Doris. If she's not down, how can you be? Right now, she's grasping all this at age sixteen. In the Lord's own time and way, we'll come to terms with it."

And by the Lord's own grace, what could have become a time of desperation and horror for us all instead turned into drawing together to face an uncertain future.

Hope

Hope is the power of being cheerful in circumstances that we know to be desperate.

—G. K. Chesterton

I'd always quarreled with that song lyric about, "People who need people are the luckiest people in the world," while it was one of Allison's favorites. That very song kept running around in my mind to the point I figured I'd better take some lessons from her in needing people. Allison's friends were sorting themselves out according to their coping abilities with new ones drawing closer and some formerly loyal ones dropping by the wayside.

Big brother Kent exhibited the most positive attitude of all in his belief that Allison would get well and the problem would soon be over. He managed to continue on a busy round of activities in addition to his summer fry cook job at a local eatery and keeping Grandpa company many evenings over spirited games of pool in the basement.

One of Allison's friend's from her church group, Guy Seay, stands out for his merely 'being there.' On the night before her discharge from the hospital, I saw him enter her room. Something told me not to interrupt the reunion and remain in a nearby waiting room. But soon curiosity got the better of me and I saw from the hallway an image worthy of being painted. He stood next to her bed while she slept soundly, his eyes almost devouring his Camille, concentrating on her with such intensity as to will her back to health. Guy held a dozen long-stemmed red roses, talismans in grasping for understanding and praying that her cancer was not real. Allison taught the heartbroken Guy, only one among her many friends, that life is precious and fleeting.

Hope

The telephone was becoming more user-friendly as well wishers called. I credited them with the courage to inquire, but I debated endlessly how to explain the unexplainable. I went into a safer schoolteacher mode with a certainty that probably did not assure most listeners, "Oh, she's recuperating just wonderfully. The doctors want to see her over at Columbia-Presbyterian in July so they can get a better look-see. We'll keep you posted." The usual tag line implying, "That's the most I can cope with. When I can do more, I may let you know." I kept it light, never mentioning the 'C' word.

Allison, on the other hand, instinctively handled the morbidly curious, the inarticulate, and those who came with good intentions and were never seen again. What touched us most were simple, pure expressions of love that unfolded so awkwardly at times. But one afternoon I learned some painful, permanent lessons by eavesdropping from the kitchen while Allison's schoolmate, Diane, visited.

Throughout the year Allison had described this person who had it all: beauty, wealth, poise, brains—everything a girl could ask for. Diane had learned through the rumor mill of Allison's story and had asked to visit, much to Allison's surprise; Diane surrounded herself with a coterie of sophomores Allison hadn't hoped to join. Perhaps this visit signaled the start of Allison's long-desired entrance into Diane's clique. I scrambled to make the house, some snacks, and ourselves grand enough for the occasion.

I'm glad I made such a fuss, for when Diane arrived, her eyes took in our home's entire décor, level of taste, and atmosphere. Instead of making direct eye contact, her gaze assessed what we were wearing. Following the introductory niceties, I vanished to putter around the kitchen and upstairs, but not too far to escape the fact that Diane was questioning Allison relentlessly about her condition and prognosis. Her questioning techniques were practiced beyond her years. Both Allison's character and problems served as fit subjects piquing her curiosity.

I decided to protect Allison or at least interrupt this question and answer session, so offered them more refreshments. Shortly after, their conversation reached its zenith, not because of my intrusion, but because of Allison's ability to answer Diane's many doubts and fears with honesty and love. Allison's composed demeanor during

their conversation failed to relieve Diane's self-centered distress. But it did exercise Allison's God-given gift for focusing on the eternal rather than the transitory. She'd begun the formidable task of teaching Diane and us all that cancer is no respecter of age and that certain of us are called to face its reality before their allotted time. A far different and emotionally unstrung Diane left our house that afternoon, still unaware that the actual gift-giver was Allison. With monumental understatement, Allison commented, "Mom, I don't think Diane understands about cancer."

With Allison I always felt on the edge of something new, and her proclivity for asking challenging questions kept me ever alert. Now, on a steamy July morning as we crossed the George Washington Bridge, I thought back to an easier question she used to pose, "Are we in New York yet?" Watchful for the state seal marking the exact middle of the Hudson River dividing New Jersey and New York, I'd taken teacherly pride in answering her. No such question came from the back seat this morning. Ordinarily I'd thrilled at the sight of New York City and remembered that line, "a cardboard city against a cardboard sky," but this morning I instead searched out the imposing cluster of buildings and our destination, Columbia-Presbyterian Hospital.

Ken turned off the bridge at the 178th St. exit and we could see ancient walk-up apartments fronted by red brick and brownstone steps. On street corners were shops labeled, "Bodega." Ah, a Puerto Rican neighborhood. It took me back to the months I'd worked in Puerto Rico. On this warm summer day, residents sat on their front steps watching children playing on the sidewalks, and men accomplished major car repair right there on the curb. A real New York scene!

As we neared the hospital on Ft. Washington Avenue, the mother in me kept saying, "Assure her, for heaven's sake, that just because the hospital's in the City, she has nothing to be afraid of. We're all facing new places, ideas, and experiences, but when it's over, she's going to be healed." I scooted over to get a squint of her in the rear view mirror. She seemed to be savoring the sights even more than we. Then came her remark, "Reminds me of last week when Marla and I came over—kinda creepy at times before we reached midtown, but then, boy, what a blast!" So that's how she and her friend Marla had spent the day—leaving us in the dust of experience.

When a row of uniform, venerable buildings appeared, the plaque "Columbia-Presbyterian Hospital" confirmed my hope that we were here. Ken would search for a parking place, so I gathered Allison's bag with her turquoise robe and pink slipper socks while she harnessed herself in her navy backpack. As we entered, I noticed that the high ceilings and plastered walls must have dated from the last century, and chastened myself for judging by outside appearances. After all, Dr. Todd had good reason for sending us here.

Smiling brightly at the reception clerk, I announced Allison's name. She went down her list of incoming patients, frowned, and then picked up the telephone. There must be some confusion. Admittance had no record of an Allison Hall on their list either. Come on, did I have to raise a rumpus to get my daughter even admitted to this place? As I geared for battle, a broad smile of recognition beamed from the clerk. "Are you sure you're in the right place, Mrs. Hall? Don't you really belong in the private wing, Harkness Pavilion, rather than the main hospital?" I mumbled that Harkness Pavilion had been mentioned, and we were off down more hallways.

We peaked through half-open doors into labs and offices, wondering what this Harkness Pavilion would bring. "It's just another hospital, Mom, like in *General Hospital*." (How could she learn anything from those soap operas she insisted on watching!) "You take the bitter with the sweet, and pretty soon you're well and out of here," she continued. (Leave it to Allison to sense my turmoil and instead look forward to getting well again. Certainly children led you on tough journeys with no turning back and unknown destinations.)

Twice that morning Allison taught me about problem solving. Here I'd made an issue out of temporary setbacks and anticipated more. Meanwhile she accepted step by step what came her way and seemed all the stronger for whatever the future held. Were my heart and mind getting it? Time would tell.

The Harkness Pavilion lobby resembled that of a gracious old midtown hotel: mahogany wainscoting and columns; comfortable furniture positioned for conversations; unobtrusive little offices tucked away for handling patients' needs. Another smiling receptionist confirmed that indeed Allison's name appeared on her list for admitting and we should come right this way. Would Ken ever find us?

Our welcome to the Harkness Pavilion felt almost too good to be true, in fact, rather beyond my control. Right off they ushered us into a laboratory for blood work, eliciting from Allison, "I thought you told me no more needles, Mom!"

"I'm sorry, Allison, I made a mistake, but what can I do? They need to have it before the operation."

Again before I had time to prepare, a nurse led us to Room 5103. Not even a chance to detect whether or not the fifth floor was a good one, as my teacher-friend Barbara urged me to do. Well, make the best of it; at least we were in a private room away from the general wards.

The hospital green walls were dingier for being shaded from natural sunlight. Yearning for any view of the outside world, I peered through a windowpane layered with years of city smoke. Another hospital wing loomed up, but if I positioned myself just right I could see in the distance a grassy courtyard where staff and occasional visitors crossed to the street. What a contrast to Valley Hospital! While I mused, Allison began settling in: toiletries in the medicine cabinet; writing pad in the drawer; pictures of school friends on the end table; beloved teddy bear snuggled in bed; coat and backpack in the narrow closet; herself into her new nightgown.

A more tentative Ken poked his head in, and the completeness his presence gave swept over me. How I loved and depended on this man more than he suspected or I admitted. Surely he'd help me understand the businesslike brusqueness of our surroundings compared to Valley. In fact, the Hall threesome had just better form our own island of solidarity in this city that Ken and I had otherwise sought out for entertainment, learning, and livelihood.

Allison brightened when Ken complimented her on her new pink nightgown purchased to assure good luck during this hospital stay. Then came a reminder of our reason for being here: an LPN inquired whether or not Allison had pain. No. Did she want anything? No. The doctor would be in later this afternoon. Ken's unerring faculty for detecting a person's origins from his speech told him that Marie, the LPN, came from the Caribbean, possibly Jamaica. But now he grew restless, and I suggested, "Why don't you go make your sales calls, Ken? We'll be all right for the rest of the afternoon. Just tell anybody who calls home that we're in Room five-one-zero-three. See you tonight."

At last a chance to do the needlepoint I'd longed for. Funny how it worked: while sewing, I focused on the design, but my thoughts and feelings sorted themselves out in remarkable ways. Allison switched on her afternoon soap operas, and I again wondered how she relished those TV entanglements when real life offered enough challenges. Must've created her own landscape and not relinquished a jot of her identity to those troubled heroines of *General Hospital* and *Days of Our Lives*. Instead she seemed more their wise, sisterly confidante. She made meaning of their predicaments without judging. Anyway, Allison would never land in the straits those writers created. She was too sensible for that!

Marie reappeared, this time to take Allison's temp, and my gracious hostess mode kicked in—the one that embarrassed Allison. How could I convince her that the mix was only one part manipulation and five parts sociability? Besides, engaging Marie in conversation revealed she came from Kingston, Jamaica. Allison and I smiled at each other knowingly as if to say, "How did Dad know she came from there!"

Ten minutes into my needlepoint, I'd regrouped sufficiently to take on the next confrontation. Was this how life went—always gearing up for the next emergency? Guess that's why I'd led the Minerva Literary Society (read *sorority*) in high school. The old gal may have been goddess of wisdom, but her armor helped her engage in war too. I mentally girded my loins.

I began at the nurses' station, spotting the nurse whose manner appeared most receptive. My words came tumbling out like the Lego towers Allison used to love knocking down: "I wonder if I could stay all night. You see, my daughter's being operated on in the morning, and I think she'd do better if I were with her. All I'd need would be just a cot or even the Barcalounger that's there, if it's okay with you."

Her receptivity turned to resistance, "I'm sorry, Mrs. Hall, we ordinarily can't provide for family members except in cases of dire emergency."

"But she's undergoing major surgery, you know, and she's only sixteen."

Some impulse prompted the nurse to reconsider with, "We'll see what we can do."

Just before dinnertime as the nurse went off duty, she conceded, "Oh, Mrs. Hall, Housekeeping's trying to locate a rollaway for you. They're in short supply right now. There's an Arab sheik up on Six surrounded by bodyguards taking up every last extra bed we have." My hopes danced like butter on a hot griddle. At least they were trying. I'd be Allison's protector and see her through to good health again.

In due time Ken and Kent arrived bringing my nightgown and toothbrush, a gesture that reinforced my determination to stay for as long as needed. How wonderful for the four of us to spend the evening together in conversations we never seemed to get around to at home. No one would be crossing the Hudson to visit us.

My spirits quickened at the sight of "J.B.," the attending surgeon and Dr. Todd's trusted friend. After introductory niceties, he asked us to step out in the hall please while he talked with and examined Allison. Hallways were becoming prime locations for important talks.

J.B. began with scientific terms we tried hard to grasp, even though we'd pored over that page on muscles in the encyclopedia. When he tossed off mention of the psoas muscle, the exterior and inferior vena cava veins, and the lymph nodes, I decided to take notes. Simply put, he'd studied the x-rays and examined in every way he could from the outside where the tumor or tumors might be. The real moment of truth would come when they operated. In the meantime, he'd like us to sign a release because of an outside chance they'd have to remove the right kidney. The right kidney, J.B.! How could she get along like that? He assured us that people do fine with just one, and we signed the release. My parting words to him, "Good luck," inadequately expressed my underlying plea, "Oh, please, please do right by Allison in the morning." Knowing we hadn't the strength to face Allison right then, we three found a waiting room overlooking one of nature's wonders, the Hudson River, at a time nature wasn't being very kind to the Hall family, as I saw it.

Returning to the room, I only half realized how much I depended on Allison's intuition about people and our most recent focus, doctors, as I asked, "Well, what d' ya think about him, Allison?" Much to my relief, she pronounced him acceptable. She evaluated doctors first as human beings and then as healers and now tolerated physi-

cal examinations in direct proportion to what she believed yielded clear results. Later on, I'd deal with a new dilemma: she'd told me in no uncertain terms that she'd take only the bare minimum of shots.

It must have been more fear than clear thinking that made me so sure no one would cross the Hudson to visit us, a certainty soon reversed by the appearance of Steve, Allison's youth minister. For four years he'd known the athletic, competitive, exuberant Allison during church weekend trips and confirmation classes. How could I forget just two short years ago his prayer for her at confirmation, "Lord, bless this lovely confirmand, Allison, to Your service. We are grateful and confident in the knowledge that in her developing faith she will enjoy a bright future. Be with her in all the blessings that we know You have in store for her."

The gathering that night in Room 5103 began our church's ministering in ways I'd not known before. Here was Steve bringing the church to us from across the Hudson. That night Room 5103 became a place of worship and we five, celebrants of Allison's life.

Visiting one of his charges hospitalized for cancer must have tested even Steve's equanimity, and, after some small talk, I regretted seeing him rise for what I thought would be goodbye. Instead he turned his dark eyes on us, suggesting, "Could we join hands for a moment of prayer?" Kent, unusually touched by the moment's solemnity, and Steve took each of Allison's bony hands in theirs, and we encircled her bed. He began, "Our help is in the name of the Lord. Those who wait for the Lord shall renew their strength, they shall mount up with wings like eagles, they shall run and not be weary, they shall walk and not faint." Already his reciting scripture was bringing us such comfort. He continued: "Let us pray: God of compassion, You have given us Jesus Christ, the Great Physician, who made the broken whole and healed the sick. Touch our wounds, relieve our hurts, and restore us to wholeness of life, through the same Jesus Christ our Lord. Amen."

This was turning into a whole ceremony. Steve brought out a little vial, dipped his thumb in it, and made a sign of the cross on Allison's forehead, saying "Gracious God, source of all healing, in Jesus Christ You heal the sick and mend the broken. We bless You with this oil pressed from the fruits of the earth, given to us as a sign of healing and forgiveness, and of the fullness of life you give.

By Your Spirit, come upon Allison, who now receives the anointing with oil, that she may receive Your healing touch and be made whole, to the glory of Jesus Christ our Redeemer. Amen."

She lay there so still and receptive that we naturally continued blessing her through our touch, as Steve prayed, "Lord and giver of life, as by your power the apostles anointed the sick, and they were healed, so come, Creator Spirit, and heal Allison, who now receives the laying on of hands." Imagine all these blessings and love flowing from God through us and into Allison! More than ever I found reason to hope that she'd come through all right.

Steve's final blessing had the most impact: "May the God of hope fill you with all joy and peace in believing, so that you may abound in hope by the power of the Holy Spirit." I mumbled a brief, "Thanks so much, Steve," and he departed.

I avoided eye contact, concentrating on holding back a fresh onslaught of tears. Certainly couldn't let Allison see me like this. Then she summed up with, "That was nice of Steve," as a knock sounded at the door—an orderly asking if he could bring in a roll-away bed. I thanked God for this blessing too.

The next morning we awakened with a start: I, seeing Ken at the door, and Allison, rousing from minimal sedation. Too soon the nurses transferred her from bed to gurney, and we followed exchanging mutual assurances, "We love you, Allison. We'll be right here waiting when you come back. Good luck!" answered by her, "Don't worry. It'll be all right, Mom, Dad. I love you."

Through the swinging doors leading to surgery, we caught a glimpse of Dr. Todd who, true to his word, interrupted his vacation to return to assist J. B. Taking Allison's hand, he'd walked along with her, offering more gurney-side conversation. Mercifully it was a year later that we learned what they talked about. Instead of stifling her fears, Allison had forthrightly and innocently asked Dr. Todd, "Am I going to die?" to which he'd just as courageously replied, "No, of course not, Allison!"

"Go Out and Live!"

Experience is a brutal teacher, but you learn, my God you learn.

Shadowlands
—William Nicholson

Back in the room, Doris and I sank into our chairs to wile away the four hours they'd predicted the whole procedure would take. The room's bare walls and tiny window cloistered us from the outside world and only increased our loneliness. We missed Kent's not being there, but he felt obligated to his duties at the fast-food restaurant. Kent was not disposed to sitting and waiting for anything, so he was where he belonged. Doris remade the bed all nice for Allison's return while I halfheartedly thumbed through a magazine.

My eyes lit on the present a friend had given Allison and I wondered at the oddity of this new dexterity game, the Rubik cube. This'll be a snap! But as I twisted the nine rows of colored cubes, attempting to align identical colors, I found it more challenging than I'd expected. More importantly, I'd found a focus. Before long, I realized I was concentrating longer and harder. While my hands were busy, my mind raced into overdrive visualizing what was happening to Allison.

More than that, the cube was leading the way to prayer, "God, why'd You put me to this test anyway?" Then either God or that still small voice within me replied, "Remember, Ken, who's doing the most suffering around here. Allison's the one you should be praying for. So pray that you'll be given the strength and wisdom to help her." Soon my prayers gained intensity, "God, You've just got to help her through this! Please save her!"

Thanks to Mr. Rubik, my thoughts became more disciplined. I'd try more visualizing like those self-help books described. Focus your thoughts real hard and imagine that damned cancer gone forever.

On the day before Allison's discharge, a visitor observed my intently working the Rubik cube and joked, "Has it come to this, Ken? Come on now, a Rubik cube?" I admitted, "Well, I haven't solved the puzzle yet, but that little block of plastic's kept me from a nervous breakdown."

As the morning drew on with both of us wondering what to do with ourselves, Doris proposed, "Let's eat. That'll take up some time." In the hospital cafeteria we projected a false gaiety, joking with the servers as if we were the greatest wits around. Afterwards it embarrassed me to recognize we were trying to win a popularity contest to somehow guarantee Allison's positive outcome.

Then we devised an even better bargain with God. We'd volunteer to give the hospital some blood, if they'd take it on the spur of the moment. Yes, indeed, they gratefully directed us along more long corridors, took our histories, and assured us that, should Allison need a transfusion, our gestures most certainly would receive credit. Doris hoped that her O-negative type blood would count for more—admittedly a stretch in reasoning.

As the day wore on, we gave up walking the halls to diffuse our nervous tension in favor of remaining where we most wanted to be, in her room. Around one o'clock, I roused from half-sleep to declare, "Doris, it's out! The tumor's gone!" In talking with J.B. later, he confirmed that he'd removed the hated mass at that very hour.

After eight—rather than the predicted four—hours they brought Allison back to the room sleeping peacefully and attached to an IV. We geared up for J.B.'s next little talk. The surgery had gone smoothly enough, except they'd found the tumor attached to a rear muscle in her back. So they'd had to cut it away from healthy tissue like golfers take divots in swinging. Taking those divots had done two things: it lessened the possibility of remaining cancer cells but also diminished the range of motion she'd have in her back. We cringed over the comparison to golf, and found the next part even harder to accept. As they were removing the tumor in one mass, it had dropped back into her abdomen, breaking into many pieces.

The delicacy and difficulty of the undertaking had been similar to removing a handful of Jell-O. J.B. assured us he had done everything in his power to irrigate and literally vacuum out every possible malignant cell that might have remained in her body cavity.

We must have appeared half-paralyzed as J.B. explained that the tumor had attached itself to and surrounded the vena cava vein leading from the torso to the heart. So he'd had to cut and tie off some of this vein. However, in time she would grow smaller parallel veins to compensate. He would recommend support hose and elevation to help restore circulation to her right leg. As for now, the most we could do would be to wait for the biopsy report confirming the nature, age, and extent of the cells.

J.B. must have read our minds wrestling with the fundamental issues of how the cancer started in the first place, where we'd gone so wrong, how and where she got it, and how we could avoid a recurrence. He replied with almost a side remark that we committed to memory, "We don't know, really. We think it was just a cell that mutated—that just went crazy. She was probably born with it." J.B. provided the closest anyone had or ever would come to an explanation.

After that, my memory focuses mostly on pivotal scenes. Allison's delight over seeing an admired dress we purchased for her and hung where she'd see it when she came to full consciousness. Just her style: feminine and flowing in a tiny multicolored flowered print. Her refusal to take pain medication—again, the needles. Her intransigence in eating very little, eliciting the kind Head Dietitian's fruitless visit to renew her interest in food. Her badgering doctors, nurses, and us to get her out of this place! It left me wondering what to expect next: the compliant daughter, always anticipating and trying to fulfill others' needs, or the rebel, facing adversity on her own terms.

What I mistook at the time for Allison's willfulness in reality consisted of her understanding and demonstrations of love. She became a source of hospital scuttlebutt, "Did 'ya hear about that sixteen-year-old with cancer up on Five who's refusing painkillers and wants out of here tomorrow?" Few of us adults realized that what she felt emotionally registered in every cell, in the core of her personality, in her mind, and in her eternal self. Open and receptive to

wellness, Allison believed in and looked forward to a full and prompt recovery, and as she gave love, it came back to her tenfold.

Remarkably enough, many callers crossed the Hudson to 'be there' for us and with us. I noticed that the calls seemed harder on the men wanting to search for final truths, while the women were more content to just offer support for the moment. Here were people from our church taking us on as a project and marshalling volunteers to help us. Their expressions of Christian love enriched my faith.

First came the senior minister who had conducted Doris' mother, Grace's, memorial service less than a year ago. He came posing the right questions, presenting the right countenance, offering the right encouragement. But somewhere in the middle of his visit with Allison, I heard the conversation come to an abrupt halt. Out of the corner of my eye, I glimpsed from outside the door a man broken by tears. He had been unable to bear the sight of Allison, with her thick shiny chestnut hair, probing hazel eyes, and slight figure now tipping the scale at a mere one hundred pounds. I asked myself if we were living out times difficult enough to 'make grown men cry.'

The church's importance began to register even more when women we didn't even know telephoned asking that we select convenient times for them to sit with Allison to allow us a few hours' respite. How could we repay the timid volunteer who we later learned was in the throes of a divorce, the statuesque opera singer whose very presence filled the room with vitality, and the busy member who had rearranged her priorities to calmly sit beside Allison's bed for as long as we needed or could bear to be away from her? On Sunday came a friend with flowers and a note explaining, "These flowers have been at the service today. They have heard the hymns that have been sung, the prayers that have been offered, and the sermon that has been preached. Now with their silent message, they come to you with God's love and our good wishes."

Church members held Allison in their thoughts across the Atlantic Ocean where our choir toured Germany. Weeks later they described reckoning the exact time she entered surgery, gathering by themselves at a rest stop off the Autobahn, and praying for her healing. I marveled at how love can be so powerful that we don't need to be in the person's presence to receive it.

One week after surgery, Allison had recuperated so miraculously that discharge was planned quite soon, much to the amazement of the doctors.

Life had brought us so many shocks that no alarm bells sounded when J.B. drew us aside and sat us down in a nearby office for the third of his little talks. I sensed he had found no easy way to deliver the truth about Allison's future, and he began, "You know, folks, the type of cancer Allison's afflicted with is probably the worst kind there is. It's not responsive to any known chemotherapy treatment, and radiation doesn't affect it either. Only good point is that it's slow growing."

We sat mute with despair, our dull minds mulling over the news. I broke the silence, "Doctor, are you telling us there's ultimately no hope?"

"Yes, you could say that, Ken."

Our hearts plummeted, as J.B. anticipated the question neither of us could bring ourselves to ask.

"Our prognosis is that she has two and a half years to live."

We broke into tears, helpless before such an incomprehensible death sentence. Through the shock, we heard him conclude, "I know it'd be really hard to share this prognosis with Allison. You've been through a whole lot lately. So before she's discharged, I'll make sure I discuss this with her. Now you two go get some rest." And the meeting was over.

We slowly walked back to Room 5103, dazed by probably the worst news a parent can ever be told. As Allison clicked off the TV, her sixth sense kicked in, and, detecting something amiss, she demanded, "Why've you guys been crying?"

Feeling like a couple of stumblebums, we played off of each other's awkwardness.

"Oh, it's nothing, Allison. Just tired, I guess."

"Yeah, sweetie, we've been burning the candle at both ends, you know."

Allison could differentiate between reasons and excuses.

"I know it, but your eyes are all red—both of you!"

"Well, uh, it feels like everything's just caved in on us all at once!"

"Yeah, you can appreciate that, Allison, how scared and sad we've been over your getting operated on."

"Yeah, sugarplum, but you're doing so well. They're going to discharge you real soon, and then you and Mom'll have a good time together up in the Adirondacks."

"All right, but I don't want to cause you any more grief than I already have. You know that, don't you?"

"Sure, sweetie, none of us asked for all this, so you just concentrate on getting well, will you?"

"I will, Dad."

Whew! Next time Doris and I talked alone, we reminded each other about presenting a united front and all that, about steeling ourselves to not show suffering, keeping a stiff upper lip, and somehow gaining more self-control. If I'd plumbed the depths of my feelings, it would have been wonderment over the fact that Allison loved us so much she wanted to protect us from more pain.

On the morning of discharge, we'd almost completed packing when a nurse entered for what I presumed was a kind goodbye. Instead she remarked that J.B. wanted to visit with Allison in his office.

"You mean he wants us there too?" I inquired.

"No," was the quiet reply.

Three-quarters of an hour later, Allison bounded into the room with a breezy, "Well, let's go."

We looked for hints of her reaction to the news she had just received, but instead she appeared only a shade more somber than usual.

"Maybe we can catch a movie this week," she suggested.

"Great," I responded, hoping against hope that we could take her to lots and lots of movies clear into old age.

As we set off on the return trip across the George Washington Bridge, I braced myself to ask, "What'd the doctor have to say, Allison?"

With her admirable penchant for detail, she offered, "Oh, he mostly talked about aftercare of myself so as not to undo the oper-

ation. No running fast, lifting heavy things, or doing stuff for a while that could cause adhesions." More silence, and then the key words, "He said I should go out and live."

My eyes met Doris' with the mutual acknowledgment, "She knows!" From that moment on, we never divulged to her we knew she was destined to die an early death. Mercifully, Allison believed we had not been told her ultimate fate. We kept this family secret from each other, pushing it down so far into the inner recesses of our thinking that in time we functioned as if it had never been said.

Her motive, you may ask: a desire to spare us from the devastating facts. Perhaps Allison herself believed the prediction would not come true and therefore need not be discussed. As for our silence, we felt deep down that she would outlive the prognosis. Maybe a new miracle cancer drug or cure would appear. After all, doctors had been wrong before. But, above all, we did not want to make a greater reality of this evil. A 'limited future' was not going to control our lives. Doris and I decided that for now we would withhold telling Kent about her worst-case diagnosis. There are as many ways as there are people in facing death, and this was ours.

Two days later, Doris and Allison began a restorative vacation in the Adirondacks.

Renewal

Love is the messenger of life.

Masnevi
—Rumi

At last Allison and I were alone together other than in a hospital room. This was living! I could count on the fingers of one hand our brief escapes in recent months: a Girl Scout weekend and mother-daughter dinner; glorious matinees seeing *My Fair Lady* and *Peter Pan* on Broadway; once to the New York ballet. Now we would have one entire week with the freedom to be ourselves and to be there for each other. The past weeks had worn us down.

All three men in the family had seen us off, checking and rechecking the car and cautioning me about driving the three hundred miles to the lakeside lodge. By the time we reached the first toll-booth of the New York Thruway, I felt a surge of anticipation I'd not felt in a long while.

Passing the stone outcroppings, grassy meadows, and towering hemlocks of the Thruway seemed fit preparation for our getting back to nature. I recollected Mother's chance comment one time that my grandmother's favorite pastime was viewing passing scenery from an automobile. My peripheral vision took in Allison also thriving on the ride. I'd requested a room easily accessible for her—one we could reach without climbing stairs. After all, only two weeks out of surgery, Allison must be protected from overexertion.

Our jaunt was already working its magic with Allison's exclamations, "Oh, Mom, look at all those deer out on that meadow." And now in the Adirondack Park itself, "Look at that neat country store. Let's check it out." As we entered the lodge, we were enfolded in

surroundings whose sole purpose was relaxation. From Allison came the advice, "Don't worry, Mom, about my climbing a few steps. Look at that gorgeous Blue Mountain Lake! Smell that clean, fresh air! Why, it's everything I've ever dreamed of!"

Each hour regenerated Allison more than medicine. I shall remember the rest of that day for the games we challenged each other to. First, we could not rest without completing the lodge's jigsaw puzzle. Then I beat her at gin rummy, knowing she had not yet mastered some of the pointers in winning. Next we turned to the Scrabble game I had brought. While savoring the fact that we both loved words, it secretly alarmed me that Allison won. Here she'd undergone major surgery and I was the one lacking concentration. Tiring of that, she challenged me to a game of ping-pong and won again.

The following day revealed a gregariousness in Allison I had almost forgotten. Her natural affinity with children emerged as she pitched horseshoes or played on the beach with them. Next we struck up an acquaintance with a young married couple. But extending the perimeters of our togetherness crystallized in one unforgettable image: I nervously watched from the shore while Allison rowed across the lake to investigate an osprey's nest.

New worries pounced on my mind like the moths that attacked our cabin lamp. Being on our own in this larger testing ground made me want to confide in each new acquaintance, "Listen, our daughter Allison has cancer, so be gentle with her, will you?" which translated to "Please be gentle with us! I'm trying hard to understand all that's been happening lately." Outwardly we appeared to be just another mother and daughter enjoying a couple of weeks together. Inside, however, motherhood was becoming a high-wire act.

I stifled my impulse to tell fellow guests and strangers alike about the past month's events, and, mostly before going to sleep, I lapsed into an interior monologue that went something like: Since I've told the manager of the lodge that Allison just had surgery, then did he tell anybody else? If so, then how far did the news travel? Did our fellow guests sense something was wrong? Out of curiosity, pity, or simple human regard, would they ask us for details? If so, how should I describe her condition if we were together? If apart? Granted, my primary responsibility lay with Allison, but how far

did my obligation extend to strangers, relatives, friends? How about when we return home?

To tell you the honest truth, when I'd reached fever pitch in posing unanswerable questions to myself, their intensity and importance vanished as quickly as those moths when we turned out the light. Those questions paled as I watched both lodge owners and fellow guests seek out Allison as if she had some secret to life that they wanted to fathom. Now I know that the secret of her grace and wisdom was actually no secret at all had anyone wondered what inspired her. She had been told to go out and live and she was doing exactly that. Was it any wonder that she interpreted the advice differently at sixteen than I did at fifty-one?

With only the doctors' prohibitions about "no heavy lifting" to protect her two abdominal scars and no medicines or treatments prescribed, Allison's recovery was so miraculous that I wondered if healing had nothing to do with time. Maybe she could be well in an instant. I suggested some day trips to see what the area had to offer.

The day trips fell into a pattern as we avoided discussing her daily physical status. We were a community of two, out to find what life had to offer. First, the museum, with Allison patiently following my lead. Next, a tour of a nearby lake conducted by the mailman expertly steering his motorboat, delivering mail, and showing us the points of interest. The most pleasure for Allison came from exploring the gift shops, and I hope I can be forgiven for observing rather than more actively partaking in those expeditions. It was a chance to learn about my daughter all over again.

Allison led the way through gift shops, with "Look, Mom, how they've arranged those uncut stones on that bracelet!" and "Did you see that gorgeous hand woven material?" observing objects as if in a museum. From those shopping expeditions, Allison taught me to value our differences: she, the artistic, I the functional; she, the specialist, I, the generalist; she, savoring the temporal, I, now yearning for permanency.

Another reward came as if the Princes of Serendip themselves engineered it. Emerging from a shop, she had exclaimed, "You know, Mom, I'd really like to be a gemologist someday." To which I'd replied with a mother's mixture of caution and hope, "That's

great, Allison. Just get through school and you can be anything you want to be." What a joy to be dreaming about her future.

Before long we began jaunts out at night. One local attraction centered on the town dump to watch families of black bears forage for food. As I found a spot to park the car for good viewing, the scene reminded me of going to a drive-in movie, except here live bears enacted the drama. We reveled over the scene, "Allison, look at that mama bear snatching stuff away from her rival. She wants it for her cub." And, "Never thought it'd be this exciting, Mom. Why do you suppose they have to fight like that?" And from our animal-lover as we left, "I'm going to leave more on my plate after this, so maybe they'll have more to eat."

Next I wrestled with the decision to go to the local movie or keep it a secret from Allison. Not as simple as you might suppose, since the movie was *On Golden Pond* and I debated our merely having a good cry together or taking on more troubles than we had already. Not to decide was to decide, as Allison returned from an evening's gathering at the lodge proposing, "Let's go see *On Golden Pond* tomorrow night, Mom. It's on down at the local theater." Even better than the good cry came my realization that I should quit trying to protect Allison from unhappiness, an instinct that proved easier wished for than accomplished. At least I would never deliver Hepburn's advice to Fonda when she said, "Life marches on, Chelsea. I suggest you get on with it!"

The next morning, Allison again took me unaware in announcing, "Mom, I think it's time I gave you a makeover."

"A makeover, Allison? What's that supposed to be for?"

Here I was harping on outcomes again instead of just accepting her experiment for what it was—a gift of her very own devising. She'd hinted more than once that I could use some lessons in buying more stylish clothes, which I'd discounted because we'd 'had' her later in life than her peers' mothers. But she whipped out her own make-up kit containing variegated shades of eye shadow and subtle tones in powders and rouges. I had no choice but to pleasantly comply.

What artistry she displayed as she went to work on my face with professional competence and confidence, even sharing beauty

tricks, "See, Mom, you put a little red dot right there in the inside corner of each eye and it makes them look bigger!" Next came savvy pointers such as, "Now, Mom, you really should put mascara on those lower lashes. Look at how it brings them out." I fought off the fidgets while Allison painstakingly attended to each facial feature as if she were painting a portrait. But I also gloried in her motherly concentration, interrupted only by my remarking to the mirror that indeed she had worked wonders. At last when she was satisfied with the results, we danced around the room exclaiming that it had truly made me over. That noon I made a grand entrance into the dining hall, my made-over face beaming with happiness. Allison's caring was the reason.

What is it about existence that often places the highs and the lows in such close juxtaposition to each other? Not many nights after makeover day, I was reluctantly awakened by strange sounds whose origin I couldn't determine. What was going on? Had someone broken into the cabin? Where was Ken? Oh, not here. Better get up and find out what's wrong.

The noise came from Allison's bed—short, insistent cries mixed with low, pitiful moans. I listened to her as long as I could and then stroked her shoulder, hoping to comfort. Whatever the cause of her nightmares, she sank back into deeper sleep, and I returned to bed. But again the next night her cries awakened me, welling up memories of my own childhood.

Sleeping in the back yard under the Arizona sky had been a practical necessity for our family in the summer heat. One night I experienced a nightmare so real that it made me believe I must get up and return home. I sleepwalked down our driveway about one hundred feet into an iron gate fronting the road. It all came back: the terror on awakening, my parents comforting me, friends teasing me the next day over the resulting black eye. Although I was then only six and Allison was sixteen, I knew gentleness was the best approach to sleep disturbances.

When her cries increased, I began, "Allison, sweetheart, what is it? Tell me. It's all right, really it is. Everything's going to be okay. Get some sleep now, will you?" Fortunately she sank into a deeper sleep while my midnight musings began in earnest. What was this private horror of a world she inhabited at night? She'd survived two

surgeries and was bravely fighting cancer. Now to be subjected to some kind of subconscious torture was damned unfair! What should I do? How could I help her without invading her privacy?

Ignoring advice I had once heard about not making important decisions at night, I planned my strategy: the time, the setting, and the approach to the subject of her nightmares. I would take us to lunch the next day in a neutral setting, and about two-thirds through the meal, I would joke about how I can usually sleep even if a war were going on around me. I would then confess that despite these habits, I suspected that she had been having some bad dreams. I would go on for as long as her patience permitted saying I had heard it was a good idea to tell friends about dreams. They're the mind's safety valve for coping with and understanding our waking world. Even the most seemingly insignificant dreams contain helpful patterns and symbols.

According to plan, I broached the subject, and again my fears vanished before Allison's directness.

"Sorry I woke you up, Mom. No big deal though about the dreams, except they're not much fun. Anyway, this guy with dark curly hair keeps popping up. Don't recognize him as anybody I've ever known, but he's quite a hunk! Dresses in an old trench coat, smokes a cigarette, and walks down this long alley toward me. Seems to take an awful long time. You know how sometimes dreams are almost like in slow motion? Anyway, the part that bugs me is when he pulls out this gun and shoots me dead. It's not always that bad, but most of the time it's a male, kinda destructive type person."

At the same time I prayed that her nightmares would somehow vanish, I found myself confessing with delicious intimacy about my own recurring dream.

"How 'bout that, Allison, you've got your cigarette man and I've got a helicopter man."

"Oh, come off it, Mom. You're not really giving these guys names!"

"Sure! Goodness knows my helicopter man comes around often enough for me to know him pretty well. Usually in my dream I'm standing in a crowd of people kind of lost and uncertain about what's going on. Then in the distance I see up in the sky the bright

lights of a helicopter like it's coming down from heaven. Finally it lands and some people get out. But the main interest focuses on this tall, tall man who sort of looks like Grandpa. He's got a big, bright smile, and—you'll never believe this, Allison—out of all the folks in that crowd, he comes straight for me! Well, I'm not scared at all, but I do notice that he's got a microphone in his hand, which has me really curious. So he hands me the microphone just like it was meant for me. I accept it with lots of confidence, and that's usually when the dream ends. But, you know, Allison, whenever I wake up in the morning after having that dream, I'm pretty happy about the whole thing—almost as if he'd given me permission to express myself."

An awkward pause told me I had gone on too long, but still our sharing these confidences had worked their magic. Unfortunately we rarely talked about our sleeping or waking dreams, and before long the world outside Blue Mountain Lake encroached on us in the form of television coverage of the 1980 Olympics.

A dozen of us crowded around the lodge's one television set, cheering for swimmers finishing within split seconds of each other and marveling at graceful divers cutting through the air and into the water. Allison reveled in the track and field events, which pricked my sensibilities; she probably could not run again in competition. That night walking back to the cabin, I edged toward the question uppermost in our minds, which Allison quickly settled, "Sure hope I'll be well enough to compete this year, Mom. I'm certainly going to try!"

With only two days left of our vacation, I noticed Allison now engrossed in reading as if a deadline were approaching. "Ever read *Breakfast at Tiffany's*, Mom? It's great!" Since I'd seen the film, I decided one night to dip in and see why she so admired this Holly Golightly character. Out leaped Holly's clear self-analysis, "He's (her cat) an independent, and so am I." You can say that again— about both Allison and Holly. Fortunately Holly wasn't turning out to be any role model in her rootlessness with such remarks as, "After all, how do I know where I'll be living tomorrow... Home is where you feel at home. I'm still looking." And how about her views on men! "I like a man who sees the humor (in sex); most of them, they're all pant and puff... I'd rather be natural." Thank goodness

Allison wasn't into sex! We'd better have another mother-daughter chat soon.

It turned out I couldn't put down the book either. Here was a protagonist, mind you, who'd run away and married at fourteen years of age. What was there to admire about that? Must have been something else that fascinated Allison, such as that part about Holly having been "given her character too soon, which, like sudden riches, leads to a lack of proportion" and becoming "a lopsided romantic." Heavens, this wasn't another one of Allison's identity crises looming its ugly head!

I don't mind telling you that the novel got downright provoking when I reached the part where Holly warns, "You can't give your heart to a wild thing: the more you do, the stronger they get. Until they're strong enough to run into the woods. Or fly into a tree. Then a taller tree. Then the sky. That's how you'll end up. If you let yourself love a wild thing, you'll end up looking at the sky." Well, I knew for sure how much I loved Allison's strength, but the wildness? Did she see herself as wild in certain ways?

By the time I neared the end of reading that book, I knew that God Himself must have left it in the lodge's library for Allison to read. I wondered how she'd felt about Holly's little speech on "unto-thyself-type honesty. Be anything but a coward, a pretender, an emotional crook, a whore: I'd rather have cancer than a dishonest heart. Which isn't being pious. Just practical. Cancer may cool you, but the other's sure to." Certainly Allison had so much of that "unto-thyself-type honesty" she could give us all lessons.

When I read the final three words of *Breakfast at Tiffany's*, "I hope so," I'd have written Truman Capote, had he been alive, to find out whether or not Holly ever did find herself. Mere hoping was too iffy for me. At least I had better memories of the film's final clinch with Audrey Hepburn and George Peppard in the rain. The next morning Allison expectantly asked me how I'd liked the book to which I'd muttered, "Interesting!" Heavens! As an English teacher, I'd long preached about how books can shape character, but my own daughter emulating Holly Golightly? We'd just see about that!

If Allison's carefree airs and capricious philosophy were influenced by her brush with Holly Golightly, now even her conversation reflected a freer spirit. While I wondered what next, she suggested

we shop for back-to-school clothes on the way home. Certainly Allison and Holly had in common a keen sense of fashion. But how could she conserve her energy and still search with characteristic thoroughness for suitable outfits? The following two hours of shopping became the prototype for future years. Our teamwork was something to behold.

I delivered Allison to the store entrance, relieved that the women's department was nearby. I could see she was already combing the inventory finding colors, sizes, and styles. Uh-oh! Why that momentary leaning against a pillar? I motioned that she should sit on the edge of a display rack while I found a fitting room. Only temporary relief! These stores were built for ambulatory not sedentary shoppers, for a salesclerk approached—all helpfulness until she sensed that something must be wrong. We followed her lead into a fitting room where—oh, happy day—Allison could sit on the floor and try on outfits to her heart's content. "You just take it easy in there, Allison. I'll keep guard!"

Later I would become expert at keeping salesclerks at bay, bringing Allison likely selections and rapidly paying for them all. That day our unorthodox experiment in shopping took its toll on our nerves and energy. However, it paid off immeasurably in our buying a complete, attractive new wardrobe for Allison. With such a confidence-builder, how could she help but enjoy a glorious junior year in high school? We returned home far more self-assured women than those who had left two weeks earlier.

Life Happens

Life is what happens to us when we're making other plans.

—John Lennon

I had the place all to myself late that August night working in my home office. Doris and Allison were still in the Adirondacks, Kent was busy deep-frying potato hunks at the local fast food restaurant, and Ed was visiting relatives in California. Normally when I returned home from work, Doris gave me a welcome-home peck on the cheek, fed me, and then watched me disappear into the office for a couple of more hours of work. On this night in the office, only the telephone broke the silence.

The caller, Mr. Johnson, conveyed his message in determined, businesslike tones, "Mr. Hall, I'm an independent athletic trainer of young people who're interested in developing their abilities in track and running. I happened to watch your daughter Allison recently at the Rutgers Invitational. She certainly has great style and real potential ability. That girl runs as naturally as a gazelle! I think she could be a champion, Mr. Hall."

My thoughts went back to that time I'd seen her set a record in one of her seventh grade meets. She'd been winning in most of the meets she'd entered—fifty-yard dashes, long jumps, and hurdles. Driving her home, I'd blurted out, "Why, Allison, you could train for the Olympics!" Here I'd done it again in showing one of my less endearing sales traits of escalating a few facts to their supposed ultimate conclusion.

She'd quickly set me straight on that score. "Dad, I'm not going to any Olympics. I run because it's fun—because I love doing it. Can't you understand? I enjoy running more than anything else. So just let me be, will you, Dad?"

85

Never again did either Doris or I mention Olympic possibilities. Little did we realize that Allison was teaching us an early lesson in savoring achievement just for the miracle and joy of doing so, for knowing that today your body, your mind, and your will can reach those heights. A valuable lesson for her ambitious, goal-centered parents!

As Mr. Johnson seemed to be making an offer, my business instincts set upon deciphering his character over the telephone. Here was an honest fellow genuinely interested in furthering kids' careers. He went on, "I've helped lots of high school athletes improve their track skills so much, Mr. Hall, that they've gotten college scholarships. Now, we've got an excellent track down here at Rutgers. I'm sure Allison could practice here any time she'd like to."

Damn, what timing, I thought. This fellow's a scout! How can I let him down gently? How can I describe these last few weeks to one more person? I'm so tired of telling people about Allison and then dealing with the long, awkward silences on the other end of the line. I waited for a chance to interrupt his surprising proposal and said, "Mr. Johnson, I'm afraid Allison won't be able to run for a while, for quite a long while, in fact. She's been stricken by cancer—had a serious operation. Uh, I guess we'll just have to see how long the recovery time will be." I couldn't dampen his enthusiasm with further details about our family nightmare. After mustering all my wits to deliver the terrible truth in just the right way, I knew that Mr. Johnson had hardly absorbed the information.

We ended by Mr. Johnson's leaving his telephone number and my promising to contact him when Allison was ready. I hung up the receiver, clinging—as the proverbial drowning man—to my own life preserver, the dream that, "Maybe, just maybe she could have been an Olympic runner!"

Allison returned to an active social life with her free-spirited but value-centered girlfriends and dates with a few young men from her church group. She palled around with Kent, although he and his friends had different interest: mopeds, tractors, and cars—anything mechanical.

Often we three would take in a movie, followed by active discussions of plot, actors, and themes. Allison saw one movie, "The Stepford Wives," in such a humorous context that it became the source of a longstanding family joke. "The Stepford Wives" is set in

a mythical Connecticut town where the husbands create completely subservient robotic copies of the original wife.

One scene depicts Joanna, the protagonist, who confirms her suspicions that her neighbor Bobbie has become a robot by knifing Bobbie's tummy to see that it draws no blood. However, the action so upsets Bobbie's electronic circuits that she exclaims to Joanna four times, "How could you do a thing like that," interspersed with five, "I was just going to give you coffee," all the while dropping china cups and measures of coffee on the floor, while her body arcs in random movements. Joanna flees in terror with Bobbie now repeating, "I thought we were friends!"

For year afterwards, Allison re-enacted Bobbie's stilted hostess routine, sending us into bouts of laughter. Although it managed to lift my occasional down moods, I admired Allison's intelligence in seeing that victimization would not lessen her individuality.

As fall continued, we all eased back into our routines. One memorable day Allison called to ask me to pick her up after school. I entered the lobby to find her bending over a cardboard box. She stood up and turned around to reveal a small black Labrador puppy in her arms. Our eyes met, she pleaded, "Can I keep her, Dad?" and I knew at once that we had a new dog. She named the new charge Tasha, and she was loved, but she was not Ben.

As fall slipped into winter, I could see Kent becoming increasingly frustrated with the regimen and responsibilities of high school. His grades for the first marking period confirmed our fears, and I could see it was time for a man-to-man talk. I'd rehearsed my little speech: "Son, you've really got to concentrate more on school or you could end up in some menial job somewhere (He now had a part-time job pumping gas) or maybe in the military. His classic reply to that suggestion was, "That's the last thing I'll ever do is join the military!"

Not long afterwards, Doris and I in our reading of magazines zeroed in on those Army, Navy, and Air Force recruitment advertisements. Soon their return coupons had yielded brochures that found their way to Kent's desk. The seed that had been planted sprouted one winter morning when Kent announced to Doris, "Mom, I'm joining the Navy on Thursday." Through her tears, Doris blubbered, "Well, Kent, at least it's the Navy. You remember, my mother was in the Navy in World War I"

Breaking Away

*Each one of us will at one time in our lives look upon
a loved one who is in need and ask the same ques-
tion. We are willing to help, Lord, but what, if any-
thing, is needed? For it is true we can seldom help
those closest to us. Either we don't know what part
of ourselves to give or more often than not the part
we have to give is not wanted. And so it is those we
live with and should know who elude us. But we can
still love them. We can love completely without com-
plete understanding.*

> *A River Runs Through It*
> —Norman Maclean

We'd been told to expect new experiences in rearing children,
and Kent's enlistment in the Navy was another example.
Allison counseled with me as a mother might, "Oh, Mom, it's going
to be all right. He's finally doing what he really wants to do." At
least the actual date of his leaving would be postponed until after
Christmas.

Allison's junior year sailed by, and we fell into an after-school pat-
tern I loved: she at the kitchen table doing homework and telling
me about her day; I, preparing dinner absorbing only some of the
details. Allison relished details.

I wished that I taught in the same high school they attended, but
perhaps it was just as well that I did not. Too much undue pressure
on us. All those books on psychology I'd read in my teens must have
helped me now that I was teaching English to teens. I simply com-

partmentalized by shutting off my personal life during the day. I could teach the daylights out of a lesson almost in inverse proportion to my worries over Allison. Except at times—and those times sprang up without warning—I suspected there might be flaws in my compartmentalizing.

Like that day in the lunchroom when one of the teachers began her usual litany of complaints about her daughter. "Would you believe what she's gone and done now, Doris? She's dyed her hair green! What's the matter with her? She's just trying to get back at me. Sometimes I get so mad I could kill!'

My listening shut down right then and there, although I muttered the usual, "hmmmm's" and "I knows," all the while jealous that her green-haired daughter was blessed with good health, if not an even-tempered mother. I vowed I'd keep my temper better than I'd been doing. Still I could not erase the conversation. Better write about it, I told myself. Follow that old bromide you foist off on students, "How do you know what you think until you see what you write?" I discovered the outlet in writing a poem:

Daughters

The age-old struggle ensues,
Mothers and daughters
Forsaking reason and all else,
In a battle of wills.

And barely one year later,
Mine was to begin her dark assault
On evil
Alone.

Death intrudes! If we combatants can choose our stance,
Then give me understanding, O Lord,
Where there is no victory.

Although Biology was Allison's favorite subject, she often filled me in on her English class. Thank God she hadn't been asked to write an essay on "What I did over the summer vacation." Instead she had read Knowles' *A Separate Peace* finding an affinity for the athletic character of Finny living outside the rules but possessing terrific inner harmony. She said her class discussed the idea of the fortunate fall from grace (Finny dies tragically) and was to write an

essay applying that theme to their own lives. Hmmmm, interesting, I thought, playing amateur psychologist. Maybe Holly Golightly will lose ground while Allison tries on other identities. Nevertheless, having Holly's free spirit around invigorating our lives had been great fun.

Had Allison shared that assigned essay with us, we would have gained from her perspective. Years later I discovered it:

"Allison Hall
English III
Period II
"The Loss of My Childhood Innocence"

Every few months of my life I had encountered back pain. I mean, they were intense. But no doctor could find anything wrong with me outside of a weak back and bad muscle spasms. And so, believing that was all it was, I bore with the pain, and life was still wonderful.

A few weeks before the end of my sophomore year in high school, I had another attack. This time the pain was unbearable, the last straw. And this time, luck was on our side. We went to a man named Dr. Jim Todd.

My life had been so well protected and carefree that when Dr. Todd discovered after one simple sound scan test that I had cancer, it was a real eye-opener. All of a sudden, I found myself spending the summer in Valley and Columbia Presbyterian Hospitals with two major operations, two foot-long scars, and a lot of growing up to do hanging over my head.

Suddenly dreams of living in the mountains, singing and dancing all day long seemed to be vanishing. I realized how unrealistic my outlook on life had been. I realized too that people didn't want to talk about cancer. They only wanted to run away and hide.

Now my simple life was filled with relatives and people whom I had never heard from sending me presents, praying for me, and writing to me. All of a sudden life was so serious and instead of accepting this love, I was scared away and I crawled inside of myself because I couldn't handle it.

Months later I look back at it all. I especially look back at the months before I knew I had cancer. I had been happy and free and innocent. I had never enjoyed life more than those few months preceding the summer of 1980. Life had seemed so clear, beautiful, and simple. I miss that feeling and I'll never totally have it back. It included childhood innocence—very naïve and unrealistic—a part I don't want back. This is the one way I profited from my illness. It was my 'fortunate fall.'"

Allison got an "A" on that paper.

Celebrating Allison's seventeenth birthday held special significance for us with seven months elapsed and no apparent recurrence of cancer. Although she did not enter the athletic program this year, she was flourishing otherwise. I timidly suggested she could even help out with light housework. Certainly she was back to her old self when she announced she wanted to celebrate this birthday in her own way—with a party for her friends here at the house. Her planning held strong implications that we should remain in the background. The party was a smash with only minimal damage.

With the approach of glorious May, Ken and I felt like spirited racehorses on the home stretch. Kent was enduring boot camp at the Great Lakes Naval Training Center, Allison was relishing her social life and studies in that order, Ken and I were galloping to keep up. As with many of life's challenges, my meeting one of Allison's dates at the door one evening began casually enough but ended in disaster. The next day I decided on a little motherly chat hinting that I'd had negative vibes over that fellow—too old for her and not really a long-term prospect. I could see Allison's jaw line firming up. Out of the blue, she was up the stairs, down with her backpack, and through the door with, "See 'ya!" It was clear over into the next afternoon when she strolled in all smiles as if nothing had happened. She'd stayed overnight at the neighbor's—warmed up her friendship with that snotty Gina Howard. Allison's unspoken message of "I want space!" went unheeded.

Only one month later at the Great Lakes Naval Training Center, Ken and I wordlessly beamed at Kent's graduation ceremony—an earlier and far different one from what we'd expected—but still welling up in us great pride that our son was an honor guard and

would soon enter advanced training as a Boiler Technician. Did the law of averages mandate that one child flourish while another rebel?

At last school was out and even the start of summer had set me to thinking that parenting was the hardest thing I could ever do. This Saturday morning began with only a minor skirmish between Allison and me. This time, about eating breakfast, it was "Lay off, Mom, will you? I'm not hungry. Can't you understand?"

I'd backed off until I could stand it no more. I'd ask her to at least vacuum the downstairs. That'd be a way to get in her good graces again—a way to "relate." Forget all that psychology baloney. I was now into the Tough Love route after attending a couple of sessions last month at the high school. Otherwise decisive Ken was waffling on this issue and was overprotecting her, causing what the shrinks like to call 'triangulation' in our family.

Maybe I shouldn't have eavesdropped earlier that morning, but mothers have their rights too, you know. I'd heard Ken trying to straighten her out saying, "Now, Allison, I know you have your ideas and Mom has hers. It's only natural that you guys don't always agree. But can't you just try to go along with her some of the time, sweetie, 'cause it's our home, remember? And, uh, bottom line, she's really not asking too much of you." Hell! I'd always believed that the husband should wear the pants in the family; this waffling hadn't settled anything. Allison had absolutely steamrollered over both of us at this point.

This time instead of doing all that pussyfooting I'd tried lately, I'd be 'firm but fair' with her, like in teaching. "Allison," I told her, "just face it. You're stuck with me, the great-granddaughter of Elvira McPherson Parsons whose 1903 book, *Ethics of Household Economy*, taught women how to keep house the right way. That Scottish heritage is here to stay and I'm proud of it, so you just find a way to accept both it and me."

Later on I peeked in while she was reshuffling the contents of her room and heard, "Mom, just back off, will you? Who's ever going to see this anyway? Besides, my room's my very own, and I really don't care how it looks. That's the trouble with you, Mom—all you care about is how things look to other people!"

I didn't let that one go by. Instantly an image of Millie Van Cleve, our former neighbor, popped into my mind. Seventeen years ago

she'd come over just after we'd brought baby Allison home from the hospital. "Any friend who comes over to see my house instead of me is no friend of mine!" she'd said. So I'd pass that on to Allison, "Hey, remember Millie Van Cleve? Well, I agree with her when she—"

Right there in mid-sentence, Allison turned up her perky nose, picked up her backpack, and walked right out of the house—walked out with only a thin little coat on her back. That day dragged on like no other. I'd been such a wreck I couldn't even finish my list of things to do. It was like a spear through my heart. Where had I gone wrong?

Allison's second departure brought special agony, since, after many telephone calls, we could not find her. Our pillow talk that night decided two things: wait until morning, and, if we had not heard, call the police.

Calling them eased my pent-up fears. They would put out a missing persons bulletin all over the United States to be on the lookout for Allison. If her disappearance were by design or, heaven forbid, kidnapping, they would find her and bring her home.

At the police station, they led me into an office where the detective approached me as if it were an everyday matter instead of the life and death crisis I knew it to be. First, he would need a recent photograph of the missing person. I assured him I would bring it right down, trying to remember where I had put that smiling one taken with her teammates when they had won the cross-country meet. Those had been happier days—we'd not taken any recent photos.

The detective's voice grew firmer, "Ma'am, we're not allowed to begin the search for runaways until twenty-four hours have elapsed from the time of reporting."

"Why not?" I demanded.

"That's federal law, Ma'am. It's procedure in such cases."

I thanked him and said I would still return with the picture. How could we waste twenty-four hours? Horrendous things could happen in twenty-four hours. I simply could not wait twenty-four hours.

Often we accomplish the impossible. Those hours seemed suspended in time. I brought the picture to the police station late that

night when no one would notice. Who knows? Friends or neighbors might have happened by the police station and wondered.

The Chief Detective said he'd need certain information to pursue the case. What was this, *"L.A.Law"*? I just wanted my daughter back! I suppressed my tears enough to tell him she was 5'3", with light brown short hair and hazel eyes. Distinguishing characteristics? Two ten-inch scars down her middle from the last surgery; otherwise, a perfect body. (I prayed a short prayer asking the dear Lord to please protect her from any more harm.) Last known address? Last seen? Detective Burns looked up from his writing to level with me parent to parent. "I can see you have your hands full, Mrs. Hall. We'll certainly do all we can to find her." Then almost as a post-script, "I have a hunch you'll be seeing your daughter again before very long."

"Oh, thank you, thank you, Detective Burns. Please, please, help us find her," I rushed out before my tears embarrassed us more.

Twenty-four hours later, we leaped to the telephone to hear Allison's voice, as if from heaven. "Hi! How're you guys doing? Oh, I didn't mean to worry you. I went upstate with Brian (an old friend from elementary school) and his family to their place on the lake. Brian's going to college! Sure, I'll be home soon."

Relief to know she was alive and safe overshadowed every other emotion. Once more we had panicked, forgetting her desire to pursue her own path. Best I remember I'd been taught always to defer to my parents, a relationship I had not wanted for Allison. Later that day and before the police could start their search, Allison appeared at the front door. She was giving us a third chance to get it right, although none of us recognized it as that. Ken and I had been jolted into some understanding, but we might have learned from Allison to listen more closely, choose courage, work through our fear, and, most of all, that she was instinctively ready for the next step to independence, one that necessitated genuine breaking away.

Now with the start of Allison's senior year, I tried to follow my Saturday schedule of running to the grocery store, cleaning house, and generally restoring order to life. On this early October Saturday, I began rehearsing a little please-help-me-with-the-vacuuming speech all the way up the stairs and down the hall. I sucked in a deep breath, knocked on Allison's door, and heard, "What is it?"

"Allison, the house needs a little vacuuming. Would you mind doing the downstairs when you can, and I'll take care of the upstairs and dusting?"

"Oh, shit!" came the reply in barely audible tones, followed by, "Yeah. Okay. Life's a bummer!"

My memory of this scene less than an hour later surfaces with absolute clarity: Ken, Allison, and me almost transfixed in a corner of the wood-paneled den. Allison stood in front of the crowded bookcase in worn jeans and wool plaid shirt. This time, however, she carried her winter coat and all-purpose navy backpack. Where was she going all of a sudden? What had happened to bring on this entire hubbub? Why was she looking so determined, so enraged, so harried beyond anything I'd seen before?

In perplexing but level tones she said, "Mom, I just can't stand it around here anymore."

"What's the matter, Allison?" Watch your step, I reminded myself. Don't meet her anger. Keep steady or you'll say something you'll regret or don't mean.

"You phony!" she shot back. "You know very well what's the matter. You're what's the matter."

"I'm sorry, Allison," I answered, resolving to encourage her to spew out all her venom. At least we were all communicating. I countered with, "I honestly don't—"

"You always want this damned house just so. You rag me about my room, about my clothes, my friends, my grades—everything all the time. Why don't you guys get a life!"

I told myself: you're scared stiff at this point. Just stand there and take it. This is important stuff. Meanwhile, the momentum was building.

"You're such a goody two shoes. You and Dad haven't ever understood, much less accepted, my point of view!"

She was right. I couldn't fathom what was going on. Why was she so against me? What did she mean by calling me a "goody two shoes"? Then five words resounded that imprinted themselves on my heart and mind.

"I hate you! I'm leaving!"

At that moment I couldn't register the impact of her words. Daughters didn't hate their mothers. In real life, Allison could not be leaving again. Certainly she did not mean what she had just said. Undoubtedly, I had been taking part in some kind of bad play, some hoax that would soon be over.

Then Allison took the six steps required to reach the front door. She grabbed the doorknob while I seemed to be viewing a slow-motion film. As long as I live I shall see the image of her resolute stride taking in the expanse of the front lawn, crossing our quiet tree-lined street, moving across the intersection, and disappearing down the highway. Her leaving had happened and yet not happened. Surely she would return by nightfall.

Allison did not return home that night or the next day or even the next month. A few agonizing days after she left, she called saying that she was not returning home, she had moved in with a girl-friend also estranged from her family, and secured a job at a local Woolworth's. Later when Ken met Allison after work, he longed for some magic wand he could wave or a mantra he could chant that would protect this lovely young soul.

Not yet having earned her first paycheck, Allison quietly asked for the loan of a few dollars. "How much do you need?" Ken had asked, and her reply, as usual, had been for only the bare minimum. He gave her more, adding, "It's not a loan but a gift," to help protect that fierce pride of hers. Sensing that from now on she had set her own course in life, he stifled an urge to ask the ultimate question, "Allison, do you want to come back home?"

A few weeks later, we discovered an unsent letter in Allison's desk whose contents wounded like an arrow.

Dear Mom and Dad,

I am filled with hurt and anger and frustration and I'm very, very scared. I know I need to seek help, but even when I do, that doesn't mean I have to be the one to swallow my pride and be the gracious one. People in my life have a responsibility to find out how to treat me. But you two obviously don't feel that way. You could make it a lot better for me if you sought help and advice and insight into your-selves and me over the position we are all in. It is not just I, but it is just I who is left holding the bag of emotions...

No matter how much you think you've got me figured out—you sure don't know how to show it compassionately.

We replayed that Saturday's scenario over a thousand times, wishing it had been otherwise. Once again, Allison's teaching of how and when to let go went unheeded. Meanwhile, she plunged into life rather than choosing the protection of home to await her predicted death. While I clung to the hope of "Pretty soon she'll come to her senses and come home," Ken considered that day the second worst of his lifetime. Allison's leaving recalled memories of the worst day of his life that years later he described as his "Recollection:"

> A circle of light was my first image, and then my slow focus brought forth a ring of faces all apparently looking down at me.
>
> They spoke softly, but everything they said seemed bad, as the memories of their voices came back.
>
> You see, I was lying in a crib and two years of age. This was my first recollection. The circle of faces had gathered to lament over me because my mother had just died.
>
> The thought formed in my infant mind, "God, help me!"

The Saturday Allison launched herself into an unknown future, Ken's prayer went out, "God, help her!"

Head Repair

Out of desperation, one finds.

Yiddish proverb

A s the months stretched on, I exemplified the truism that people need three things in life: someone to love, something to do, and something to hope for. More than ever I felt grateful for something to do: teach my charges about life through literature so they would have both positive *(Kristin Lavransdatter)* and negative *(Rebecca)* role models when they reached adulthood and confronted tough situations as my own daughter was doing.

I could still handle runaways such as Huck Finn and Holden Caulfield, but other characters—take Willie Loman in *Death of a Salesman,* for instance—got to me. How could he so thoroughly confuse his real self with his job? And how could his wife Linda get so swept up in his values? Another play I taught, *A Streetcar Named Desire,* had that Blanche DuBois simpering, "I get by on the kindness of strangers." Allison and I had disagreed on that idea of the degree to which a person should or could depend on "the kindness of strangers." No matter now.

While I theorized, Allison's new roommate Lisa saw the genuine Allison and later wrote,

> Allison questioned everything. She was like a child who asks "Why?" at every so-called answer and is never satisfied, especially with dismissive answers. While most of our peers were preoccupied with crushes, clothes, and popularity, Allison was intent on discovering truths and beauty in life. She'd stay up late at night reading me poetry and journal entries.

I can see now that we were both working out our adolescence in rebellion: she questioning norms, rules, affluence, and consumerism that would lead her to living a simple life of either naturalist or philosopher. I seemed headed for either a career as a lawyer for those most in need or continuing to be a happy outcast. Fortunately we both took our first choice.

The irony of our life at just seventeen was confronting one gripping, adult reality: Allison suffered back and stomach pains probably still persisting after surgery.

We had our apartment together for several months until I decided that my future lay in school in Boston. That's when she decided to get another apartment, drop out of school, and work full time. For those months we were together we truly sustained each other. It may seem corny, but one of our songs for each other was *"You Are My Sunshine."*

Whatever triggered my decision, one Saturday rolled around when I could no longer endure our estrangement. Unsure of Allison's hours or duties at Woolworth's, much less her willingness to see me, I made up my mind to see her. My usual interior monologue played out as I drove to the neighboring town. What if she wasn't there? What if she wouldn't see me? How would I find her? I couldn't just walk up to the cashier and announce, "I want to see my sick runaway daughter who's supposed to be near death by now." No, I'd slip right by the front displays and quickly go along checking each aisle the entire length of the store. That way I'd spot her before she saw me. Would she be embarrassed? Possibly hug me? Or would she be cold?

Despite my planning, she was nowhere to be found. Get a grip, I told myself, and look some more. Then I peered into housewares, and there she sat on one of the displays (Was she hurting?) folding a pile of washcloths. (How orderly she could be in certain respects.) She glanced up. (Her complexion had an alarming pallor.) "Oh, hi, Mom. What a surprise to see you here." (We hugged!)

"Hi, sweetheart. I just had to see how you're doing." (Don't show your heaviness. Looks like she needs support, not pity.)

"I'm okay. It's inventory time, so that's what they have me doing. How's Dad?"

"He's fine. Says to say hello." (I lied. I'd kept my plans to myself.)

"How's Kent? Haven't heard from him in a while."

"Oh, fine. He's finished his advanced training course and will stop by for a few days on his way to Norfolk."

"Well, thanks for coming by, Mom. I see some customers."

(Customers be damned! This was my daughter and I'd say what I'd come to say!) "Allison, think about coming home. We'll try harder to work things out. Your father says he'll buy you a car to get back and forth to school. We'll give you driving lessons. Oh, and this mail came for you."

We hugged again, and, as I turned away my eyes felt that fullness, the stinging that precedes tears. I rushed to the car where I could let go. She'd carved out a life for herself, but what a life! Wasn't even wearing those oranges, greens, and purples as before. She not only looked different, our relationship had a different feel to it—more equal—more respectful. All I could do was hope.

I wondered what had been in that letter I gave her from *Seventeen* Magazine. One of our conflicts had turned on her "rights to privacy" issue, so I'd avoided the temptation of steaming it open. Only later did I find she'd developed a brisk correspondence with an editor over the existence of a national clearinghouse for adoptees and their birth parents. I was grateful to that editor for a kind, insightful letter counseling Allison against further efforts to locate her birth mother, ending with the memorable postscript, "Remember, Allison, no more lies!"

I went home and tried to drum into my mind some wisdom I'd quarreled with from Kahlil Gibran's *The Prophet*. Much of it was quite comforting, but the part on children I still couldn't get right.

> And a woman who held a babe against her bosom said, Speak to us of Children.
>
> And he said:
>
> Your children are not your children.
>
> They are the sons and daughters of Life's longing for itself.

They come through but not from you,

And though they are with you yet they belong not to you.

You may give them your love but not your thoughts.

For they have their own thoughts.

You may house their bodies but not their souls,

For their souls dwell in the house of tomorrow, which you cannot visit, not even in your dreams.

You may strive to be like them, but seek not to make them like you.

For life goes not backward nor tarries with yesterday.

You are the bows from which your children as living arrows are sent forth.

The archer sees the mark upon the path of the infinite, and He bends you with His might that his arrows may go swift and far.

Let your bending in the archer's hand be for gladness;

For even as he loved the arrow that flies, so he loves also the bow that is stable.

In October Ken and I staged a quiet birthday party for my dear eighty-six-year-old father, who quietly passed away in his sleep five days later after having seen his beloved Los Angeles Dodgers win the World Series. Mother gone just two years earlier and now Daddy gone so suddenly left me heartbroken. Fortunately Kent had visited him on his way to Norfolk only a few days before, so he remembered his grandfather with greater clarity. I missed the weekly Saturday lunches that Daddy and I had savored, and found that now Saturdays were calmer but sadder.

A few weeks later one Saturday started off with a visit from Lucille, loyal friend and fellow teacher. Our chatting had roamed far afield from teachers' workroom scuttlebutt, when the telephone interrupted, and I heard the sound of Allison's voice. For many people, scents conjure up images of a person—a perfume, clothes still remaining in dresser drawers. For me, the sound of Allison's voice evokes the most poignant memories. I would play those notes on a violin, if I could play the violin. Her voice went up several notes,

tentatively, as if to say, "Mom, are you still there for me?" The "Mom?" was slightly elongated, followed by a moment's hesitation seeking reassurance. I uttered a brief prayer of thanksgiving that I would always be "Mom," closer in a different way than my respected, adored "Mother" was to me.

Then came, "I'm okay." How could she be "okay" away from home and parents who'd protected her for nearly eighteen years? How could she be "okay" with the specter of cancer looming large? Hadn't I remembered an occasional halting gait and sometimes hunched shoulders bent as if she were carrying someone on her back?

Before I could voice a plea that she come home, that I come get her, that we start over again, she continued, "I just wanted to say hello and tell you I'm all right."

"Oh, I'm glad, Allison, that everything's all right." How could I cut through this tip-of-the-iceberg conversation? "Where are you, Allison? Can we get together?" Extending olive branches always came out awkwardly.

"I've gotta run, Mom. I'm late for work."

"But, Allison, can't we talk?" Traffic sounds in the background.

"Not right now, Mom. Later. Okay?" Click went the receiver. Years later, I learned that she had telephoned from a booth on one of the nation's busiest highways, Route Seventeen.

Coffee with Lucille dissolved into tear-soaked entreaties, "But, Lucille, how could she just call that way and then go on with her life?"

"She just wanted and needed to touch base with you, Doris. I don't think she had any clue that it could cause such torment."

"Every day I think of her and ask, 'Why did all this have to happen?'"

As Christmas drew near, I felt myself only going through the motions of rituals, aware that outward gayety sometimes masks inward despair and loneliness. For me, Christmas loomed like a juggernaut rather than a welcome and blessed experience. We had received a call from Allison that she would not come home for Christmas. With brittle determination, I steeled myself against

appeals to sentiment until I was rescued by one spontaneous turn of my car's steering wheel and the kindness of a stranger.

Habitually I accomplished some of my best thinking while driving alone. Without benefit of radio, I brought up issues as if in a court of law, debated the pros and cons with some vigor, and settled troublesome matters. The very motion of driving lured me into believing I was going somewhere both literally and figuratively. However, I also knew the danger of enclosing myself in such a mobile little world that I could have an accident.

One afternoon shortly before Christmas, I drove by the hospital where Allison had undergone her first surgery one year and a half earlier. As I approached a nearby building, it sprang from my memory that inside was a team of psychologists. The steering wheel made such a sudden turn that I seemed to have no conscious choice anymore. Something led me to pull up front, park the car, walk in, and announce to the receptionist that I wanted to see a psychologist. Either my manner or her instinct triggered a response, for there in an office doorway appeared a young, smiling psychologist who seemingly had all the time in the world just for me.

I poured out my story, with thoughts and tears tumbling one after another, until I sensed that the time had come for her reply. I took down notes for remembering afterward, and the results of that meeting saw me through Christmas and many months after. The young lady addressed not only my desperation and confusion, but also my specific questions.

"How can I help Allison under these circumstances? What can I do when she doesn't seem to want my help?"

"You're there for many purposes, Mrs. Hall. Sometimes you just have to ignore her anger and push her to take the action you know is right. Other times you could try asking questions to clarify certain issues. Sometimes it's just enough to be there to comfort her or distract her from her troubles. But, most of all, the bottom line is that she needs to know you're there for her, you're there to help her, and that you'll never stop caring. Even little efforts, although at the time they don't seem like much, will help see her through."

"I think I know what you mean. But she's so angry sometimes that she doesn't even want me asking how she is, how she feels, much less what's happening medically. Ties me in knots!"

"Mrs. Hall, there's a certain comfort angle that she's not yet achieved, so one important thing is to help her preserve her dignity. Let her call the shots with the doctor. Let her know and feel that she's in control. If she holds back information from you, then it's because she really can and must handle it alone on her own terms."

"But she doesn't want us to even talk with her doctor. It's so frustrating as a mother that she shuts me out of any decision-making! How can I squelch my own feelings in all this when I only want to help her?"

"I understand completely. No one really has a right to dump on another person. If it's happening a lot, then I'd suggest you try to set some limits. And, as for yourself, try to find some outlets like exercise, walking, whatever. As much as you can, you all have to get past this and go on with living. People have a way of concentrating on the cancer exclusively and forgetting that they're people first and foremost. Especially the patient herself gets lost in the details of the battle, so encourage her to turn to other things such as her reading and writing. And remember that it's a lot easier to be angry than not. She's angry and defensive because she's afraid. Understand where this rage is coming from."

"Mrs. Dawson, you've helped me an awful lot, and I really do thank you. On down the line, where else do you suppose I could turn for help should the going get rougher?"

"Just remember that this one meeting certainly can't resolve everything, and that you'll never need to be alone. For instance, if Allison were to return home, there are nurses who will visit, along with social workers and other volunteers, depending on your needs. Now, if you and your husband would like to talk with another counselor who could meet with both of you some evening soon, please call this number."

"Thanks again, Mrs. Dawson. Merry Christmas and God bless you!"

I rushed out, overcome with therapeutic tears, never again to seek the services of the kind Mrs. Dawson. Thank you, wherever you are.

The Apartment

Only in retrospect do great dreams take on the muscle of plausibility. Who has not been through a devastating loss—a job suddenly terminated or a marriage irretrievably broken—and found, by surprise on the far side of experience, that life has gained a new radiance?

The Train to Nagasaki

*I*n late January came a call from Allison that she'd changed jobs, left school, and moved into her own apartment. I was working in my office one day when I decided to call her and invite myself to the taco palace where she worked. I'd eaten there once and found the food abominable, but with her "Great, Dad. I'd love to see you." I told her, "I'll see you about noon."

Walking into the tiny struggling restaurant, my spirits soared to see Allison cleaning off the top of a table. She spied me immediately with a glad, "Oh, hi, Dad," and a big hug. Fortunately, only a few customers were there, so she quickly sat down with me, "My back's kinda tired and sore today, but I'm getting along okay. It's great to be able to sit down."

"Can't you look for a job where you can sit down more, Allison?"

"Oh, I don't mind working here at all, Dad. I just need to rest once in a while, like I'm doing now. I've got another problem though. The manager's getting on my case. He knows that Chris, who also works here, is a good friend I've known for some time. Seems to be just plain jealous over Chris, so he's taking it out on me."

"What's a 'Chris?'" I just had to ask.

"He's nice, Dad, and we've been dating lately. Not here right now. Anyway, the manager asks me to do all the extra work—lots of it physically hard, like cleaning those humongous metal pans they cook the meat in. It's always, 'Lift this! Clean up that mess, Allison!' It's not right, Dad. He's acting like such a bully."

At that point the manager himself brought out my plate of tacos. I gave him a civil "Thank you," along with a scowl that said, "No more shit with my daughter or you'll have me to contend with." I knew I couldn't tell him how to run his business. Besides, Allison wasn't being held there against her will. She could walk out whenever she wanted to. I'd try to reason with her.

"Allison, you don't need this!"

"I know, Dad, I know. I won't be working here forever. I'll call you when I'm ready to make a change."

With that, I knew it was useless to discuss the matter any further. She'd make her move in her own good time. So I finished my miserable tacos and headed for home. As usual, the subject of money never came up, so for my $3.50 meal, I left her a $20 tip.

Driving home, one of my more vehement on-the-road interior debates took place. "Allison, why don't you just get the hell out of there? Go anywhere, do anything, just get out of that jerk's clutches." My more reasonable self answered, "You know that she's the one in charge of her life now. You can't wave any magic wand to make the jerks in her life evaporate, so just cool it."

One week later, Allison called to tell us she'd taken a job across Route Seventeen serving behind the counter at a Dunkin' Donuts. Then she invited me to stop by some morning at her new apartment.

Later in the month after kissing Doris goodbye and returning a few business phone calls, I went to see Allison, following Doris' suggestion to bring her some food. As I climbed three flights of stairs outside the dilapidated house leading to her one-room apartment, my arms ached from lugging two bags overflowing with groceries. I'd picked out some of her favorites—ziti, Spaghetti-O's, and bananas—along with oatmeal and whole wheat bread to salve my worries over whether or not she was getting enough nourishment. It was one way to help her out financially, although she'd never hint

that she needed money. Seeing her in person would be an improvement over our recent telephone chats, and bringing the food, as good an excuse as any to find out how she was after these lonely weeks. God, how I missed her!

As she pulled open the weathered door with "Hi, Dad!" I responded with "Hi, sugarplum." The greeting brought me back to the time we'd all seen the "Nutcracker Suite." With her penchant for taking on other identities, she'd become the Sugarplum Fairy, prancing around the house and staging command performances for the family. She naturally became our "Sugarplum," and just as naturally, the name stuck. Even now her delight showed in a quick smile of response.

Once inside, I looked away from the distressing mustard yellow linoleum floor. Avoiding its grotesqueness kept my line of vision straight ahead, as my gaze took in the unique addition to her room. Sitting in one of her captain's chairs was a young man—yes, a real live man! Our eyes met and his demeanor struck me as quite direct. He stood as Allison explained, "Dad, Chris and I have know each other for a couple of years now. He still works at the Mexican Place."

Her casual introduction quelled the initial hostility that at first filled my heart. At last I had met Chris! His relaxed manner began to soothe my anxieties. His handshake was firm—something I looked for in a man.

He began with a quiet confidence that momentarily stilled my fears, "Allison's told me a lot about you, Mr. Hall. I'm certainly glad to meet you. I didn't attend Allison's high school, but went to Ramsey High School instead. Right now I'm studying at Ramapo College, and when I graduate, I'm going into the investment field."

Wow! With this fountain of information spewing forth, I said to myself, next he's going to ask for her hand in marriage! My curiosity was getting the better of me over his sense of security and poise far in excess of what I expected in an eighteen-year-old. We lapsed into rather unsatisfying small talk when he abruptly decided to leave. Tactful fellow, I decided, in sensing that I wanted to be alone with Allison.

Let's see how they say goodbye to each other, I mused. That'll give me a clue as to their relationship. As Chris approached the door, he

reached out his hand and she extended hers. Their hands and eyes met just for a moment. Then a gentle squeeze of hands, an "I'll call you," and he was gone. A parting of affectionate ease with a harmony that both puzzled and pleased me.

Allison turned to unloading the groceries, examining each selection with a ready, "Oh, thanks, Dad. That's exactly what I needed!" or a diplomatic, "You shouldn't have!" or "Okay, I'll cook up the trees," her pet name for broccoli.

Then the inevitable, outwardly casual question, "How's Mom?" Why couldn't those two get together?

"Oh, she's just fine—busy, of course. She really misses you, Allison." Once again, this tormenting separation—a subject we'd carefully avoided over the telephone. "Please can't you give it another try, sugarplum. We'll all try harder. We can get you a car that'd help you get around more."

With determination that often took my breath away, she directed her steady gaze at me. I remembered how in times of such intensity the pupils of her hazel eyes wiggled, as she said, "Dad, I'm not coming home. You know that, so don't get your hopes up. And don't try to bribe me!"

There it was. No room for further discussion. She was off on another topic. "What d' ya think of Chris?"

"Gee, sweetie, I've just met and talked with him for all of five minutes. Can't say I know a whole lot about him. Seems like a nice enough guy though." Keep it upbeat, I told myself; after all, how could I tell her how to run her love life at a time like this?

"Dad, Chris's the nicest guy I've ever met. I really like him. He respects me, and my health problem doesn't affect our relationship. We just naturally have the best times together."

Followed by another shocker, "You know, Dad, we've never ever had a real father-daughter talk."

"You mean about the birds and the bees?" Oh, boy, where's this heading, I wondered.

"Oh, come off it, Dad. I know where the pollen goes. What I mean is, what pointers should a girl have to get along with guys in general?"

Wow! Hadn't her mother told her all about that? Then, of all the luck, what sprang to mind was a sales meeting I'd recently attended.

We'd been sitting around after a couple of drinks joking about what an ideal man-woman relationship would be. Until I could think of a more adult approach, I'd try out this one on her.

"Well, uh, Allison, men are really kinda simple—sort of like cavemen. If you think of them like that, well then picture this. A man's out sweating all day, hunting a mastodon to bring home for dinner. Finally he makes a kill and comes home dragging the main course behind him. After his sweetie cooks up a couple of filets for dinner, he tosses her down on a nice saber tooth tiger rug for some you-know-what. When he's finished, he runs down the path a few caves away where one of his hunting buddies has just fermented a skin full of grapes. So ends one more day in man's pursuit of the good life!"

I paused, half expecting applause, but instead it was, "Oh, Dad, that's so cynical—so gross!"

"You're right, Allison. I guess it is."

I knew it smacked of lecturing, but I went on, "I'm sorry to say it, Allison, but most men don't lend themselves very easily to getting tied down—as in marriage. So women have to carefully guide them that way, like to the altar. But once you get the ring in their nose, then the really hard part begins—training them to be husbands—human beings, so to speak. Domesticating comes hard, believe me."

"Oh, Dad, I can't tell if you're being serious or not."

"There's truth in what I'm saying, dear. When you're looking for a man to settle down with, try to figure out what his long-range qualities are and what kind of person he's going to be in an extended relationship. You know, marriage is supposed to be for a long time, and it will be if you're right for each other. It's actually the best way to go, Allison!"

"What about living with a guy beforehand, Dad?" she interrupted.

I thought for a moment and simply told her, "If you feel it's the right thing to do," concealing my own distaste for the practice. I droned on, "So think about whether or not a guy's going to grow in his job, for instance, and what he thinks about family values and religion. Best to find out early 'cause those things'll become more and more important later on. You know, Allison, one of the reasons your mom picked me was because I'd written down some long-term goals. That really impressed her!"

"Dad, I'm sure she fell in love with you for a lot more reasons—."

"Oh, of course, there were. But let me tell you something else. Be real careful how you use your body around men. A woman's body simply intoxicates a man to the point his reason goes out the window. So proceed with caution. Go slowly when playing with sex 'cause things can happen you never dreamed of. Some men can't control themselves and can cause big trouble."

"Oh, Dad, we had all that sex stuff in school."

"What you had in school doesn't exactly prepare you for the groping and pinching world out there." I looked at my watch. "I've gotta go, sweetie. I'm already late for a sales call." Why was I feeling like a teenage boy whose mother had found a pile of girlie magazines underneath his bed?

Turning to leave, I told myself I'd failed her. Here I'd gone and flunked parenthood one more time. Why did I end up lecturing our kids instead of having nice give-and-take conversations? But we hugged, and I noticed how slight a frame she had. Must've been no more than 105 pounds. Her usual cheerfulness buoyed me, and she thanked me over and over again for coming. Edging out the door, I tossed some twenty-dollar bills on the chair.

"See you soon. G'bye, sugarplum. Take good care of yourself. I love you," and I was down the steps.

Back in the car, I kept mulling over our visit. Had Chris spent the night with her? Do they have genuine affection for each other or did they draw together like ships in a storm? How does Chris really feel about her? Dammit, why couldn't she just come back home where we could protect her?

Then her doctor's advice came back, "Go out and live, Allison," which I echoed with "Go do your thing, sweetie." In that instant I mentally handed her a carte blanche to explore her life and make her own decisions in the time she had remaining. In actuality, she was already accelerating life's experiences.

By the time I reached home that evening, I decided that perhaps I hadn't flunked fatherhood after all. Rather I'd stopped judging her and would keep on loving that daughter of mine all the more.

Chris

It was the best of times, it was the worst of times,
It was the age of wisdom, it was the age of foolishness.

A Tale of Two Cities
—Charles Dickens

I've always been fascinated by the theory that young people when first in love exist in a state of grace protected by the slings and arrows of life confronting the rest of us. The reasoning suggests that the couple's outrageous, innocent love fulfills God's purposes and they therefore deserve encouragement. Chris and Allison must have been safeguarded somehow during months that were at once the best and the worst of times. Neither they nor we realized that such times would not come again.

I compared Allison's eighteenth year of going out and living with my own twentieth, so I believed that sooner or later she would see the light and come home. Summer of that year arrived as well as an unexpected visitor. When I opened the front door to see Chris standing there, I had no idea that his visit would explain almost everything, endear him to us forevermore, and reveal a love story that few people experience.

Seeing him nervously shifting from one foot to the other shocked both Ken and me for different reasons: he, puzzling over the reason for his visit, I, curious to know 'The Chris' I had heard so much about. Ken had described his good looks, curly hair, and medium build, but not the purposeful energy he transmitted. We welcomed him in, and even before I could offer him coffee, he inquired about Allison.

"Oh, she's doing well—moved into still another apartment—one closer to home, but says it's only temporary." My curiosity got the better of me and I asked,

"Tell me, Chris, how'd you two meet again after knowing each other in the middle school?"

"Well, Mrs. Hall, guess you didn't know, but I was working at the Mexican Place when she started there. I remember the morning we looked at each other, realized that we knew each other, and just clicked—I mean a lot!

"At the time I didn't understand my feelings. Besides, these are different times. For instance, when you and my parents were younger, people got married at eighteen. But now I know I fell in love with Allison. Unfortunately, we haven't shared that exact word, probably because I've been a little too immature."

How forthcoming of Chris, I thought to myself. Seems to want to talk things out.

"It didn't take long after we met again that I became her accomplice in some escapades that embarrass me. I'll never forget the day she told me that a few months earlier she had run away from home. One day we left work from the Mexican Place—you didn't know this and I feel so horrible telling you—and we parked up on that hill behind your house and watched you pull away. She didn't have her keys, so I boosted her up the back of your house onto the porch roof. She got into the house by climbing into Kent's bedroom window— he was home on leave—that he'd left unlocked by prearrangement. She made sure she got her pillow, some clothes, and a few belongings from her room.

"Even now looking back, I don't think I'd do that again, and I know it must be terribly hurtful to the two of you. But I guess every family has a degree of generational conflicts."

"I guess so," was all I could mutter, almost speechless hearing this boy philosopher talking about loving our daughter. Not seeing them together, I hadn't dreamed such a serious relationship had blossomed.

Fortunately, Ken jumped in. "On second thought, Chris, maybe that was the best way Allison could make a clean break and start her new life."

"Maybe so," he continued. "I remember one time this winter when you came over, Mr. Hall, and I was there at her apartment. You brought her some big bags of groceries. You were wearing a long trench coat, and that was the first time I met you. She was so happy that you'd come over—and with some food at that.

"But, speaking of coats, remember that we were out of high school and pretty broke on the salaries we were making. Anyway, she saved up and saved up and surprised me at Christmas by getting me the only thing in all the world I really wanted, a "Members Only" jacket. I was absolutely shocked, and I have to tell you I wear it now only for special occasions or when I'm kinda down.

"Oh, and in case you're wondering, I knew all about her condition, and I'm relieved to hear she's getting along okay. When we were going out, she had these two pretty long scars, and I know most kids would feel, 'Oh, my God, look at that!' But, probably from the way my parents raised me, I realize that that's just the way life goes. Who am I to judge? I have a humongous scar down my leg."

"Chris," Ken declared, "that's very kind of you to accept her physical condition that way. I'm sure it's given her greater confidence in herself and certainly respect for you."

"Thanks, Mr. Hall. You know, just doing everyday things with Allison was fun. I remember one night we were driving around and we went to this supermarket she really liked. We were trying to decide what we were going to have for dinner, and we finally settled on it, some Aunt Jemima pancakes in those little cartons. We bought them and ended up going back to my house and making blueberry pancakes with all the fixings for dinner. It was so great! Uh, hope you don't mind my going on like this."

"Oh, no, no, not at all," we assured him.

"Well, I need someone who's independent and Allison is, for sure. You see, I was raised to be self-sufficient and not to count on other people all the time 'cause they're not going to be there for you—be your own best friend and all that. So I've always been able to take care of myself. You know, Mr. Hall, how men talk about women: 'Oh, she's high maintenance. She needs to go out.' Well, Allison's low maintenance, if you don't mind my saying so. For instance, one of our favorite things to do was to go to a spot in Ridgewood high

up on a hill and sit on a rock wall where we could look out and see the lights of New York City. She just loved looking out over the trees and towns. I so wish I could still keep caring for her needs, but they're few because she's so unusually self-reliant.

"Some of the best times we had involved the simplest things. Because she was so athletic, we used to challenge each other to footraces up and down the street in front of her apartment. She'd always get so angry because I beat her, and here she was this big track star. And it would go through my mind, "Allison, you are sick, you know!"

The coffee was almost ready, so I went to the kitchen to fix some pastries for him, too. What a remarkable young man—so articulate I wish he'd been in one of my classes.

I also wish I'd overheard what he was telling Ken in lowered tones. "Another special time I remember was in the middle of winter when we'd been riding around in my car and decided to stop by the Adorno Fathers Park. It was late at night—really late—and there were at least four inches of snow on the ground. She had on—what did she have on?—I think she was wearing jeans and her shoes. She didn't have a top on or anything, and I dared her to get out of the car, run around it, and come back in. We bet on something—I forget what it was—but anyway, she's topless and it's snowing out—no one's around—it's in the middle of a field, there's snow all over, and she goes to run around. She gets in front of the car, and I turn my lights on. She's getting all upset. She ran around the car and came right back in. It was funny—so funny."

From their laughter when I returned to the living room, I sensed some kind of male bonding taking place. Later Ken told me the story—didn't think it all that humorous, but had the good sense to keep his mouth shut. Although Chris changed the subject, he always returned to thoughts of Allison.

"Do either of you know the Jethro Tull group? I rarely hear them, but when I do I immediately think of Allison. She really likes them—had a tape recorder in her apartment and was always playing their music. I think she likes Jethro Tull 'cause their lyrics are more poetic and she's really into writing.

"I've never known anyone so into writing. She used to write down every thought, like, if we had a disagreement or something, she'd

say, "I have to write." And she would! I always thought it was kind of neat—I've never met anyone like that before.

"In fact, I still have one of the first notes she ever wrote me—I don't throw out stuff like that. We were there at the Holidome up on Route 59 one night for a drink when she said, 'I want to write something to you,' and in just six lines she wrote down her feelings about me."

He drew a piece of paper out of a back pocket and read:

Why do I like thee?
Let me count the ways—
You are so perfectly human, touching, and
You are worthwhile...
Also witty, and I like the way you look at me.

Peace and total bliss,
Al
(alias Ally, Breezy,
Junior, Allison Marie Hall)

I brushed back a tear as it came over me that it must be genuine love between these two. But more surprises lay ahead.

"We've had a wonderful eight months together, dating only each other. Mind you, our relationship was an unspoken agreement—I thought just understood—because I've never wanted to date two women at the same time. But since it wasn't spoken, I can't hold it against Allison now that she's planning to go off to college. It's a young age to make a commitment when everyone's going out and experimenting 'n stuff."

We talked on for a few more minutes and then Chris said he had to leave for an appointment. As he reached the door, he added, "Thanks for hearing me out. As you've probably guessed, I really care for Allison, wish her well, and hope we can get back together."

He and Ken shook hands, I kissed him on the cheek, and he was out the door. As I closed it, I pressed my forehead against the back of the door and whispered, "My God, Ken, she finally wants to go to college!"

College-bound

The mother-child relationship is paradoxical and, in a sense, tragic. It requires the most intense love on the mother's side, yet this very love must help the child grow away from the mother, and to become fully independent.

The Sane Society
—Erich Fromm

As the July Fourth weekend approached, I called Allison on the chance that perhaps she would come over for a delayed—very delayed—eighteenth birthday celebration. She agreed! Since my previous overtures –cards sent and messages left—hadn't worked, this would be a golden opportunity to cook her favorite meal. Coming from the school of motherhood that maintains that most problems can be solved by or after a good home-cooked meal, I decided on some ziti, fried eggplant, and Jell-O salad. She told me she wanted no celebration, but did agree to a cake—white with butter cream frosting and lemon filling.

The question of what to give Allison at this point baffled me, so I decided on money and clothes. How I longed to have her knack for picking out just the right gift. My usual pattern was mentally selecting and then rejecting many gift possibilities while she went right ahead choosing presents that never failed to delight. She seemed to know people so well that it was easy to guess at what they'd like to own. Guess I could have taken a cue from her, but change comes pretty hard at times.

Trying to meet the expectations even for a delayed birthday, I muttered to myself, "Thank God for ceremonies," as I lit the "1" and "8" candles on her cake. Then it was "Make a wish, sweetheart," while Ken and I prayed, not merely wished that the cancer would never recur. Next the two of us belted out "Happy Birthday" and presented money and an outfit to comfort her small frame in ways I could no longer do. I could tell she was genuinely grateful, and not just on the outside.

Supposedly, people can't hold two contradictory ideas in their heads simultaneously, but images of a very different birthday celebration kept horning in. Even as I felt the exhilaration that unnerved Allison, I remembered my own fiftieth birthday celebration at that same table three years before. The lingering odor of blown-out candles had first triggered a vision of that other white cake with butter cream frosting and lemon filling. But the clearest image remained of Mother and Daddy beaming on each side of me. There we were—all six of us together—and my secret birthday wish became a dumbfounded prayer of happiness, "Oh, Lord, thank you, thank you, thank you for the miracle of all six of us gathered together around this table!" Then quickly followed my premonition, "I wonder how long we'll be together." Mother and Daddy died within two years of each other; Kent joined the Navy; now our numbers were reduced by half.

A pause in the conversation jolted me back into the present and I knew in my bones an important Allison-type question would materialize. Was this reminder of her birthday inspiring her to more decision-making? Her timing had been unerring before; I'd better get used to it. Sure enough, she began, "Mom, would you help me get my GED?"

"Why, of course, Allison, I'll be happy to." My mind leaped ahead to tutoring her, calling for the next test date, and then sending her off to college. Allison's mind had also leaped ahead to studying on her own. Again, preparations would be on her own terms.

The happy morning I drove her to a neighboring town to take the GED test, I could not refrain from discussing college plans. No time for any early decision acceptances, but at least she would catch up with her peers and might just enter college in September with the rest of her class. What did it matter that we all had not savored her

high school's traditional ceremony where each female graduate processed holding a single red rose, or shared in the excitement of a senior prom? Now in the privacy of the car, she brought me up short, "Oh, cool it, Mom. Let me pass the GED test first, and then I'll think about going to college."

And pass she did, after which she returned home for two glorious nights. Was she testing the waters to return home permanently? I should have remembered Allison's being far more practical, determined, and far-sighted than that.

On her second night at home came a question measuring a "4" on the difficulty scale and a clear "10" for its happiness quotient. Allison's nonchalant tone triggered my intensity as she asked, "Mom, how d 'ya get into college? I don't know, but I'm thinking of possibly applying to Prescott College." Visions of philosophy classes, football weekends, and tea dances with nice young men coursed through my brain. I took the steps upstairs two at a time to locate the *Barron's Profiles of American Colleges* I'd stashed away for this eventuality. She'd look it over, thank you very much.

Within two weeks Allison was on a plane to Phoenix, and it did not take *Barron's* to tell me the reasons for her choice of Prescott College: it was non-competitive, rural, and in the beloved state of her birth, Arizona. Thanks to the kindness of trusted Phoenix friends, she was able to tour the college.

Both Ken and I lunged for the telephone when her call came from Prescott. "Hi, you guys...I'm having a ball at this Hassayampa Hotel. This is the neatest town... Oh, the college? It's great! The interview went okay. They're such nice people out here. Mom, I'm coming home Thursday night. Can you guys pick me up?"

The invisible umbilical was still connected; Allison knew I yearned for her to return nearer home. What she did not know and I could not share were my imaginings that she still yearned to contact her birth mother. The concern never quite left my mind, like those unanswerable questions we ponder over the years: Was your spouse ever tempted to leave you for somebody else? Would I have been happier in another profession, like law, for instance? Would I have been a better person if I 'd had sisters and brothers? On and on endlessly. These days my questions took a different tack: Did Allison plan this whole trip to contact her birth mother? If so, does

she want to move to Arizona to be closer to her? And, of course, the ultimate riddle: If she could choose between the two of us, would she choose her birth mother?

Riddles were hard for me to the point I could build a whole interior life around them. Certainly Ken and I had always tried to be so rational, so empathetic the few times Allison had expressed any interest in locating her birth mother. I'd connected it to that search we all go through to find and establish our own identity. Fortunately, these days she wasn't latching onto other identities so much: Laura Ingalls Wilder and Holly Golightly had given way to Jethro Tull and Cat Stevens. Besides, I'd always been relieved—and flabbergasted at her self-analysis—a few years back when she'd confided, "Guess I was just curious—just wanted to meet her (birth mother) and see what she looked like. That's all." Hmmmm. The English teacher in me noted the use of the past tense and secretly hoped the search was over.

Don't get me wrong. Ken and I hadn't ever discouraged Kent and Allison from a contact. We'd told them everything we knew except about those twenty-four hours when we feared that Allison's adoption wouldn't go through. But we'd also made it clear that we weren't going to conduct a search for them. I'd taken my stand with, "Listen, Allison, we love you guys so dearly. You must know that. And we accept you fully and completely for the wonderful daughter you are. You and Kent are the greatest thing that's ever happened to us! The way I see it is kind of like your father and me coming together as strangers by the Lord's own grace. Well, after what seemed like a very long time, you and Kent came to us to complete the family. The thing binding all four of us together is love. And I know, Allison, that one of these days you're going to accept yourself for the precious person you are and that God brought to us."

At that point I didn't go into all the other nitty-gritty about how most of us can never really fathom the juncture it is to either relinquish or be relinquished at birth and that if Allison did find her birth mother, the results might just turn into a massive disappointment. I can only assume that Allison made no effort to locate her birth mother. In fact, she'd conjectured with a friend, "What could I have done? Call her up to say, "Hi, I'm your child and I have cancer"?

Now I see that Arizona trip as the start of Allison's moving—no longer running—away from us in almost concentric half-circles, fortunately not as distant as Arizona. The next trip was to Boston to spend time with Lisa who was already in college. Meanwhile, I was panicked that Allison had made no more mention of going to college.

Then came another evening's visit when I said to myself after dinner, "Follow your instinct, for heaven's sake, and bring up the subject of college. See what she says. What have you got to lose?" Before long we were back to *Barron's*.

Do you ever look back on meetings, conversations, even gestures that make all the difference to the rest of your life? This was one such decision that changed the course of Allison's life from that night on. The decision was Allison's and hers alone, although it must have been the Lord Himself working through her. She flipped through *Barron's* and reached the thirteenth letter of the alphabet, the M's—early in the M's—before Massachusetts and Minnesota. She happened on the state of Maine. At age eight Allison traveled with the family on a visit to Bar Harbor, Maine, and later we'd rented a cabin on Swan Island, Maine, for a week's vacation. Does an eight-year-old record impressions sufficiently to want to return eleven years later to take up residence? Perhaps so, because Allison's investigation of colleges stopped with Unity College in Maine. She proceeded no further after reading about its environmental studies and idyllic setting. Before many more weeks, Allison was accepted there and prepared to enter Unity College sight unseen.

How opposite my entering college had been. Mother had programmed me since the tenth grade with the belief that I was destined to attend Mills College, a small liberal arts women's college in California. Following my high school graduation, when my parents and I had left Kansas City and stayed for the summer in Colorado, all preparations focused on my going to college. Even now, when I want to well up an image of happiness, it is that morning when Mother, Daddy, and a maiden aunt delivered me to Richard's Gate, the main entrance to Mills that might as well have been the Pearly Gates.

The contrast struck home all the more the morning Ken left our vacation cottage in Chatham, Massachusetts, following Allison's insistence that only he accompany her. How was he succeeding

with her where I couldn't? Their give-and-take manner was so easy while Allison and I frightened each other: I, because of her resolute will, and she, because of that same quality in me. I'd always valued individuality, but this was going too far. I could take charge of a classroom full of adolescents, but my own flummoxed me! I had some uncharted emotional terrain here yet to master. So that August morning I contented myself with mentally traversing the route Ken and Allison would take to college.

Welcome to Maine

The way life should be.

—*The state of Maine*

A s I drove away that morning I knew that this isn't how it's sup-posed to be. Taking Allison to college should be shared with Doris. Why couldn't she heal the breach between the two of them? I couldn't for the life of me understand the mysteries of female rela-tionships.

A couple of days earlier, I'd made plans with Allison, who'd been staying at Lisa's apartment in Boston. Thank God for friends like Lisa who was now studying hard for a law degree. Probably she'd helped motivate Allison to apply to college.

My heart raced with joy as I spotted Allison almost a block away at our planned meeting place, the reflecting pool next to the Christian Science Church. I'll always picture her there like a fig-ure in a painting: solitary young woman seated in an oasis against a background of a tall modern building and magnificent domed church. Any passing motorist observing that 7:00 A.M. encounter would never have identified the scene as the start of her college life. My pride welled up realizing what a beautiful, graceful young woman she'd become. Even wearing her favorite purple headscarf, serviceable blue jacket, and jeans, along with shouldering her knapsack and duffel, she retained her feminine elegance. Indeed that headscarf had a personality all its own, or was it that she tied it so artistically?

Her bright smile told me how much she'd looked forward to this day. Quickly gathering her meager belongings, she ran over, jumped into the car, and with warm hugs and kisses, greeted me with her

122

favorite name, "Hi, popsie, I'm so happy you're taking me up to school!"

"Wouldn't have it any other way, sweetie."

"It's been a blast here in Boston, Dad. I've met lots of Lisa's friends and we went to some neat shops along Newbury Street.

"Lisa got me a job at Burger King, and the manager had us both working at the counter all dressed up in our polyester yellow, orange, and brown uniforms. They even included baseball caps. So, Dad, we worked up a skit where we twirled the caps on our finger, shook our hips, and sang out their slogan to the customers, 'Have it your way!' I tell you, the customers loved it."

"That's fantastic, Allison. I'd love to have seen you two!"

"We had so much fun doing it, Dad. I just love it here in Boston."

As I drove north out of town on I-95, my hopes turned to Allison's putting a love of learning above that of socializing, until I caught myself again thinking of her as eight instead of eighteen. I made a mental note to remember this day when we shared this important rite of passage. After all, we'd missed some of those occasions, but maybe there'd be more—marriage to a nice guy, babies—but I was drifting. I managed to sneak into the conversation some fatherly musings.

"Allison, these are going to be the happiest years of your life." Who knew? Maybe today would begin four wonderful years of college leading to a degree. I pushed away the qualms about her health that always hovered over me. Finally she volunteered the exact news I'd wanted to hear.

"I'm feeling pretty good, Dad. Got the usual back pain, but otherwise, I'm okay."

"That's great, Allison!" The minute she broached the subject, it came over me how much I hated discussing her cancer. Inwardly I pleaded, "God, why can't You just let her be healthy without any pain ever again. She's had her share for a lifetime." Telltale tears of relief welled up, so I glanced out the side window hoping she wouldn't notice. Quickly wiping away the moisture, I decided I'd better concentrate on driving.

We caught up on news of the last few weeks—her quitting her job at Dunkin' Donuts, explaining to Chris how much she wanted to

go to college, and sadly saying goodbye to him. By the time we reached New Hampshire, she'd fallen fast asleep. Once again, driving inspired some solitary thinking and my mind reverted to the day I entered college. Rather than my father driving me through picturesque countryside, a streetcar conductor delivered me to the sprawling campus of the University of Minnesota, "Streetcar U," as it was called. Instead of an early fall day with its brilliant foliage, a –28 degree freeze welcomed me mid-year to college. The U.S. government's GI Bill financed my education granting tuition payments, book allowances, and a $75 monthly living stipend.

Following I-95 to Waterville, Maine, I turned off to go to Unity, driving through sparsely settled areas with occasional small houses sporting pickup trucks on dirt driveways and large stacks of freshly cut cords of wood near the door ready for winter. It seemed that in almost every other back yard rested a stationary old car waiting to be restored. Along the road, handmade signs proclaimed "Fresh Eggs" or "Crafts Ahead."

Dense woods lining the road brought me back to innocent summer vacations in northern Minnesota spent with a childless aunt and uncle offering the closest experience I'd ever had to being parented. Here a few dairy or potato farms interrupted the tree line as testimonials to sturdy farmers who'd cut back the woods, dug up stumps, removed boulders, and built permanent dwellings. All in all, the terrain was far removed from the fertile midwestern soil of my other uncle's lush eighty acres planted in corn to feed his thousands of chickens.

My spirits quickened at the sight of the road sign: "Welcome to Unity, Pop. 1100. Where old-fashioned values are not old-fashioned."

Allison awakened to her first sight of neat, orderly Main Street with "Wow! Unity's bigger than I'd imagined, Dad." With this optimism, she was bound to have a good year.

Three blocks later, we reached what looked like a giant farm and I recalled reading that Unity College had started in 1965 as an outgrowth of a farm that the owner dedicated to starting the school. Some of the original rustic buildings remained. The approaching road bordered one side of a spacious green meadow dotted with campus buildings, and on two sides of the meadow were evergreen

forests of spruce, white and red pine, white birch, and aspen. On the fourth side, a tranquil stream completed the pastoral scene.

"Isn't it beautiful, Dad!" Allison declared.

"Sure is, Allison," I agreed, while privately musing, *Thank God she doesn't have to take those streetcars to class.*

The Admissions Office turned out to be part of a larger and more crowded building by campus standards. A young staff member found Allison's name in her file and warmly welcomed her. "You'll be in Wood Hall, Allison, which is just down this road, first building on your left. You're part of our largest freshman class—ninety strong this year. We're really growing."

Wood Hall, two stories of sturdy brick construction, assured me that at least Allison would have a warm place to withstand the coming Maine winter. But as I felt more secure in visualizing her living here, I cringed at the sight of unwashed windows and dust balls on the hallway floors. Sensing my dismay, our student escort volunteered, "Please overlook the mess, folks. Cleanup Weekend begins next Friday after Freshman Orientation."

Allison's assigned room was Spartan but sufficient, with two sets of rustic furniture: a desk, dresser, and bed for each student. She thrilled to the sight with, "Jeez, look at the view from this window, Dad."

Had she come by that trait from her mother or was it just womanly to make the best of most any situation? While she unpacked and arranged her few belongings, I spotted occasional males in the hallway, seemingly at home. Damn! Wood Hall, a co-ed dorm! I certainly hadn't anticipated that! *Get in step with the times, Ken,* I muttered to myself. Anyway, we'd had our father-daughter talk about guys.

Next came a campus tour of classrooms, library, cafeteria, and student social center, "The Tavern." Allison took special note that dances accompanied by local bands were held there.

By noon Allison seemed ready to join other incoming freshmen gathering for lunch in the student cafeteria. "You don't mind, Dad, if we don't eat together, do you? I'd like to meet some of the other kids."

"Oh, no," I hastened, envisioning the lonely 250-mile return trip to a wife whose questions would begin the minute I opened the cottage door.

With a quick, firm hug and kiss, she added, "Give my love to Mom."

"I will, sugarplum. We'll be thinking about you, honey. We're so happy you're here. Love you."

Leaving this idyllic setting, I felt a sense of security about Allison's new home. I sent both a blessing and a prayer her way: "Please be happy and adjust to these new surroundings." Granted, she had great resilience, but how quickly would she transform from being a 'flatlander' from suburban New Jersey to a 'Maine-er' here?

As I headed south and the forested hills turned to flat meadows and seacoast, I was happier than I'd been in years. Allison was in college! Even better, Unity's small size and remote location would foster her love of nature. Surely she must be in the right place at the right time in her life.

When I got back to Chatham, Doris was at the door to meet me, first remembering the niceties of asking how the trip had gone and whether or not I'd eaten. Then she got right to the point: "How's her health, her energy level, her color? Did I find the college all right? What's it like? Did she seem happy to be there?" Soon questions became demands: "Only ninety entering freshmen! What's the dorm like? Do I think she'll fit in and make friends? What's her schedule of classes? Shouldn't we get a winter coat and send it up to her?"

The question and answer session continued into pillow talk until I confess that my answers became slower and slower, finally lapsing into snores.

That week while our dreams remained earthbound, Allison literally climbed a mountain, as recounted in her own words.

> "For Freshman Orientation I was required to spend a weekend camping at Acadia National Park and to climb Cadillac Mountain there. Because of my poor health, I had no choice but to tell my leaders of my condition and have them understand I would have difficulty in climbing

the mountain. This filled me with such resentment over my physical condition that I became determined once again not to let it get the best of me. I was the first to reach the top of Cadillac Mountain."

Unity

Education remains one of the most important factors in resilience; its greatest side effect is the belief that one is building a roadway out of despair.

—Deborah Blum
Psychology Today, May/June, 1998

That September renewed me more than most in recent memory not merely because I could return to teaching but because Allison was where I knew she should be, in college and beginning a new life. My Irish mother ingrained in me the notion that education provided the means to most of the good in this world, certainly to independence for a woman. These days I held fewer solitary pity parties and turned instead to awaiting news from Allison. I attacked the envelope containing her first letter, reading words spilling over with happiness. She sounded downright lyrical:

"Maine is breathtaking! My college is very small, so it feels like a big family. Closest I've come to communal life, and I love it! There are cows and horses in my back yard. One horse in particular, Claudius, has become my best buddy, and I treat him to green apples every day. Mounds of green, grassy hills surround me and the campus overlooks a beautiful, serene lake, Unity Pond. There is a lot going on here—many bands, festivals, outdoor activities, etc. And gradually I am finding good friends more like me. Still I am different, as usual. But I'm enjoying it. My classes are easy, but interesting, and I'm doing fine in the homework department."

Her telephone calls bubbled over with equal intensity as she described newfound friends, compassionate teachers, and weekend jaunts around Maine in Bob's Jeep. Who's Bob? Oh, just a guy she'd met. I pressed to know about her courses—after all, getting an education was her reason for being there, wasn't it? Oh, sure, she was taking Oral Communication, Composition I, Conservation History, Introduction to Outdoor Recreation, and Introduction to Sociology.

What made me the most proud was hearing her say, "Listen, Mom, listen to what I wrote on an essay recently. Mrs. Clark must've liked it—she gave me an *A*! 'Once in Maine and enrolled at Unity College, I realized that learning and growing by means of centering on the greatness of the outdoors was my niche in life. I chose to accomplish this by finding a college which fostered a love and respect for the outdoors. Since I had often dreamed of living in Maine, Unity College seemed ideal.'"

As always, Allison had acted on faith. She had not known what Unity College would offer her, but going there turned out to be the right decision. How had she known sight unseen the path to take? She had just plunged straight ahead Allison-like, and her life unfolded according to plan.

In her new environment, I noticed another trait surfacing, Allison's simple trust in and openness to nature, which reminded me of those English Romantic poets I had taught who had found inspiration in the wildness and freedom of nature. Certainly there seemed to be something to the notion of seeing God in nature— probably what Allison had already experienced. I recalled an epiphany I'd had one summer afternoon in Colorado at an impressionable eighteen. I'd been hiking in the hills near my parents' cabin as a change of pace from my usual habits of keeping my nose in a book. Veering from the trail, I suddenly came upon a graceful, sparkling, tumbling waterfall and in a singular impulse waded into the pool at its base to glory in the water falling down on me. "Oh, God, God, how wonderful!" I'd exclaimed to no one in particular, understanding with my entire being that God had made that waterfall, brought me to revel in it, and shown how He was in all of nature. Someday I would share that high point of my life with Allison when it wouldn't embarrass us, except that she had already found God in nature anyway.

These days Ken and I lunged for the telephone not in dread but in expectation of pleasant surprises from Allison. She had not shared this much of her life with us for the last two years. We learned that her roommate, the statuesque Jennifer, equaled Allison in spontaneity and verve. Together they formed a triumvirate with reserved Dede, who stood in awe of Allison's sociability. Then into their sphere came hyper Kathy, outdoor woman, who yearned to live in her own log cabin to prove her mastery of the elements. But increasingly, Bob had become the center of interest. In sharing her exuberance for life with this handsome, mild-mannered Maine-er, they soon became a pair. We rarely reached her on weekends and finally realized that the state of Maine had become their playground. She sang to us the praises of its mountains, forests, seacoasts, and towns.

With Allison's new identity as "Bob's girl," it was not long before he took her home to meet his parents. To hear her describe it, their home on Cape St. Elizabeth resembled a magical place, and Bob's mother, an ideal woman, who knit wool socks for her friend Leon, whose nearby company, L.L.Bean, did well. I tried to convey admiration, working around the conversation to determine what else Bob's mother did with her life. Oh, she worked as a registered nurse.

Then Allison surprised us with an invitation to attend Parents Weekend at the college on the next Saturday. The old terror struck my heart that perhaps we would argue, but we followed her lead and gratefully accepted. We would all be on our best behavior, with plenty of outside distractions to prevent any family squabbles.

I can still see her the October morning we pulled up to Wood Hall. She must have been watching for us, as she ran out and threw her arms around us just like in the old days. Soon Jennifer and Dede appeared for introductions, relieving our curiosity all around. Bob had gone home for the weekend. As she proudly showed us her room, I stifled my disappointment over its plainness. She must have read my mind and altered both topic of conversation and atmosphere with the offhand remark, "I'm feeling pretty good these days, Mom—the usual backaches, of course—but otherwise, I'm okay." Thank God! Hearing her reassurance that the evil had not returned made the trip worthwhile and life fit for living again. The CAT scan, "negative for recurrent tumor," ordered six months earlier, had been right after all: the imagery they had noticed was evidently just scar tissue.

Next she showed us her favorite haunt, the student social center—like no other I had seen with simple gray block walls, practical linoleum floors, rustic wood furniture, bandstand, and billiard tables. Concentrating on Allison more than the room, I sensed her serenity—again like no other I had seen in her before. She had found where she belonged. Her voice conveyed a new self-possession when she remarked, "They have some pretty good pool players here, Mom." I indulged in some private moments of motherly pride, remembering when she had perfected her game on our pool table well enough to take on all comers. But before long I figured out that here the essential ingredient, the most energizing activity in this room, had become dancing. Her natural grace must have attracted everyone and increased with each passing month, whether she entertained herself dancing alone or yielded to the invitations of certain fortunate males. No wonder some observers later commented that she danced as if she were in a dream. Certainly her dancing fulfilled a dream that she would be happy and healthy enough to do so.

I can still feel the crispness in the air and excitement surrounding the climax of Parents Weekend, the men and women's Regional Woodsmen Meet. Gathered in a campus clearing, teams of plucky co-eds competed in events such as fire starting without benefit of matches, a useful skill in withstanding winter cold in a pinch. Their teamwork permitted few false moves. One young woman created friction with an ancient bow and wood drill until ignition occurred. Another team member vigorously fanned the flame the very second it ignited. The third woman fed the newly ignited flame with bits of leaves and small twigs until it burst into a full-fledged blaze. The lively winners had brought that fire into existence in no more than two and one-half minutes.

We watched individual events where other hardy women clad in plaid wool shirts competed in chopping logs not sized for fireplaces, mind you, but extending six feet long. These wholesome young students stood spread-eagled on the center point of the log armed with single-edged axes held overhead ready to attack at the signal. When the whistle sounded, down came their axes, chips flying everywhere. Time after time they chopped away between their legs so vigorously that we feared for their feet had they not been wearing steel-capped shoes. Each stroke began high overhead, coming down so precisely and forcefully that soon they split the logs nearly in half.

As the excitement mounted and friends cheered for their favorites, Ken and I watched transfixed, wondering at the carnage resulting from a misdirected swing. Wide-eyed we looked at each other, affirming that at Unity College there was more to life than book learning. In the end, Allison's assessment prevailed, "These Outdoor Rec majors are really into it, aren't they? Wish I had their stamina, but I guess the most we'll be doing this winter is cross-country skiing." I noticed that her tone smacked neither of bitterness nor of envy; maybe we could take a cue from her to really accept, not just talk about, individual differences.

The next morning arrived all too soon for a farewell breakfast at the Homestead Restaurant where Allison had already made friends among the staff. Considering my penchant for crying, I reminded myself to use some non-smear makeup that morning. Over pancakes, our conversation flowed so easily that I made a mental note to imprint the scene on my memory for when I most needed encouragement. I figured the time was right to fill her in on what we'd heard from Kent. "Can you believe it, Allison? Kent's been in the Navy nearly two years now. We hear from him every once in a while, even when he's on those long Mediterranean cruises. Maybe he didn't tell you, but he got a commendation from the Captain when he stayed on duty for sixteen hours helping to load about a million gallons of diesel fuel into the ship while they were docked in Spain."

"Gosh, he didn't tell me! He did say that he's thinking about reenlisting though."

"Well, I sure hope he doesn't!" I missed him desperately; our nest had emptied out years before I'd been ready.

Ken interrupted my musings with, "As far as I'm concerned, if he wants to re-up, then let him do it. I'm not so sure he should make a career out of it, mind you, but for now it just might be the right path for him to take. He seems to have found a kind of home there, he's expressing himself in finding new interests, and he's getting lots of training. The way I see it, he's finally getting his act together."

I let him wind down, but inside I could feel myself smoking! Why did he have to counter me at a time like this, spouting off his opposite views? They both sensed my anger as I delivered a return salvo,

"Can I get a word in edgewise here? I think he'd do better getting out of the Navy. Why couldn't he just settle down where he could be closer to home? He could even start in a college nearby. He's got his future to think about, and there's no better way he could find a career path than in civilian life and in school. That's what I think!"

Though bent on stating my position just right, I saw Allison's jaw line harden and her eyes become dull and expressionless. In the next split second, it dawned on me that she had begun to pull inward. Our stumbling on this disagreement must have rekindled memories of other conflicts. She looked as if she might be drowning or trapped or tortured. Perhaps that's what it felt like for her, as she quickly snapped, "Oh, cut it out, you guys!" An uncomfortable pause, and then, "Whatever! Why don't you two let Kent do whatever he wants to do? He's going to anyway, you know!" I felt like a misbehaving child and would not have been surprised to hear her recommend next, "Grow up, you guys!"

Instead, our breakfast conversation played out in an uneasy peace while I lamented that we would not see Allison for two long months. We could not and fortunately did not say goodbye with storm clouds hanging over us. The emotional dam burst in the parking lot as we all fell into each other's arms hugging and kissing and telling each other how much we cared. At times like this I remembered a less demonstrative relative who had observed, "Your family looks like a scene from The Partridge Family the way you carry on. You'd think you were never going to see each other again."

Decisions

*There is no way we can overestimate the effect we
have on others. We are never on the path of life
alone. Every action we take, every smile we smile,
every word we utter is a statement about the value
of the person who is walking beside us. And from
there the actions, the smiles, and the words ripple
out forever. Every moment we are true to ourselves,
we offer even more value to others.*

—Deborah Blum
Psychology Today, May/June, 1998

*I*f the light bulbs went on about our toning down any arguments
before Allison, the wattage dimmed over determining her physi-
cal condition. I varied my repertoire of questions with each tele-
phone call, watched for symptoms when she came home for
Christmas, and granted myself occasional reprieves from worry. In
Maine she had gone to a local osteopath when her friends said she
"walks funny" and "can't seem to stand straight," but he had dis-
missed her stabbing back pains as being all in her head. Although
Ken and I in our deepest recesses knew differently, we must have
gone numb to her signals. By January, she had returned to Bob's
arms, assuring him that nothing was amiss.

Both Allison and I knew from experience that one of the most
persuasive forms of denial is to convince one's peers that nothing is
seriously wrong. If Jen, Dee, and Kathy tried to ignore Allison's
increasing symptoms, Bob brought food to her in her room and for-
tunately took her home to his mother one weekend. Clearly their
relationship had developed into more than he reckoned for.

It must have been God working in our lives through Allison's friendship with Bob's mother, a nurse who knew the significance of her being awakened with night pains. She insisted that an oncologist friend in Portland examine Allison, and a CAT scan revealed the dreaded results, a 6x10 cm. mass in her stomach. When Allison called us, the alarm bells sounded in our heads: How much time had been lost? How quickly could we get help? How readily would she agree to come home? Oh, God, what'll we do now?

The wise doctor from Maine must have worked both his human and medical magic, as we sensed his influence in her decision-making. Allison proposed coming home for the next weekend. Reeling from this turn of events, we tried to put our questions and fears on hold.

I vividly recall the drive from the airport during which she told us that she wanted to be home to decide just where she should have surgery. Where to have surgery? Here, of course, where we could help take care of her. But Allison did not feel so sure. I wondered to myself whether we would always live our lives by accident rather than by plan.

That mid-January weekend of two days might as well have been two hundred for Ken and me, a minor problem compared to Allison's. The English teacher in me tried to see the wisdom in that line of Milton, "They also serve who only stand and wait." We watched helplessly as Allison sought out friends to be with rather than talking over the issue of impending surgery. Ken and I, functioning outwardly yet torn apart inside, saw her off to Maine with no plans discussed.

We were learning the hard lesson that people cannot remain indefinitely in a state of tension. Soon Ken and I decided to face the reality of our willingly pursuing demanding professions and feeling we could not take time off to be with Allison in Maine. She would have to take leave from school for surgery at Columbia-Presbyterian Hospital in New York.

We rehearsed how we would broach the subject with Allison, but she had already crystallized her thinking, again managing her life in her own way, as she concluded, "No way am I going to take any leave from school, you guys! I'll have the operation down at Columbia, but not before my birthday, and I'll get back to school

just as soon as I can afterwards. I'm ready to come home now, Mom."

Whether she decided out of love, desperation, courage, or all three, I do not know. But I do know that our guilt and frustration gave way to resignation, and our inaction, to organization: ask the photographer to take another family portrait as photographic insurance that all would go well; take Allison for more tests and then hospitalization.

Airports now began to stir up pretty deep emotions in Ken and me as we spotted Allison making her way down the ramp. The night before we had picked up Kent at the Newark Airport as he had received a family leave to come home. Allison looked shorter than 5′3″ somehow, and we hastened to relieve her shoulders of her carefully packed backpack. We all hugged longer and tighter than I'd remembered. "It's so good to have you home, Allison," I murmured in her ear, hoping energy from my body would flow right into hers. Then I gave her up to Ken and next to Kent, who hadn't seen her in over a year.

How would they get along, this brother and sister with such different temperaments and lifestyles? Kent's natural shyness shone through. Certainly two and one-half years of Navy life and two six-month Mediterranean cruises jammed on board ship with 2,800 other men had not refined his social skills. I loved seeing him so warm, cordial, even tender with Allison. He'd managed to nullify our reports of her condition, deny its seriousness, and believe that, given enough time, the cancer would go away. Allison gazed admiringly at his neat-as-a-pin uniform, an image helping to erase memories of his teenage aimlessness. Minutes after arriving home, they called up their friends and went out on the town.

I could delay no longer in announcing plans. "Listen, you guys, be home early so you can get your beauty sleep. Mr. Haviland's coming in the morning to take some pictures."

Mock groans and then, "Aw, Mom, do we have to?"

"Yeah. It's all set. He'll be here at 10. It won't hurt a bit."

Thankfully, they let me win at this little game we played over a family tradition of picture taking. Certainly we had precious few family traditions observed on birthdays and holidays, so this one I treasured. After all, pictures should properly record the progress of

our tiny family, and here the operative word was "properly." No mere snapshots would do. I wanted family portraits turned out by the best photographer in the area.

The first portrait in 1974 showed a remarkably self-assured ten-year-old Allison nestled next to our roaring fireplace and welcoming a life just opening up to her. Mr. Haviland has worked his magic, crumpling newspapers in our fireplace for the instantaneous fire, quelling our nerves and self-consciousness, and deepening our individual and family pride. I had heard that people's expressions in pictures are largely determined by their response to the person taking the picture, another testimonial to his winning ways.

Three years later the next portrait, another command performance, included my parents. Our buying a new house and posing in front of an adjacent forest provided reasons enough for me to insist on a group picture one steamy August day. Our smiles belie the frantic preparations beforehand: my makeover of Mother who believed her eyebrows needed darkening; Allison's changing outfits three times; Daddy's borrowing a necktie to achieve just the right image; Kent's insistence on including his beloved cat, Nasel. I put on a smile, inwardly chafing at the shabby furniture and questioning whether or not the family portrait warranted all this turmoil.

To me the final outcome records Allison at age thirteen with self-assurance beyond her years. Her favorite activities, running and dancing, disciplined her trim, lithe body. Individuality in a person can be elusive, but she had already become an individual soon to begin her freshman year among less secure peers she labeled "snobby." Even then more observer than participant, she would later relinquish her passivity for the fight of her life.

My hesitance in not wanting to record the hard times partially accounts for the lapse of seven years between portraits. No hurried preparations preceded Mr. Haviland's arrival that February morning. Instead we concentrated on trying to bring Allison whatever release from pain we could achieve. Inwardly, I thanked Mr. Haviland who more artfully than usual sized up his choice of props, placement of his subjects, and our somber mood. As he snapped away, I felt almost voyeuristic in imposing on Allison's understandable sadness.

The final picture, culled from fewer proofs this time, turned out surprisingly well, with her eyes projecting greater purpose. Allison's expression seems to say, "I'll get through this somehow because it's the only thing I can do."

With that duty behind us, Ken took on the next responsibility, taking Allison to Columbia for tests.

Angel Unaware

*We do not really live in the real world, we live in the
world of our perceptions.*

—Gaylin

"Dad," Allison confided, "I just hate those angio things! They hurt."

I could count on the fingers of one hand the times I had seen her cry in anticipation of physical pain. This was one of those times—fortunately in the privacy of the car. Even under this stress, I was grateful to be with her again on the day after her twentieth birthday.

"Oh, you'll get through it just fine, sweetie," I shot back, concentrating on taking the right exit off the George Washington Bridge that led to the hospital.

Then I heard woeful sobs coming from deep within her. She sensed that I hadn't been listening. "God, I'm sorry, honey." I reached over for her hand. "I know it must hurt like hell, Allison, but just remember I'll be right there. And besides, Columbia's a terrific hospital. I'm sure they'll be as careful with you as they possibly can." My words strengthened with conviction.

We'd known that they had to do an angiography beforehand, both to check the exact location of the tumor and to trace its connection to her blood supply. One more hurdle to get over, one more challenge to endure, I told myself. Then I remembered how the needles hurt her from the angiography four years ago. They'd had difficulty in finding those tiny veins of hers. "Just more hurt and pain," she muttered as we pulled up to the hospital entrance.

Once inside, the pace of activity so quickened that I could hardly keep up. Before we knew it, a nurse prepped Allison and rolled her out on a gurney into the hallway where I waited. I walked alongside holding her thin hand in mine until we reached a formidable set of swinging doors marked "Tests." I kissed her, whispering, "I love you, Allison. Good luck, sweetie. It won't take long at all." How useless my words sounded!

The kindly but authoritative nurse into whose care I was delivering my daughter pointed to a solitary bench, "You can wait here for her, Mr. Hall."

With Allison now beyond my reach, I could let down. How depressing! Why, oh why must she be in this place? Only then did I become aware of that hospital medicinal odor permeating everything. I slumped down on the bench, staring at the dull beige walls, my dejection as bleak as the dimly lit corridor stretching into the distance.

Usually these moods gave rise to running dialogues with God wherein I begged Him to show me why all this had happened to us. Instead a squeaking noise drew my attention to a door opening at the end of the hall. As it opened, I read the sign "Chemotherapy."

First two bony feet extended into the hallway followed by a slumped form in a green hospital gown being pushed in a wheelchair by a uniformed aide. I saw a young woman about Allison's age. Her skinny shoulders barely supported the weight of her hospital gown, her head was as bald as if it had been shaved, her cheeks sunken, her skin colorless. The sight of her terrified me! She looked like one of those horrific pictures you see of the victims of Auschwitz.

As her wheelchair drew nearer, my dread deepened. In my lifetime I'd never seen such a sight, and I sat transfixed. Her expressionless dark eyes seemed larger than life-size, and the instant she rolled by, those vacant eyes caught mine, imploring, "Help me! Help me!" As I stared at her backbones protruding from her hospital gown, I silently protested, "I can't help you! I can't even help my own daughter."

I'd seen pictures but never a person close up, suffering from the effects of intensive chemotherapy. I had to fight back anger and defensiveness triggered by the sight of that innocent young girl. My

rage made me want to smash the wall behind me as I vowed to myself, "This is never going to happen to Allison." But I must have shouted it, as a man passing by in the hall stared slack-jawed. I struggled to settle my emotions by promising, "Allison will beat this cancer. She'll never ever get that way." My hostility began to subside and I started to think again.

Half an hour later the "Tests" door opened and out rolled Allison. My heart skipped a beat in gratitude. I greeted and hugged and kissed her more forcefully than before, murmuring a silent prayer of thanks for those soft, chestnut brown curls and the smile of relief she now beamed at me. "It wasn't as bad as I remembered, Dad," she happily reported. The test results would give the doctors the go-ahead for surgery.

In our naiveté after her operation four years earlier, we'd been so glad that the doctors advised against radiation and chemotherapy. This time they would strongly recommend it. Still shaken by seeing "the girl in the hallway," as I came to call her, I anguished over Allison's future. "The girl in the hallway" had in reality pictured for a moment Allison's destiny and prepared me for the eventuality that she too would suffer in similar ways. It would not be an immediate turn of events, but it would happen.

As Allison's years of chemotherapy began and stretched on, occasional images of "the girl in the hallway" reappeared to me, and I asked both her and God to forgive my anger and give me greater understanding of that emotional moment. Now years later, I consider her an angel who prepared me for Allison's trials and who herself probably entered heaven not long after our encounter.

"A Full of Light and Life Person"

People who've overcome adversity often try to make the world a better place.

—Deborah Blum
Psychology Today, May/June, 1998

*E*ven now when I see the skyline of New York City from the George Washington Bridge, combining both natural and man-made wonders, I recall that second time we brought Allison for admittance to Columbia Presbyterian Hospital. This week would be no repeat of our experience four years ago. Allison had outlived the doctors' prophecy of two and one-half years to live. We could start over again and reset the time clock; this time we and the doctors together would get it right.

I'll admit we looked to Allison for strength as a prime example of how to handle the junk that life dishes out. She had fears all right, but did not cover them up with false enthusiasm. She just went forward with quiet courage and determination—wanted to have the surgery over so she could get on with living.

When it baffled me why she was not more afraid, I remembered a psychologist friend telling me about projection and how easily we foist off our own fears onto others. It reminded me of a time in my twenties when I had been riding in the car with my parents, resenting Mother's criticism of Daddy's driving. I had snapped at her, "Don't give us your fears!" Even as I had blurted out the truth, I had wanted to cut out my tongue for uttering those now memorable words, although I had told her the right thing for the wrong reasons.

On that February morning, we three brought greater assurance to the ritual of settling Allison into a hospital room. I decided to give myself a brief respite by doing some reading in the Pavilion's cozy

lobby. Its quiet, impersonal atmosphere calmed me until I heard a steady dialogue coming from the direction of the front revolving door.

"Sir, you really can't park here!"

"I know, but it's only for a little bit."

"I can't help it. This is against the rules, sir!"

"Well, lemme just stop long enough for her to get out. Will you please?"

"Oh, sorry, I see it's Miss Hepburn!"

And in floated Katherine Hepburn, her upturned head swathed in graceful white scarves flowing in her wake. With that broad smile, high cheekbones and queenly bearing, she swept through the lobby to a receptionist's window where she enlisted employees in gracious conversation. Her real-life appearance seemed petite compared to her gigantic screen images in *The Philadelphia Story* and *On Golden Pond*. Then she disappeared into an inner sanctum of the hospital for what I later learned were frequent visits.

I sat transfixed by that momentary glance at my favorite screen heroine and stayed to see her leave several minutes later. Her polished exit exuded more star quality in thanking the hospital employees who had eased the way for her. Seeing her took on personal symbolism that I admit exceeded the event itself. If aware of her more brittle qualities, I ignored them in remembering her incredible strength of character. If Katherine Hepburn underwent treatment here, then surely they would cure our Allison. Moreover, since kismet or whatever had led me to read her autobiography, I would try to go by her father's advice to her, "Don't take life or its happenings too seriously. Lift up the corners of that mouth that I gave you one moonlight night." (*Me: Stories of My Life* by Katherine Hepburn)

I swept back to Allison's room to describe every exciting detail of my one-way communion with Miss Hepburn. Confiding all that it symbolized for me awaited pillow talk with Ken that evening. To my surprise my movie buff husband revealed that he had seen a strong resemblance between Allison and the young Katherine Hepburn in her first screen portrayal in *A Bill of Divorcement*.

As the afternoon wore on, I knew my next priority: buttonholing Allison's doctor, "J.B.," in the hallway rather than woolgathering

over a film star I had seen in the lobby. Before long, we spotted him and began our stored-up questions: How large was the mass on her right side? Couldn't tell, because of shadows and lots of organs obstructing the view—he'd know more when he operated. Then we gathered our wits to press him harder. What was his guess then? Probably the tumor had invaded her right kidney and he might have to remove it, but a person can get along fine with only one—the other kidney takes over and does the job for two. I had written down questions now coming back to me. Did he think that the cancer had metastasized to other organs? Couldn't be sure—would have to check out the colon, liver, psoas muscle, lymph nodes, and the aorta. We scrambled to take in all those terms. Then I repeated my question of four years ago. Why, Dr. Price? Where did all this come from in the first place? Now the latest research seems to point to a genetic factor. It was probably a cell she was born with.

Right then, if I could have taken Allison's cancer from her and done battle with it myself, I would gratefully have done so. It would have been a far better plan that God end my life at fifty-five years of age and let her live out her natural life span. For now, I didn't feel up to confronting much less trying to understand God's plan for us. Our efforts had to go into helping Allison through the next morning's surgery.

That morning our minds seemed detached from reality and time, like one of those dreams where you're floating effortlessly through space—except this became emotional, not physical suspension. First, Ken and I drifted into the tiny hospital chapel and sat alone in the back row, comforted by its warm wood paneling and muted lighting.

Ken always seemed surer of himself with God, but now I sank to my knees in more ways than one, "Well, God, here we are again. Since You're supposed to know all things, You must know how terrible we feel. Really, ever since You brought Allison to us, I've felt she was special, and not just to us. Everybody thinks so. Please, please, I beg of You, work a miracle now and destroy those cancer cells in her. Let her live the way she's supposed to. You must realize how much we love her. I'll do anything, God! Just give me a sign. Help us like never before. You're the only One who can give us strength now!"

After our separate, silent prayers, Ken and I looked at each other with that "What next?" glance. He suggested we get a bite at the hospital cafeteria, and, as we sat eating the bland hospital fare, deep feelings stirred in him.

"Don't look now, Doris, but when you can, notice that older guy with glasses sitting behind us. He's wearing a green hospital gown and sitting with some other staff people. I'll just bet he's the Head Radiologist who misdiagnosed Allison's CT scan five months ago! Remember they said it was scar tissue instead of cancer in her abdomen?" Ken drew closer, whispering furiously. "Do you realize that man probably robbed us of five precious months when we should have been fighting that cancer!"

Leaving the cafeteria, we glared at the new object of our hostility, the two of us now in league against our scapegoat. In reality, he may have been a loyal hospital orderly or loving family doctor.

Part of me considered myself a veteran of the post-operative phase we had entered: surgeon reveals his findings; Allison returns to the room frail and inert; we help her recuperate; she continues in improved health. Much of the week fit that pattern with J.B.'s discovery of the hated spindle cell tumor requiring removal of her right kidney. But two conversations the morning before release once again chipped away at my vulnerability.

A young oncologist who spotted us in the waiting room delivered the first shock. He drew us aside for what we thought would confirm J.B.'s findings: the prognosis appeared uncertain, but follow-up radiation and chemotherapy would conquer it once and for all. Instead his message repeated the déjà vu pronouncement of four years ago: this time Allison had no more than two years to live.

I, in my heart, and we, steadfastly together, simply would not accept such an opinion. Look at Allison's miraculous recovery, the bare minimum of painkillers she'd needed, her inner resolve to live. No, we would not believe it and certainly we would not share such a grim prediction with her. Our courageous Allison whom God had given to us would beat the odds and endure. Any distraction or deterrent from that goal we did not need. As I look back, we were right.

The other surprise came from Allison herself in her insistence on returning to school immediately. I protested out of sheer helpless-

ness. What was a mother good for but to help her daughter recover under such circumstances? I pleaded, "Allison, can't you at least spend one night with us, for heaven's sakes? You can't just go from the hospital bed to the airport!" With that, she granted us one night's stay, gathered prescriptions and possessions, and took the next plane back to Maine. She had reframed the bad times into a temporary state that would vanish when she returned to her beloved Maine where she felt competent, accepted, and purposeful. Anything but helpless, Allison looked to future goals.

Much later, I learned of another source of her strength, Chris. Their reunion in her hospital room made them feel as if they'd never been separated, as he described:

> We'd been apart for a long time, but I always thought we'd get back together again. So when she called me, I rushed over to Columbia and hung out for the afternoon. She must've known I was a true friend who could handle the situation. Of course, it was upsetting, but she was really happy to see me. I didn't feel, "Oh, my God, she's— she's got this thing!" Instead I said to myself, "That's the way it goes." You accept hardship and help the person through it. Mostly that's the way life goes—you can't change it, so deal with it, and help the person.

They did not see each other again until the summer.

Returning to Unity College and the closeness of its students, Allison found that many of her acquaintances lacked Chris's grip on reality. In fact, their denial almost to a person resembled an elephant of a problem roaming the college campus. One fortunate exception, Dede, recalls the first time Allison mentioned her cancer:

> At Unity we set up an extra room as sort of a gathering place. That's where Allison and I were sitting alone one day when she first told me of her battle with cancer. I remember crying and crying, and she was the one who comforted me! She was just the happiest, most full of light and life person I had ever met!

Even a doctor's report one month after surgery confirmed her vitality:

General: The patient is a young, very healthy-appearing female in no distress. She is bright, alert, and able to give an excellent history regarding the multiple events pertaining to her present illness.

Social History: The patient smokes approximately a pack of cigarettes per day, does not use alcoholic beverages or illicit drugs. She is single and attending college here in Maine.

Allison's fortunate habit of writing letters, notes, extensive lists, and even journal entries meant for her eyes alone, helped her understand what was happening to her. In fact, it was one major key to her continuing survival. I thanked God for her penchant for thorough descriptions:

"Dear Mom and Dad,

Things are going well. Yesterday was my last day of radiation treatments and the doctor shook my hand. I got a little misty saying goodbye to all the nurses. Funny, I had only been there a week, yet in these situations you get close to people fast. It's sort of an unspoken kindness and understanding among patient, nurses, and doctors. The medication is still working, and I haven't been sick since Monday. Still, sometimes during the day I feel queasy, dizzy, and always *tired*. I haven't gained any weight, but my appetite has definitely improved. Tomorrow I go back to school full time.

Bob's mother and sister and I took a wonderful road trip today to Brunswick, Maine, to browse in lots of neat little shops. Then we all went to a movie. This has been my biggest day all week and tonight I'm resting and writing letters in front of the TV.

Well, I'll keep you posted. You know, when I lose my hair, I also lose my eyebrows, hair on my arms, legs (even between my legs!)

I always have more to tell you and will very soon. I'll also start working on some of the things we talked over. Hope you are well and I'll talk to you soon. I love you both, Allison.

P.S. Could I maybe have some extra money to buy some scarves and maybe some more clothes? And could I buy a suitcase cheaply from an Army-Navy store?

We lived for her telephone calls, and they could fill us with either hope or despair. One night we awakened to her burst of enthusiasm over a volunteer project she and some friends had undertaken. Despite debilitating chemotherapy treatments, she still felt the love and need to help those around her. "Mom, they've actually got some hungry people in the area around Unity. So the pottery classes make some big ceramic bowls, we fill them with good, nutritious soup, and we feed all the folks who come here two nights a week. They really appreciate it. Can you imagine being that hungry!"

The surprises never ceased, as with another telephone call not long after. Usually when Allison called, I would grab some paper to scribble down the essence of her conversation—helped me to remember and savor all she had said. Except for this time. I can still see myself standing at the window staring at the back yard, frozen in disbelief. The conversation began happily enough exchanging news about our busy lives: Kent's made Petty Officer; just about time for her final exams; the forsythia's so gorgeous now. Then a worrisome pause:

"Mom, Dad, there's something I thought I ought to share with you… I talked with the doctor yesterday about all this radiation and chemo and what it's doing to me. I'm feeling some better, but I've asked if they'll give me a breather from the chemo, like until I get back to New Jersey. Anyway, I asked him what all this was doing to my insides, you know, my uterus and my ovaries and everything."

"Yes, Allison, what did he say?"

We could hear her catch her breath. I sensed the worst was coming.

"He doesn't think I can have children!"

"Oh, Allison, sweetheart, I'm so sorry. I really am!"

"Yeah, sweetie, that's tough to take!" Ken added.

"And I'm still having my periods and everything. He says that if my reproductive organs haven't been damaged already, this chemo might finish them off… You know, Mom, how I love children and here I'm never going to be able to have any!"

Even as we tried to comfort, thoughts raced through our heads that never would we have grandchildren by this beautiful daughter. But the ultimate comfort came from Allison herself, "Well, if I can, maybe I'll just adopt some children!'

School ended that year not a day too soon for Allison and me, with the next assignment another series of chemotherapy treatments only ten miles from home. I thanked God for her being safe at home where we could take care of her, even as we returned to the reception office where almost to the day four years earlier we had met Dr. Todd.

God must have known the present limits of our tolerance for those treatments, as Allison received only two doses one month apart. The process involved literally going through the chairs in three adjoining stuffy barren rooms. At least I could accompany Allison throughout. First came a brief examination to check her vital signs. Then we went to the next room where about six other chemo patients waited. This midpoint might as well as been an elevator considering the studied way we all avoided eye contact. Finally the nurse called her name, freeing her to take her place in the largest of the rooms measuring about twelve feet square. There, one-armed wooden chairs, more suited to a college classroom than medical facility, lined the pictureless room. I cringed when I saw the nurse strap Allison's outstretched arm to the armrest, insert the needle, and administer powerful chemicals in record time, under one-half hour. The nurse then told us to wait in the outer office for any unforeseen reaction. None appeared—at least not immediately.

Next I remember scrambling to double park right in front of the office to ease Allison's entering the car. I drove as gingerly as I ever had in my life, recalling Ken's description of his college job of chauffeuring. You could drive so skillfully and smoothly that your passenger feels no bumps, jolts, or stops whatsoever. But despite my chauffeuring, a terrible shudder came from Allison. She began wrenching from waves of nausea seemingly starting in her toes and working their way up. Time after time she vomited until only bile and air remained. We grabbed a litterbag to hold it, and in between times she signaled that I shouldn't stop the car but instead just get her home as soon as I could.

By the time we entered our driveway, her dry heaves had subsided, but they had taken their toll in weakness. Was this what we could expect from chemotherapy?

The next dismal session caused me to reach one immediate and one long-range conclusion. First, there must be less barbaric ways of administering chemotherapy. Next, remembering our chaotic drives home, chances were good that sometime in my life I would encounter other drivers enduring unavoidable distractions within their car. From that time on, I learned to be more understanding of erratic drivers who might be facing similar disturbances.

I had also figured out that Allison's idea of a summer vacation differed from ours; Ken and I longed for rest and stability while she thrived on activity and variety. For several days, I happily tagged along while she shopped for a wardrobe sufficiently stylish for an upcoming visit with her California relatives. Imagine our surprise when Allison returned home early from that visit. The reason? She had begun to lose her hair.

I had wondered when it would happen and how much a woman's hair shows her individuality and her view of herself. Would Allison's come out unaware in great clumps when she brushed it? Would it show telltale signs on her pillow when she woke up some morning? Or, miracle of miracles, would it not come out at all?

While I mumbled once too often, "Oh, it's going to be okay, Allison," she welcomed her sword of Damocles in an almost perverse way. For the next week, she repeatedly brushed and shampooed her hair until she was completely bald. I fished out of her wastebasket some strands of hair to preserve in my bureau drawer for safekeeping.

Once again Chris sensed her needs and showed up at the door late one afternoon, asking her to join him for dinner. He described their reunion:

> I parked the car a couple of blocks from your house and we were trying to decide where to go for dinner. I remember it was the first time I'd seen her wearing a scarf that way. She was upset by the way her head looked because she wanted long hair. But, did you ever see the models that are bald? She looked so pretty without hair, if that's possible. I mean, I really thought she looked good. I couldn't believe

it. Obviously I was still attracted to her mentally and physically.

Afterwards she wrote me this note, and it was really a nice note. She was hoping we could be together again, and I really thought we would get back together again.

Chris,

I'm still so attracted to you! **You are beautiful.** *When you were in the living room earlier I wanted to just hug you and hug you, and I wish we could lie down together in a bed with piles and piles of blankets and spoon and snuggle!*

But beyond the physical attraction, I love you for the human being you are, for what you mean to me, and I to you and what we are together. You are truly special to me—I love you.

Allison

One summer day, I suggested she might want to vary her scarf routine with a wig. Boy, did that idea backfire! She would have no part of it until I bargained that if we returned to Blue Mountain Lake for a nice couple of weeks in the Adirondacks, she might need it for warmth. She relented, and we ended up at the wig shop the next morning.

As Allison tried on different styles of wigs, I silently pleaded, "Get one just like your own gorgeous hair was!" Instead Allison decided on a new image and chose a wig containing easily twice as much hair as her own had been, with thick bangs and luxuriant waves falling below her shoulders so she could achieve several different styles. Certainly I agreed on her choice of color, similar to her own hair—those slightly curly chestnut locks that my genes had not given her. We experimented with the wig's new look on short forays out to lunch and shopping. She declared it satisfactory for a trip to the Adirondacks.

God had it right when He did not give us the power of prophecy. Here I had expected a repeat of our carefree vacation four years ago: drawing closer together, thriving on the natural beauty, generally healing. This stay in our tiny cabin on the lake achieved all that; however, this time we learned the valuable lesson that we could not

disguise Allison's disease from other people. Some guests openly stared, suspecting the reason for her baldness. Others cast furtive glances and avoided us. Some guests her own age sought instant intimacy that Allison rewarded by recounting the entire history of her disease. She took the lead in reaching out to others, which for me took some getting used to.

Allison's knack for communicating shown through in a letter written to Dede that summer that revealed her realistic grasp of her condition.

> I miss you and school, Wood Hall, and everyone. I think about last year and next semester all the time. I can't wait to get back up there and I wonder what it will be like when we're all together again.

> I've got too much time on my hands. I've been to Boston, California, and the Adirondacks. That sounds busy, I guess, but between these trips, I have nothing to do. I stay at home and read, write, watch television, go shopping—and it's pretty lonely. Maybe once or twice a week I'll go out with friends, but everybody has jobs and is busy. Sometimes I wish I had a job too, but instead I got stuck with chemotherapy.

> Which absolutely sucks! It makes me throw up constantly for two or three days and then I still feel disgusting and wiped out for about a week. I've only had two sets of treatments this summer. This is because my reaction to it has not been good. My blood count goes down really low (so they can only give it to me once a month) and this has made me anemic so that I have to take iron pills three times a day. In other words, I have no energy, get annoyingly dizzy often and short of breath, etc.

> I've got no hair! And surprisingly I sort of like how it looks (or rather, I'm relieved it doesn't look as bad as I thought it was going to.) I wear scarves a lot, a wig, or go without anything. The only other side effects are weight loss (I'm at 95 lbs. now) and about two weeks after treatments my mouth starts killing me, my gums swell and bleed easily, my wisdom teeth kill, etc.

The best news though is that two weeks ago my blood count was too low for chemo, though it had been a month. The oncologist decided not to give me chemo for the rest of the summer because he thinks it has been too devastating on me. He is giving me a break for a month and a half to get stronger and pull myself together about this.

Bad news—this is hard to do. I have no appetite and I get along awful with my parents, cry a lot, forget to take my medicine, etc. It wouldn't be this bad, except when I threatened to go off the chemo, I must have scared the wits out of my parents and the doctors because that's when they decided to tell me what is really going on.

Turns out, if I don't have the chemotherapy, I have no chance—I'll die. And even with the chemo, my chances are only better, but still not that good. So what the hell am I supposed to do? Everybody seems to be expecting me to be optimistic, to talk willing and cooperative about this chemo shit, happy to take my medicine, etc. I'm not giving up, but how can I be anything but depressed about this?

The worst thing is I have nobody to talk about this to. Everybody is busy or there is too much distance between the people I care about and me. And even so, I worry about talking to my friends because I'm scared of upsetting them. So you see, Dede, I don't know what I'm going to do, and it's scaring the hell out of me!

But I have one thing to hang onto and that is that school, Maine, and friends are less than a month away. It's so strange, but once I'm in Maine I always feel so much better, so much happier. I can't live with my parents again, and I feel guilty about this because they love me so much and they're really scared. They are being really patient with me, but I seem to be taking a lot of this out on them. I can't seem to talk to them and they want to, but I can't talk to them about it. I'm living in the apartment attached to our house and that is where I spend most of my time.

This is all so frustrating! Dede, I'm sorry that is all coming out on you and I didn't mean to do that, but I'm glad you know what I'm feeling now. Do you understand?

I want you to be happy! I want us all to be happy! I love you, Dede! Go in peace,

Allison

One Hall family tradition, a final fling the end of August, seemed to reunite and give us strength for the coming academic year. Would we have to stay home this time? Was Allison in any condition to travel? Would she enjoy or benefit from a trip? More to the point, would she go anywhere with us?

Ken and I plotted our course, made an offer, and awaited her decision. We proposed a three-city, twelve-day tour of Italy, promising she could be on her own as much as possible and that we would try hard not to hover, increasingly one of her pet peeves. Not long after, she said she would go, given the keep-your-distance agreement, and soon we were off to sunny Italy.

Travel is Broadening

The best remedy for those who are afraid, lonely, or unhappy is to go outside—somewhere they can be quiet—alone with the heavens, nature, and God. As long as this exists—and I'm certain it always will—I know there will always be comfort for every sorrow. And I firmly believe that nature brings solace in all troubles.

—Audrey Hepburn
A & E Biography, 1997

Near noon of our first day in Rome, the telephone's foreign jangling awakened Ken and me from deep, jet lagging slumbers. Allison, already the explorer, reported, "Mom, how're you guys doing? This hotel's so cool! Did you eat yet? I did—right here in the room! There's a menu on your dresser, you can order by telephone, and they'll bring meals right up to your room! Not only that, look around and I bet you'll find a fridge! It's got some real neat snacks.... When's the city tour start?"

The city tour even included a lecture on Italian hand gestures, but after that Allison ventured out on her own. She tried one of the hand gestures, holding up two fingers to a maitre 'd expecting to be shown a W.C., but instead he led her to a table for two. Our do-your-own-thing agreement proved sensible and conducive to swapping of stories, but I missed her company. My worries over her safety would have multiplied had I known at the time about one encounter in Rome.

Intrigued by stories about Rome's sidewalk cafes, Allison strolled along the Via Veneto of La Dolce Vita fame one afternoon. One particular café with its customers relaxing, conversing, and savoring the atmosphere appealed to her. She sat down under the plastic weather flap and ordered an espresso.

An assortment of customers had gathered. Two young lovers, obviously local and with eyes only for each other, delighted in whatever tidbits of conversation the other uttered. A group of students crowded around another table in lively debate, alas speaking Italian that Allison couldn't understand. Then came four American tourists easily spotted by the locals.

Allison seldom tired of people watching, so she gloried in this chance to study human interaction and fantasize about those around her. Just as well she'd left her props in the room—her writing pad and current reading, Ursula LeGuin's *The Saga of the Earth Sea Wizard*. The espresso tasted stronger than she'd anticipated, even with milk, so she slipped in two sugar cubes. That was better. Goodbye, self-consciousness, she thought. I'm really part of the scene!

Then into that private world, her peripheral vision alerted her to encroachment. This in the form of a striking, well-dressed fortyish Italian man approaching with a polite, if deferential, "Buon giorno, Signorina. My name is Roberto. May I sit with you for a moment?"

"I'm sorry. I don't speak Italian."

"No problem." How could foreigners identify Americans with such ease? Was it our shoes, our complexion, our clothes? "I speak a little bit of American, but not so very well."

I should just get up and leave, Allison thought to herself, but then, no, just play it cool. Nothing's going to happen to me here in public and in broad daylight. Anyway, maybe he'll add a little zest to the afternoon.

"You are from America, no? Which part?"

"I live in Maine." He looked puzzled, so she explained, "Actually, I'm from New Jersey—you know, next to New York."

"Ah, si, si, New Jersey. I have relatives in New York. My second cousin—'cousin' is the right name?—he went to America fifteen years ago. He lives in the part of New York called the Queens. That's very nice, no?"

"I really don't know. I've never been there—only in Manhattan. My dad travels New York, and he's been there, I'm sure."

"My cousin, he's in the cleaning business. That's good, no?"

After a few minutes of small talk, Roberto came around to the real subject of his interest: "May I buy you a Campari, Signorina?" And before Allison could decline, it was, "I live very near, Signorina. We could go to my apartment where I have a much finer selection—Sambuca, Galliano, Nocello..."

Warning signals flashed in her head, as Allison thought, *Oh, boy, I'd better fend him off right now and not let this go any further,* and she levelly explained, "No, thank you. I really don't drink any alcoholic beverages now. I had to give them up."

"Oh, Signorina, why is that?"

"Well, actually, I'm sick. I have cancer." *He'll never believe me,* she realized, *but why not try the truth? I'm tired of dancing around the subject. Let's see how he handles it.*

"Dio mio! That cannot be! A young, beautiful woman such as you cannot be sick!"

"Honest! I've been taking chemotherapy, Roberto, and I really can't mix any alcohol with what's already been pumped into me!"

Allison could hardly stand to look at his knowing smirk, as he countered, "Then how about another espresso, Signorina?"

"Fine," Allison agreed, deciding to salvage some of the afternoon. Maybe she should have gone with the others touring the Forum after all. The waiter set down the espresso. An uncomfortable pause. Another obliging smile from Roberto.

"That is a good story, Signorina, to keep the men away from you that you do not wish to—how do I say? —get involved with. You will forgive me, Signorina, for saying, but I think this is some American game. I think I know better."

That did it. This was all she could take. Her plain English erupted with full force. "You think I'm bullshitting you?"

Roberto reeled, wondering if that word meant what he thought it meant.

Then Allison grabbed the top of her chestnut wig and pulled it up, displaying her completely bald head, shiny as the proverbial billiard

ball. "Look at this, Roberto. This bald head is from chemo! Do you believe me now?"

Roberto, now a stunned but wiser man, stumbled to his feet, tossed a few lira on the table, and quickly backed away, muttering, "Scusa, scusa, Signorina. Please forgive. I did not know."

So ended Allison's only taste of café life in Rome.

That night Allison proposed we take a little mother-daughter tour the next day to see the Trevi Fountain. She said she remembered it from the movie *Roman Holiday*. It dawned on me that Audrey Hepburn had starred in that movie, and I vowed, *Sure, Allison, I'll gladly move heaven and earth to revive Audrey, aka Holly Golightly's, spirit of adventure.*

As we boarded the bus designated by the concierge, I knew at long last we'd have a chance to talk just by ourselves. She didn't like my asking how she felt, so I steeled myself against inquiring and tiptoed toward a neutral subject.

"I see you packed the Ursula LeGuin book. How is it?"

"Great. It's one of the best books I've ever read. You should read it, Mom—light reading, but it's got two parts I just love."

"Oh, what are they?"

"Well, a couple of scenes really got to me."

"Wow. That's terrific."

"Yeah. One's about..." She started to tell me in detail, evidently forgetting that hearing plot outlines second-hand is one of my pet peeves. Anyway, I'm glad she did, and I'm glad I listened.

"Well, there's this young wizard who's in a small boat fleeing from a dark force. It's getting dark and he's getting more and more exhausted. So then the wizard decides to turn around, go back toward it, and face up to the evil force. And, you know, Mom, when he does that, the evil force flees from him! Just goes to show that facing difficult things can turn them around, help you to strengthen yourself, and learn that running away doesn't do any good.

"Then later on toward the end of the book, the young wizard is coming to the end of his pursuit in trying to destroy this evil force. In tracking it, he comes to a small island that might as well be Chatham, Mom, the way she describes it. It's so positive and well

put together and perfectly well preserved in a New England kind of way. But as the wizard comes closer, he sees that everything's fallen into disrepair. The buildings are shabby and need painting, the fences are coming down, and the people are sitting around doing nothing and are very disillusioned. As he starts to talk to them, he finds out that the evil force has been there and that they've sold their souls to him in exchange for eternal life. So now they feel they don't have to work or fish or worry about the finiteness of their lives, so things are going to pot."

Lucky I was wearing sunglasses so she couldn't see my tears. What a remarkable person to ponder ideas as deep as those. Here I couldn't face her enduring more pain, much less take on this eternal life business, and she seemed to be sorting it all out. Well, if she could stretch her thinking that much, I'd better learn from her.

Just as I verged on asking her more, the bus driver announced the Barberini stop. "Oh, that's ours!" I declared, glad we'd finally arrived, but frustrated that these moments together had been interrupted.

If sharing experiences with someone you love doubles the joy, it happened that afternoon. Allison braved traffic, vendors, crowds, and even some flirtatious pinches on the derriere rushing to the Trevi Fountain. Was it my imagination or did she assume Audrey Hepburn's princess-like bearing in savoring her own Roman holiday?

"Look, Mom, that's the very place they filmed *Roman Holiday*. Remember Audrey Hepburn came to that corner up there with Gregory Peck following her all the way. She had got her hair cut and felt so beautiful. He waited for her across the street at the Fountain, and then their eyes met. Isn't it gorgeous? I had no idea it was this big. Let's make a wish."

"Okay, Allison, here's a lira. They say you're supposed to hold it in your right hand, turn your back to the fountain, and throw it over your shoulder. Tradition says that then the spirit of the fountain will see to it that you'll return to Rome some day."

We solemnly stood with our backs to the fountain tossing our coins and relishing the ceremony. From the layers of coins at the base of the fountain, it seemed ready for an enormous dredging. Then I remembered another tradition.

"Hey, Allison, I read once that if you throw in a second coin, you can make your own wish."

"Awright! Let's do it, Mom!" she agreed first with thumbs up and then palm outstretched.

As we again stood with our backs to the fountain, made our wishes and tossed our coins, I needed no forethought. For four years, wishing had not meant sorting out possibilities, broad smiles and rolling of eyes in anticipation, or prolonged decisions on how to formulate my wish. "God, let Allison get over her cancer!"

By the time we reached Florence, our next stop, Allison had made friends with two female fellow travelers twenty years her senior, and I noticed them chatting as if they were the same age. One of them, whom we pegged "Mrs. Shopper," dropped hints that she had shopped the world. Leaving her New York City haunts, she had sought out woolens in Scotland, jewelry in Switzerland, and now leather in Italy. Wonder of wonders, on one 'free' afternoon, Mrs. Shopper offered to lead Allison through Florence's best shops. Allison eagerly agreed.

Under Mrs. Shopper's expert guidance, Allison happily found just the right purse, shoes, and gifts. Consider our astonishment later, before reentering U.S. Customs, when Mr. Shopper confided that his wife was a diagnosed compulsive shopper. For years she had mechanically, obsessively collected purchases that now mounted up in their home, price tags still attached and never leaving the place where she deposited them.

Our last night in Florence provided a memorable romantic scene. At a villa in Fiesole in the hills overlooking the lights of Florence, a reenergized Allison danced the night away with her father and whoever else could keep up. The next day brought us to the third and last stop of our visit, Venice, a city that held special meaning for Ken.

Prayer

Lighting a candle is a sign of a prayer offered, and a reminder of Christ's light taken into dark places, a witness to faith and prayer.

Plaque in the Chapel of Canterbury Cathedral

On Day Two in Venice, Doris and Allison joined the tour to Lido and Murano, but a small voice within told me to get out of that commitment and go it alone. Fortunately, everyone understood.

Leaving the hotel and turning down a short side street, I came upon the view that always took my breath away—St. Mark's Square. Uniform facades bordered three of its sides with arches leading to colorful arcades containing shops and cafes. At the end of this enormous square was my destination, St. Mark's Basilica.

I passed through the main arch into the atrium and gazed at beauty beyond belief. Nearby, an English-speaking guide was saying to the group:

> The Basilica is unique among Catholic churches. The existing church dates back to its start in the present form to 1063. The original was consecrated in 832, and shortly after received St. Mark's remains from Alexandria, Egypt. The Basilica is shaped in the form of a Greek cross and topped with five domes of Islamic design. Through the centuries, much marble, mosaics, sculpture, carvings, and paintings both in western and Byzantine style were added. To study the detail within the Basilica is to take a lesson in art history. The Basilica's greatest treasure is the

remains of St. Mark, which we shall visit later. But for now I direct you to a view of the ceiling mosaic portraying Noah and the Flood.

At that point my freeloading on someone else's tour piqued my conscience, so I walked on to the sanctuary's left transept and a small altar under the dome of St. John.

There I put some coins in the box, chose and lit a candle, and sat down on a wooden bench to fulfill my afternoon's mission, which was to pray. Certainly this ritual would give us additional insurance that Allison's condition would improve. I'd prayed in other churches for her, but maybe this time the spirit of St. Mark himself would intervene. Usually I'd prayed to a God I envisioned as spiritual, infinite, and full of goodness, but today I felt more like Job needing to talk things over with a God more in touch with us ordinary humans. My conversation went something like this.

> God, please help Allison! Please cure this terrible disease that threatens to steal away her life. Let her be cured. I know You can! I just don't understand the purpose in all this punishment that's being meted out to her. It's been four long years, remember? I think I've learned to accept my mother, my father, and my brother's being taken out of my life so early, but I simply cannot lose Allison. She's so young, so beautiful, so unselfish. She hasn't offended anyone, Lord. She's an angel right here on earth.

I sat there on that wooden bench for some time with no answers forthcoming. I decided it was time for my secret weapon, my deal:

> God, why don't You just spare Allison and take me instead? Give her a chance to live out a long life. Maybe she'll get married, have children, and find the happiness she deserves. I've lived a full life, and I'm grateful for what I've been given in my later years. It's been a rich experience, but now at fifty-six, I swear to You, I'll gladly make the trade. Just let Allison have more years to live!

More thoughts kept swirling around in my brain, which was feeling woefully inadequate at this point. Why's life so filled with injustice, disease, and death? I just can't believe everything's merely chaotic happening. There has to be some greater reality with a pur-

poseful blueprint where we can face adversity—where we can have the strength and understanding to work it all out. Somewhere there must be order and principle. That would be my heaven.

I looked over at the candle I'd lit for Allison and it still burned brightly. The old saying came to me about quitting while I was still ahead, except I didn't know whether I was ahead, behind, or just treading water. My mind signaled to God: I'm leaving now—remember my offer.

I brushed away my tears, rose from the hard bench, and gave Him a mental wink. Looking back on my deal now, Allison lived a full life for seven more years and my life continues. As it turned out, God's grace protected us all according to His plan and did not require any deals.

Help Wanted

The foremost element in transcending trouble is not having to do it alone.

—Deborah Blum
Psychology Today, May/June, 1998

*T*his September did not feel like a new beginning, as it had in my earlier years of teaching. Neither could I agree with Daddy, just three years deceased, that autumn is the death of each year when foliage goes dormant in preparation for oncoming winter. This year my relationship with September ping-ponged between those extremes. The reason? Allison. I wanted her to stay home so I could protect her from heartache, the demands of boyfriends and girl-friends, and, most of all, the reemergence of cancer. Yet I knew she had to leave; that way she would blossom into the strong person she was becoming. I also knew I could not have it both ways. Her thinly disguised eagerness to return to Maine squelched any more of my internal debates.

Mentally Allison had already returned to Maine even before the weekend we drove her back to school, and by the time our car crossed the river dividing New Hampshire and Maine, she announced a miracle. "Look, you guys, how much bluer the sky is, how much taller the trees are, how much greener the grass is! We're in Maine!" When matters dumbfound me, I resort to politely smil-ing, and I smiled a great deal that day. Once in Maine, I first noticed its unpronounceable place names: the Mesalonkee Stream and the Cobbosseecontee River, for samplers. Then Allison's enthusiasm became infectious as we reveled in the clear air, the gentle wisps of clouds, the sixties ballads playing on the local radio, and the feeling of expansiveness the area gave us.

As I look back on the events during Allison's new school year, I believe that the God-in-charge-of-relationships had a hand in all of them. Dede describes the semester's peak experience:

"After Allison introduced me to her favorite music group, Jethro Tull, we'd always put on a tape in the Student Center stereo and turn everyone on to 'our music.' On the nights I worked, she was always there, especially on band nights, for she was absolutely the best dancer of the school! She made everyone happy that she was around. She just lit up the whole place.

"Allison heard that Jethro Tull would be in Worcester, Massachusetts, and, as they were also the favorites of my roommate and her boyfriend, Kirsten and Joe, he consented to drive us all down in his VW Bug.

"Well, just going to see them was, of course, not enough for Allison. She wanted to meet them. So she spent all day on the dorm pay phones, starting with a phone number on the back of a record, and she managed to get backstage passes for the four of us. What a thrill! She even asked the lead singer for a hug. We drove all the way down and back in one night. I don't think we slept for a few days we were still so excited!"

Some time later I asked Allison to tell me about that night and she said, "Mom, it makes me so happy just remembering when I met Ian Anderson. You know, I liked a lot of different groups, Cat Stevens, Moody Blues, Randy Travis, but he's my very favorite. He's got a really sweet voice, and the way he plays the flute is just fantastic. That night he played some of his best—"Skating Away on the Thin Ice of a New Day" and "Nothing is Easy." They really got to me.

"Well, I have to admit I really hustled for us to get to meet him. After the concert, the word had gone out that nobody, but nobody would be allowed to see him 'cause too many passes had already been given out long ago. Lots of people were already crowded around, but I grabbed a security guard and just told him my story.

"Well, he let us in, and I spotted this old guy—he was really only in his late thirties—quietly sitting alone in the corner. I went over to him—it was soooo cool—and I said to him, 'Hi, Mr. Anderson, I'm Allison Hall, I have cancer, and I've always wanted to meet you.' Well, he started asking all sorts of questions: what kind of cancer is

it, where was I from, was I going to be all right, and on and on. Mom, we talked like we'd known each other for years, and I remember he told me he had a bleeding ulcer and that some nights he really didn't feel much like kicking that stool across the stage at the sound of a power chord. Then I asked Mr. Anderson if before we left he'd give me a hug, and he did so, Mom, ever so gently, whispering, 'Go in peace, Allison.' I'll never forget it!"

Thank you, Mr. Anderson, for being God's own celebrity angel/agent to sustain Allison through a semester otherwise fraught with uncertainties. Two teachers recall other times:

"Allison was very popular, always coming to class amidst a group of friends and leaving with them. They seemed to be enjoying life. I didn't realize that Allison was ill until one day when she was absent and I asked if anyone knew the reason. After class, one of her friends shocked me when she described Allison's desperate situation.

"I remember another class in which we discussed a Willa Cather short story and the central character, a frontier woman with great strength of personality. I asked the class what there was about the woman to cause us to admire her. After a thoughtful silence, a boy who seldom said anything amazed me by saying, 'She's able to meet adversity with equanimity.' After overcoming my astonishment at this unexpectedly erudite answer, I said, 'Yes, Paul. Good. That's exactly right, and very well put, but what does that mean in simpler terms?' After some thought, he said, 'She could take a lot of tough luck without getting all bent out of shape.' I praised him and knew that to a person, we were all thinking of Allison."

Another teacher, also concerned about Allison's absences, joked with her: "Oh, look who just walked in the office. Look who has finally surfaced!" She also counseled with her: "I can't advise you about stopping chemo, Allison. It's your life and you have to take responsibility for your own actions." But she deeply admired her: "She was walking her own path and searching, as anyone in her position in life had to do."

All this, while our telephone conversations went something like:

"How're your classes these days, Allison? Still want to major in Outdoor Recreation?"

A long silence and then, "It's just the pits this year, Mom. I can't seem to keep up."

"Hey, Allison, I flunked Astronomy at UCLA. It's no disgrace. Why don't you ask if you can audit some courses? I'm sure they'll go along with that."

"Well, okay, but that last chemo treatment just wiped me out."

She would say no more—as if to protect me against hurt and herself against reality—defenses that work only temporarily.

About a month later, Ken and I took a ten-day trip around Denmark. Now maybe you think us selfish or uncaring or ridiculous going off on a business-pleasure trip just then. If so, you underestimate the power of the God-in-charge-of-relationships I mentioned earlier. This trip was MEANT TO BE. Just as God guided Allison to Ian Anderson, so He also guided Ken and me to Don and Birgit.

We had known Don and Birgit for years, and to me they might as well have been one of those beautiful couples you see in society pictures savoring the good life. She was a former model, a Swedish beauty possessing great elegance and style. I watched her, knowing that such women must always have it all together.

The four of us, along with others, took in some of Denmark's finest: Tivoli Gardens, the Viking Museum, fine restaurants, and warm hospitality while we drifted closer into each other's orbits.

Then one day the women toured Hans Christian Anderson's home in Odense, and I declared it pointless to remain any longer in distant awe of Birgit's graceful confidence and designer wardrobe. Even now I could lead you to the exact street and feel again the Danish mist overhanging that half hour when Birgit and I struck up a conversation. The timid part of my nature marveled that we were enjoying a truly mutual conversation rather than intersecting monologues. I grasped for reasons: either Birgit was an unusually perceptive person or we were reaching out to each other because we were a quarter of the way around the world from home.

Usually when strangers inquired about our children, I went into automatic pilot brightly replying, "Oh, yes, we have two: a boy and girl. One's in the Navy stationed at Norfolk, and the other's in college in Maine." I could count on no further questions. But on that day in Odense, I told Birgit that our daughter had cancer. Not just that she had battled it for four years and was ready to give up on chemo because of no assurance that it would do any good, not just that she had outlived a predicted two years and who really knows

anyway, not just that she was the strongest person I had ever known, but, bottom line, I was about at the end of my rope, if the truth were known.

Spilling out my fears, anger, and hopes, in the very telling, my emotions became acceptable. I could now manage what before I could not even express, while Birgit gently listened, questioned, and assured me that she understood.

Despite the miracle of our conversation, I anticipated that afterwards would come repercussions. Humans gravitate toward pleasure, not pain. Birgit would find ways to avoid me later on. She would tell Don our story and he too would find it a burden. They would see us for the remaining days in Denmark and then bid a gentle but permanent goodbye, pursuing their own busy lives while we muddled through. *But none of this happened!*

Instead we all became close friends, enjoying unspoken mutual confidence, sharing the fact that we had all known suffering but would endure. Conversations now involved not only trivial, fleeting impressions but also our life's philosophies. We discovered surprising correspondences: Birgit yearned for advanced degrees such as I possessed while I yearned for the adoration she received from a healthy daughter. Don and Ken also discovered similarities: both troubled with angry fathers and challenged by spirited daughters. Soon we became a dinner foursome meeting every month whose conversations began with, "Wait'll you hear what happened to us!" This precious friendship did not change the events but us; our perspective and tenacity would have diminished without Don and Birgit.

The third hallmark of that semester began almost by chance with Allison's reading of a 3″ x 5″ card posted on the Unity College bulletin board.

> Wanted: bookkeeper for dairy farmer
> in Greenville. If interested, contact
> Lance Carson at 220-9745.

Allison excelled in math and would probably qualify. She took down the number, promising herself to give him a call.

The Country Mouse

I want to live, I want to grow.
I want to see, I want to know.
I want to share what I can give.
I want to be, I want to live.

I Want to Live
—John Denver

*L*ike Prufrock in T.S. Eliot's *The Love Song of J. Alfred Prufrock* who measured out his life with coffee spoons, I measured Allison's semester in telephone conversations that augured change. I thought I knew all about change being a way of life, but it took four telephone calls to make me realize I had no alternative but to trust Allison's instincts in the face of change.

The first call ended with a remark tossed off almost as an afterthought, "You know, Mom, I really think I'd better drop out at the end of this semester. The way things're going, I don't think I should continue."

"I'm sorry about that, Allison. What do you think you want to do? Get a job? Come home?" Her hesitation in answering not only immediately but for weeks later told me she was weighing her options.

Her next call spilled over with excitement. "Guess what, Mom, Dad. Brace yourself for this. I'm moving in with my friend Sally. She wants me to spend Christmas at her place and see how it goes." Sally's place turned out to be a genuine, well-worn log cabin requiring their hauling of wood and water to live more primitively than even in Allison's dreamed-of little house on the prairie.

Clearly Allison's love of nature had run amok! My daughter living in a log cabin! She'd never been in one that I knew of outside of

169

Disney World. Perhaps this was some kind of test she was putting herself through, a form of pitting herself against Mother Nature.

With the next call, I fantasized how I'd feign sickness from school and fly up there to bring her home. "Mom, don't fret. I'm all right. It's just that we had a blizzard up here the other day and we couldn't get out our access road. We were holed up for two days. But honest, Mom, we're doing fine. Yeah, we've got plenty of blankets and food and water. Please don't worry. I'll call you every few days. Oh, I almost forgot. I'm going for a job interview, bookkeeping for a dairy farmer. His farm's not far from here, and Sally's lending me her car to get there. Wish me luck!"

Lady Luck rode in the front seat with her one January afternoon driving up Carson Hill Road through barren, rocky farmland to the crest of the hill and her destination, the Carson Farm. The road cut through Lance's property, separating his aging farmhouse on one side and barns on the other.

Job interviews seldom succeed with the surprising results of this one. In a call a few weeks later, I detected a new lilt in Allison's voice, despite the seemingly mundane message, "Hello again. I just wanted to give you my new number when you want to reach me. It's 220-9745."

When we called, the suspicious part of my nature summoned up that old line, "If a man answers, hang up." A man did answer and handed over the telephone to Allison. Was she living with the dairy farmer? The idea seized me with the ferociousness of one of those alligators you see pictured in the Okefenokee Swamp. Certainly I preferred the safety of a farmhouse to a log cabin for her, but once again life had taken a twist I could not fathom.

I thought Allison and I shared the dream of her becoming engaged first, as I had done, complete with ring, party, and well wishers. Then Ken would walk her down the aisle in my wedding gown that I had saved for her. Okay, I would have compromised with a small wedding, but beforehand there would have been ceremonies, planning, and time to grasp it all. Then Kent's favorite taunt, "Would a, could a, should a," echoed, and I felt reality conquering one more dream. How I envied those take-charge mothers I had seen mapping out their daughter's lives where everyone seemed to live happily ever after!

Meanwhile Ken wrestled with more immediate issues: dairy farmer Lance was seventeen years older than Allison. To our knowledge, she had been on a farm only once in her young life on a day's visit to Ken's Uncle Ogden's. Our 100-pound daughter coping with the rigors of farm life exceeded our imagination.

In harmony with her own timetable, Allison announced her 'engagement' in a few simple words. "Mom, Dad, now don't get angry, but I decided to move in with Lance. Everything's going to be fine. I'm feeling good, he's a wonderful guy, and I really love it here on the farm. You will, too, when you see it!"

Slowly more details about their new life together filtered through. Lance, a native Maine-er in his mid-forties, had postponed his destined inheritance of the family farm after college to pursue a career in photography. Fulfilling his artistic talents in Boston and New York led to another high point in his life, falling in love with the glamorous blonde daughter of a German diplomat to the United Nations. But the romance dissolved almost as abruptly as it was consummated; she had other plans for reasons unfathomable to Lance. The one-sidedness of their commitment altered Lance's view of women forever.

When I inquired how Allison knew so much so soon, she described stumbling across photographs of the blonde German ghost displayed in an upstairs room. Hmmmm, I mused, not unlike the garret inhabited by Mrs. Rochester in *Jane Eyre*. However, this time, the secret involved a lovely rather than a crazy lady. Smart girl, I acknowledged, when Allison insisted Lance remove the photographs, replacing his memories with her own assertive presence as mistress of the Carson Hill Farm.

Lance's retreat to the safety of his early environment and what he knew best, dairy farming, came about quite naturally from an introverted nature. I puzzled over Allison's reawakening his long-dormant romanticism and concluded that all relationships are trade-offs in certain respects: she brought emotional stability to his mood swings; she soothed his arthritic body despite her own precarious health; she brought life and variety to his disciplined routine.

Worries over Allison's share in the equation set me to talking to Mother who had been in heaven nearly seven years now. If George

Burns could sort out life in weekly talks with his beloved Gracie, so I could draw strength from Mother. Together we drew some conclusions: being mistress of the Carson Hill farm gave Allison status and identity; she enjoyed a certain security there that had eluded her since leaving home; she gained a safe haven from her earlier emotional and physical trials; she became a valued partner confronting the daily emergencies of farm life. With Mother, I skipped the part about Lance and Allison being intimate; we'd never been that comfortable discussing sex. So I confessed to Mother from a storybook perspective both of us could cope with: Allison had calmed the tempestuous, morose temper of her newfound Mr. Rochester. Later I edged closer to the truth in admitting—but not to Mother—that Lance was another Robert Kinkaid of *The Bridges of Madison County* fame: ruggedly handsome, experienced with woman, sexually irresistible. More pieces of the puzzle began to fit together when I realized that Allison loved her life on the farm as much as she loved Lance. Now supported by the twin pedestals of life, love and work, she began what would become in her words "the happiest years of my life."

Allison's friend Dede recounts some of the good times:

> Allison was so excited to have friends over and show off the farm. She'd been living there several months and, even with the endless chores—wood chopping included— she just loved it there. The farm was almost magical for her, and she loved showing off her "piece of Maine" to anyone and everyone.
>
> I remember how excited she was when she got her driver's license with my little car that barely held together. She was thrilled to have that old yellow station wagon that you helped her buy. Although she loved living on the farm, she needed that extra feeling of independence by having her own car. She could do errands for Lance, go shopping, and visit friends whenever she wanted. She'd usually pick me up on the way to a hardware or feed store that she frequented for Lance, and we'd just drive along laughing at anything and everything. Those are some of my most special memories of her—us driving in the yellow wagon.

One time we drove by a farm that had a yard full of those wind figures made out of wood in the shapes of cartoon characters. Their feet spun in the breeze like windmills, and it was just the funniest sight! We had to pull over and get out to get a better look. I don't think we ever laughed so hard. A girl came out who was selling them and thought we were a couple of loons for sure. She did not see the humor. It just struck us so funny, seeing all their feet spinning and spinning. Allison didn't buy one though. She knew Lance would not see the humor.

That first couple of years she was living on the farm, she was really happy, generally content, and healthy, really from all that work. She had huge muscles on her arms.

A doctor's report confirmed Dede's observations: "Allison is doing exceedingly well... She has no symptoms to suggest recurrence in the abdomen of metastatic disease. Her life seems to be going well now that she is helping to run a dairy farm here in Maine."

In that late spring of 1986, I could have shouted from the housetops, "Thank you, God! It's true. All things do work together for good for those who love the Lord!" Allison's decision to discontinue chemotherapy had not backfired. Her hair had grown back. She thrived on farm life. And our telephone chats more closely resembled those of most mothers and daughters; we traded intimacies and information. My more cynical self considered the conversations barter: Allison readily describing the details of her life and my responding with grateful praise. Women were like that; to the extent they shared, they gained individual power and mutual trust.

As Allison's calls increased in duration and frequency, I next wanted to shout from the housetops, "Listen to me, world. Allison and I have returned to normal closeness just like all the rest of you mothers and daughters out there. What do you think about that!" Now Allison launched into her usual probing questions and I flung back equally direct answers: How was my school year going?—Had my broken leg from a freak accident healed completely?—Were Dad and I planning some trips?

In one conversation, Allison hinted that she wanted just the two of us to get together again. Catching my breath, I answered with a

173

resounding "Yes!," my mind whizzing with plans. I'd fly to Portland two weeks from Thursday if she felt she could drive down. I'd play hooky from school on Friday if she could get away and we'd have three whole days together. To myself I added: find just the right setting, a quiet hotel on her own turf in Maine for two whose grief and anger had torn them from each other.

I remember momentarily relaxing on that night flight to Portland wondering how I could explain to anyone, even myself, the long overdue meeting with my twenty-two-year-old daughter who'd had cancer and whom I hadn't seen in months.

It calmed my nerves to check into the hotel before Allison, unpack, and set out presents to please her. I changed into a new outfit specially bought for the occasion—only soft fabrics and muted colors for this weekend. No more the authoritarian schoolteacher, I would resume the mother role I had so yearned for.

I hovered close to the window hoping to glimpse her in the parking lot and drew away for only the most essential of reasons: make a list of things to discuss; check on hours for meals; rearrange her presents. My tenderness, pent-up despair, fears, and uncertainty were undermining my common sense and I prayed like an abandoned child that she would accept me back. If the sound of her voice on the telephone had unstrung me, what would her actual presence bring?

Then came her heart-stopping knock at the door, and suddenly we embraced as if to make up for lost years of agonizing loneliness. Memories flooded over me: the smallness of her 5'3" frame; the strength of her sinewy arms; the fresh scent of her hair. Though wan and in certain ways hardened, she smiled broadly and took the lead in bantering over details: Had the flight been a good one? How lucky the weather had held. How were Dad and Kent doing? I responded in kind, and we fell into the natural rhythms of people who love each other. Instinctively we tiptoed around the landmines of our differing lifestyles, tastes, and temperaments. How were we to catch up on those lost years that could not be replaced or fill in the gaps caused by our estrangement? We must have realized the uselessness of trying, so we merely began again.

Through Allison's unpacking, dinner, that first night, and breakfast, we tentatively felt our way toward a new relationship that nei-

ther of us could bear to have rebroken. Then almost as an inter-mission from the intensity of our reunion, we turned outward to the unlikely setting of a shopping mall. I might better have under-stood feeling so alone in a crowd had I read Joan Didion's "On the Mall" where she describes the mall's "role not only as equalizer but in the sedation of anxiety" and the place where we "surrender our egos to the idea of the center."

After months on the farm, Allison noticed enticements in the mall she had forgot existed. We agreed that I would pay for the weekend, so I wondered at her passing up jewelry stores, toy shops, and clothing boutiques in favor of a beauty salon. Yes, they were available, and, yes, they would give her a shampoo, set, whatever she wanted—the works. She underwent the complete works: sham-poo, cut, styling, and frosting. I could see the experience also trans-formed the inner woman, as she emerged so self-assured that we felt the rest of her life could not go too far awry. Her renaissance continued from that weekend like a Polaroid picture revealing more facets of what was there initially. Dazzled by the joy of our being together, I briefly reverted to type in asking Allison to eat better food and get more rest. For the next two days, she made a game effort to drink less coffee, smoke fewer cigarettes, and abandon late-night television programs.

Soon came the countdown to our parting: her taking me to the airport, finding a private corner for last-minute thoughts, wishing each other a safe trip home. Now that I had rediscovered my pre-cious Allison, here I was losing her again. The loss of all the time we could have had together swept over me and my spirits plum-meted as quickly as they had risen a short three days earlier. Neither of us had the will for decision-making or promises at that point, although she seemed on firmer emotional footing than I.

Through my blubbering, I looked her squarely in the eyes to ask the unanswerable, "Are you going to be all right, sweetheart?" to which she answered, "Sure, Mom, I'm doing fine." We stumbled on the cen-tral issue of her health, and she replied with assurances I longed to hear: "I've been meaning to get a six-month checkup. Guess I'll call when I get back." And "Yeah, yeah, Mom. You know I'll call you guys if anything comes up I can't handle. You worry too much!" The rec-onciliation bore fruit for our remaining years together.

By week's end, on the back of a score pad page came her letter:

Dear Mom,

Well, it's official—I can still beat you at Scrabble. Hope everything is fine. Again, I had a great time with you.

I started *The Mists of Avalon*, although it's always slow getting started.

The pineapple you brought has already been eaten up, as were the macadamias and other fruit.

Lance is not pleased at all with my hair—says, "It's not me." But I got him to admit that it's not that it looks bad but rather that I had it colored. I love it, though, and I just laugh it off that he doesn't.

Here's a little more than $10.00 because you treated me to things that I had intended to buy.

Tomorrow is CAT scan day. I'll talk to you before you get this.

<div style="text-align: right">

Love,
Allison

</div>

Little House on the Hill

What is lost in so many lives, and what must be recovered: a sense of personal calling, that there is a reason I am alive

The Soul's Code in Search of Character and Calling
—James Hillman

O n the plane to Portland, Maine, I gazed out over the idyllic landscape of New England at its summertime peak. When Allison had heard about Doris' exciting news, she had asked me to come up for my first visit to her new "home."

Doris had opted, with my encouragement, to take a three-week course at Cambridge University, England, in modern fiction.

With the command, "Prepare for landing," I could feel increasing tension as I visualized my invasion of Allison's new digs. Then driving the two hours from Portland to the farm, I calmed down after recalling my talks with Doris when we had tried to make sense of the direction Allison's life had taken. That daughter of ours was accelerating the events most people experience in a long-lived life; she jammed so much living into her years. Doris and I agreed to just encourage her to live however it best suited her.

Now, I admit all this was not without pain. Here she was living with a guy we had never even met. When she first mentioned going to work on a dairy farm, I had repeated my standard line, "Allison, you gotta do what you gotta do." (translated: "God places you at the fork in the road, but He lets you make the decision as to which fork to take.") "Just pray on it first, honey."

"I've been doing that, Dad," she quickly responded.

It did not surprise me when her latest step in fulfilling herself resulted in playing house. Somehow Doris and I would weather this episode, too.

On approaching Unity, set in the middle of farms, memories of my Uncle Ogden's chicken farm flooded my mind. As a child, I loved shoving ears of corn down the funnel of the corn grinder and watching the kernels fall like raindrops into a feeding pail. Then he had let me go into his dirt-floored basement to candle eggs by putting them before a light looking for embryos too mature for the eggs to be sold. My aunt used the whites of the "bad" eggs for luscious angel food cakes.

The most fun was walking with Uncle Ogden into the fenced chicken yard throwing feed corn to about a thousand chickens. But at twelve, I lost that privilege. What boy could resist the fun of making a sudden move to spook those chickens, sending them flying in every direction and also disturbing their egg laying? Now as I neared Lance's farm, I knew I would not be spooking sixty dairy cows. Still, my boyhood memories increased my anticipation all the more.

Turning up Carson Hill Road, I resolved to maintain a positive attitude. Doris' orders echoed in my ears, "Ken, you've simply got to treat Lance graciously." Ahead lay the farm—white frame house on one side of the road, classic red barn and assorted buildings on the other. Probably Lance's parents built the farm on both sides of the existing county road so the county snowplows clearing the road ensured their access after winter storms, a common practice with snow belt farms.

I spotted Allison's yellow station wagon and Lance's pickup, along with an assortment of farm machinery—an ancient tractor, tillers, a plow, and unidentifiable pieces of assembled metal. As I pulled up next to Allison's car, and even before I shut off the ignition, the signature odors of a dairy farm wafted through the air conditioning. At long last, I would probe the mystery of the man, this farm, the animals—all that had made Allison so happy.

I looked toward the barn to see Allison starting across the road, looking so renewed with a welcoming smile lighting up her face. Two aggressive white geese waddled toward her, sounding off with deafening honks, their heads dipping low with displeasure, and hissing at her passage. They had provided the background ruckus

we had heard so many times over the telephone.

"What a racket!" I yelled as she ran to me open-armed. We hugged so tightly, soaking up the happiness of finally being together again.

"I'm so happy you came up, Popsie!" she exclaimed.

"God, I've wanted so much to see you, honey." I rank that moment among those in my life as being one of the purest joy.

"Lemme show you the house first, Dad, and then you can put your stuff in the room we've fixed up for you upstairs."

As we entered the screened porch extending across the front of the house, a large beige Labrador hobbled up from his pad to greet us.

"This is Fella, Dad. He's a wonderful old dog, but he's a little arthritic—has trouble getting up sometimes."

Fella gave me that look of "any friend of Allison is a friend of mine," as I reached over to scratch his head and then his stomach to ensure our friendship.

"We've got two cats too—Mama and Sis—and they're always having the cutest kittens. They're great mousers, too."

Allison proudly led me from room to room. She was a stickler for detail: the antique dresser passed down from Lance's family, Lance's photographs of New England scenes, the water bed. "It's good for my back, Dad, and great for sleeping!" Enough said, I thought.

"Where's Lance?"

"Oh, he's up in the pasture doing some fence-mending. A couple of cows got out yesterday. He's had lunch, and the hired man's cleaning up the cow stalls."

Next she took me into their dirt-floor basement. I might as well have been at Uncle Ogden's; the same type of gravity wood-burning furnace with its fourteen-inch pipes was carrying heat to the registers on the first floor. An enormous pile of unstacked split logs covered nearly half of the floor where they had been dumped through the window.

"Would you believe it, Dad? We get up at four every morning so Lance can milk the cows. My job's to put more wood in the furnace. I make him some coffee and then go back to bed. Not so bad a deal, now is it? Lemme show you the kitchen, and I'll make you some lunch."

Wow, I said to myself, she's even into cooking as part of the "deal." Here in the center of activity, her increased self-confidence shone through as she presided over her antiquated domain.

"We've got lots of meat, Dad, although it may not taste like what you're used to. The freezer's full of beef 'cause Lance just butchered a heifer. Apparently she wouldn't be able to calf. That's the way it goes on a farm. Should I cook you up a hamburger?"

"Thanks, sweetie, but I'll settle for a peanut butter sandwich."

I looked around at a scene right out of the forties: cast iron enameled sink, four-legged black and white stove, plain white metal cabinets. I could not take my eyes off the black and white checkered linoleum; guess I have a thing about linoleum floors.

Seeing my preoccupation, Allison admitted, "It's a little bleak, isn't it, Dad? Lance told me to buy a large throw rug to kind of break up the starkness."

"Good idea, sweetie."

Setting in front of me a sandwich and glass of milk from their very own dairy, Allison chattered on about her new life with enthusiasm I had not heard since her pre-cancer days.

"This milk tastes stronger, no, richer than at home," I commented. "It tastes different from ours."

"Sure, Dad, the cream's still in it. It's called raw milk—right from the udder!"

"Yeah, but, being unpasteurized, won't I get some strange disease or something?" I only half-joked. Clearly I had lost touch with the realities of farm life.

"Heavens, no, Dad! I see you still worry over details."

"Yeah, I guess I do, Allison."

We chatted about our lives in New Jersey, Mom's trip to England, and the fact that Allison was feeling fine. Mostly she wanted to describe a typical day on the farm.

"Once the morning milking's done, Lance starts feeding the cows. Then he cleans and washes down the stalls after they've been turned out to pasture. He comes back in around eleven for lunch, maybe a nap, and then relaxes by making his telephone calls, doing business errands, and finishing stuff I can't attend to. Then he does

other chores like repairing machinery or, depending on the season, plowing, fertilizing, cultivating, or harvesting. He's got about one hundred and fifty acres planted in field crops—most of it, corn. Then at four, he has to start the second milking, and when he's finished with that, we have dinner. It's a long day—that's for sure—but I love it!"

Her exuberance over such a grueling schedule kept any negativisms I might have uttered locked right there in my mouth.

"Oh, here he comes now!" as she spotted Lance walking up from the milking parlor.

He entered the kitchen and his eyes met mine. He smiled, and uttered a simple "Hello." A memorable moment when each man took the measure of the other. I absorbed all I could from a first impression of the man who had transformed our daughter's life, and only guessed at his curiosity over how I would interpret their life together.

I stood up, extended a firm handshake, and Lance's hand locked on mine as if it were caught in a vice—no pain, mind you, but an unmistakable man-to-man "I'm strong" signal. Finally I had met the genuine Marlboro man—5'7", well built, with clear blue eyes that scanned everything around him.

As his presence dominated the kitchen, Allison kept up a running conversation trying to elicit responses from the quiet males. He sat down at the table and poured a cup of coffee.

Allison immediately chimed in with, "What's new with Kent? Did he make his decision about reenlisting?"

"Yeah, he did. He's signed up for three more years of service."

"Tell Lance about his ship, Dad."

I looked at Lance and started my spiel. "Kent's been on one of the Navy's largest ships, a troop transport that carries two thousand Marines, their equipment, helicopters, and even six landing craft nestled in the stern. It's gigantic! These days it's floating around the Mediterranean again—the third time he's been there."

As I hesitated and glanced at Lance for any reaction, there was none, so I continued. "A couple of years ago the Navy offered a weekend cruise for male dependents on his ship. I went on it and

managed to stand watch with Kent, facing this enormous boiler in a room where the temperature was one hundred and fifteen degrees. They only stand watch for fifteen minutes at a time, but still the heat gets to you."

Lance nodded his head as if to say, "That's interesting."

"We got a letter from Kent this week describing their docking the ship at a port in Israel. It wasn't in a secure area, so all the sentries were warned to keep a lookout for two kinds of invaders. From the water side, there were unfriendlies trying to get aboard and damage the ship, and on the dockside, were women grabbing returning sailors pleading to take them aboard or marry and take them to America. Some of the women would even try to stow away. Kent says lots of the people over there really want to come to the U.S."

At last Lance responded with a laugh. Soon he excused himself for a well-earned nap; by then he had already worked eight hours. Allison confirmed that indeed he was a man of few words.

More remarkable images awaited as Allison suggested we look over the rest of the property—not all five hundred acres, thank heavens. She continued on about the intricacies of dairy farming.

"You see, Dad, all our cows are Holsteins 'cause they give more milk with less butterfat than Guernsey's. Our co-op wants fluid milk for drinking rather than for making butter and cheese."

We crossed the road to the barn complex and entered the milk cooler room where a huge refrigerated stainless steel tank stood in immaculate surroundings.

"Boy, this's as clean as a science laboratory," I observed.

"Sure is! The milk's piped directly from the milking machines into this tank that can hold up to fourteen hundred gallons of milk, and then it's chilled to thirty-eight degrees within a couple of hours or its quality goes down. The co-op picks up every two days. The state rules are stringent to make sure the milk's free of bacteria or other health risks, and, I tell you, Dad, it can get tense around here if the co-op turns it down for being unacceptable. But Lance prides himself on delivering superior milk that is only rarely refused. Now lemme show you where the milking's done."

We walked into the adjoining, now-empty milking parlor—I smiled at the name—where twice a day the cows were lined up close as sardines in a can.

"See, Dad, these machines hang over each cow so Lance can connect them to the cow's four tits."

"God, wouldn't that smart?"

"Nope," she explained. "They eat at the trough right in front of them while they're being milked, so they're happy."

"Glad of that! How much milk does a cow give?"

"Lots, Dad, on the average of about sixty-five pounds or seven and one-half gallons a day."

"Wow! Say, you've got all this stuff down pat, haven't you? Looks like you're a natural-born dairy farmerette!"

"I guess so, Dad. It feels so right!"

"I can tell, and I'm happy for you, believe me. Just look at all you've taught me—that milk doesn't come out of cartons from the supermarket, for instance."

"Dumb joke, Dad. Come on, I'll show you more."

In the next room, the main part of the barn, two sturdy tractors of indeterminate age stood at the ready. Lining the walls were sacks of feed, rakes, shovels, pitchforks, and other trappings of a farmer. In a small back area, shelves holding ten chicken coops lined the room.

"We keep a few chickens, mostly for the eggs."

Before crossing the road, I noticed a concrete foundation the size of a garage with three cement block walls surrounding it. Inside a black tarpaulin covered a mound occupying half the floor with several large tires weighing it down.

"Oh, that's a bunker silo where we keep the silage, the fodder made from cornstalks, clover, and other goodies the cows eat. Lance feeds it to them mostly during the winter 'cause they're out in the pasture in the summer. Let's go across the road and I'll take you up to the view."

Here came the geese twosome hissing and honking again. "They won't bite you, Dad. They're just feeling territorial."

We bypassed an old garage attached to the house that now served as a machine shop "where things try to get fixed." As we climbed up a path to the high point of Lance's property, she exclaimed, "I love this view, Dad." We could scan over half of the horizon with rolling hills extending thirty miles, patches of forest, including Lance's stand of white pines, assorted maples and oaks, other farms, and even Unity Pond. "I think I can even spot the tops of a couple of Unity College buildings too," she remarked proudly.

I put my arm around her waist and thanked God that she had found this place. "Sugarplum, this is living! You've settled in the right place at the exact right time in your life. Good for you!"

"Thanks, Dad."

Returning down the hill, our last stop, her garden, revealed her greatest pride and joy. She had single-handedly planted crops new to the Carson Hill Farm: luscious ripe cherry tomatoes, cantaloupe ready for picking, and Chinese peapods that she stroked lovingly.

"I love tending my garden—reminds me of the one Grandpa grew at home in New Jersey."

"Sure does! You know, Ed was originally from an Iowa farm. He'd be proud of you."

That night Allison cooked a hearty meal of steak, potatoes, peas, and salad. Our limited dinner conversation rivaled the noontime encounter, despite my embarking on one topic after another to spark interest. By nine o'clock, both Lance and Allison excused themselves to go to bed. I, stimulated by the day and more attuned to later hours, read myself to sleep.

Morning came early enough for me, with everyone else well into the day's chores and me feeling like a fifth wheel. I had to do something to earn my keep—couldn't just lounge around while all the activity swirled about me. But what to do? I told Allison I had to help with something physical—some job that really needed doing. True, I was basically unfit and untrained for most farm work. Couldn't see myself driving tractors or milking. Maybe all that wood in the basement needed stacking. I'd save Allison from having to reach so far for it. That project lasted for about an hour until I gave out from exhaustion. When Lance came in for lunch, I suggested another project.

"Lance, I see you've just replanked the front porch. How about if I get some wood preservative and mop it on?"

A quick smile crossed his face. "Have a go at it. Allison can take you up the road to the hardware store."

How glorious to have Allison driving me to the store in her big old station wagon. Not only was I helping her more tangibly than I had been able to do in a long time, I might earn some Brownie points with her Lance. I disregarded the curious glances in the store—they could spot a stranger from ten miles away—and bought the right stuff for the porch.

Slopping preservative on that porch floor gave me as much pride as if I had preserved the ceiling of the Sistine Chapel. The job went swimmingly and I qualified as a hired man.

We celebrated that evening with Saturday night dinner out at the local Homestead Restaurant where Allison had regularly eaten before moving to the farm. Although the hour drew dangerously near bedtime, our dinner conversation ranged more easily over politics, the economy, and the outlook for dairy farming.

The next morning as I prepared to leave, rarely had I been so torn apart inside; I hated to go, yet I could not stay. As I watched Allison fixing this last breakfast for me, her happiness warmed my heart and allayed my anxiety. Her health seemed as good as I had seen it in years and everything for her was in its right orbit, but, oh, how I missed the immediate presence of her joy and spirit in my life. Kissing her goodbye seemed like saying goodbye to the happiness she had always brought me. I know she noticed my tears.

Returning home, I walked in the door and looked at the clock. Great! Three o'clock here and nine in England. I could call Doris before she went to bed.

How wonderful to hear her voice again over a connection so clear that it might as well have been in the next room. Wish she had been!

She loved the course, stayed up late studying and writing a paper due soon, missed me, and looked forward to my coming to Cambridge in just twelve days. With that out of the way, she pressed for a report on the weekend.

"Allison's really happy up there, Doris. You wouldn't believe all she's doing physically: helps in feeding and milking those big, dumb

cows, and does all kinds of chores. She even got stuck in between an unmovable heifer and the barn. The fool animal wouldn't budge, so luckily Lance came and got it moving without squashing her. Oh, and they have a great dog who loves her like a mother, and two cats who have the run of the place. They live in their own cat heaven having kittens and chasing mice.

"I'm just flabbergasted by how much she accomplishes, Doris. Her energy levels are up—way up. And, thank God, she says she's feeling much better, which is obvious when you look at her. She's even gained some weight—sometimes has that old lower back pain—but it surely doesn't stop her."

"Ken, what do you think of Lance?"

"He's a nice enough, really quiet type—strong, handsome, attractive to women, I'd say. He seems to respect her. In fact, dearie, I think he loves her. He certainly isn't demonstrative, but I have to give him credit: he's the hardest-working man I've ever met. He's up at four, works 'til about eight, and then falls in bed— seven days a week. There's always something to be done on the farm. Just when everything seems to be caught up, then some fool metal part on a piece of machinery breaks, and his work starts all over again."

Doris has a knack for getting to the point, especially long distance. "Ken, do you think anything'll come of the relationship?"

"As in wedding bells? I doubt it. He's pretty set in his ways, and from what Allison says, she isn't the first live-in bookkeeper he's had. I'm just so glad to see her so happy, dear, and considering all the shit she's faced, she's finally savoring life in her own way. I can hardly believe how well she's adapted to the demands of living on a farm. She's living her *Little House on the Prairie* life and loving every minute. It's fantastic.

"I'll tell you more when I see you. Just twelve days. How about that? We'll have lots to celebrate for sure."

"Marvelous! I've reserved a little place in the Lake District for the first weekend, and then we can tool around where we want. Can hardly wait. I love you, Ken."

"Love you, too."

Thanksgiving

Hope for the moment. There are times when it is hard to believe in the future, when we are temporarily just not brave enough. When this happens, concentrate on the present. Cultivate 'le petit bonheur' (the little happiness) until courage returns. Look forward to the beauty of the next moment, the next hour, the promise of a good meal, sleep, a book, a movie, the likelihood that tonight the stars will shine and tomorrow the sun will shine. Sink roots into the present until the strength grows to think about tomorrow.

—Ardis Whitman

*I*n my next life I shall try to get it right about families observing holidays.

Many of ours were respites from work, but now with Thanksgiving approaching, I saw an opportunity (read excuse) for us to visit Allison. I do not recall who invited whom, but soon I had ordered a pre-cooked turkey to take to them. The market and I managed some clever packaging to schlep aboard the plane the turkey and dressing with instructions for reheating in one carry-on, cranberry mold and salad in the other. Ken toted the pumpkin and mincemeat pies; the gravy and veggies we left to Allison's ingenuity.

I had memorized Ken's description of the farm, but the reality of seeing Allison running down the front steps completely undid me. As we took a repeat tour of the house, barns, and property, it came over me that my little girl had become a farm 'wife' in a quick hurry.

Best we adjust to her new status. At least Ken and I had that night to sort it out, although our pillow talk occurred while braving the chill of the upstairs bedroom, heated only by a miniscule grill permitting occasional puffs of warm air traveling two floors up from their antiquated wood-burning furnace. Random thoughts crowded in as I fell asleep: Should I set the alarm for four to help Allison stoke the furnace? She looked wonderfully vigorous. Lance's charms exceeded my expectations, even to that Boston/Maine accent of his!

That Thanksgiving Day at the farm stood out from their other days in two ways: our splicing the Thanksgiving take-out feast between chores and their friends visiting more than usual. We probably provided conversation topics for days to come. One friend, Betty, could not visit Allison and instead we went to her.

Allison and Betty had drawn together out of a shared bond, cancer. But their lives differed: Betty was blessed with three children and cursed by a husband who had deserted her. Our Thanksgiving visit proved unique; it was the last holiday before Betty became bedridden. Allison remained loyal, and visited her until Betty's death three years later. It was then that I realized the significance of the gift she had given Allison—her own personal, well-marked Bible.

That Sunday we attended "Betty's church," one of the most remarkable in our experience. This small fundamentalist group enveloped Allison in their love, prayers, and fellowship. But ultimately they misinterpreted Allison's private beliefs for acceptance of their doctrine, an outcome we little anticipated entering church that morning.

The small wooden frame building scarcely gave notice of being a church, but once inside we noticed the altar, the focal point for each member, young and old, who carried his well-worn Bible. Throughout their challenges during the week, they tried to live by their Bible's teachings, and Sunday, especially Sunday services, topped off the week. I know we three appeared reserved listening to their fervent hymns, heartfelt testimonials, and the zealous sermon. However, the overflowing gladness of this little band of believers in central Maine on that cold morning spilled over onto us.

In time, Allison's private response to their evangelism began to trouble her. She could not believe she was a sinner. Neither could

she accept, try as she might, that because of her being born into sin, she still needed to be saved and to stop dancing. She could not fathom a salvation where Jesus would not want her to dance, and before long she allowed back into her life the dancing that had given her so much joy during her college days. Although Lance no longer accompanied her, she returned to "The Tavern," and was an inspiration to behold. Onlookers compared her ecstasy to that of Snoopy when he flung his arms straight out, threw his head back, and bent his gaze to heaven in the pure love of living.

During Allison's second winter on the farm, I searched the weather maps, whether in alarm or relief, imagining what her life must be. Her telephone calls sustained us, while a Mother's Day card ("The more I understand, the more I appreciate. I love you, Mom, always.") and a Father's Day card ("You're the best Dad in the world.") assured us. But a vividly descriptive June letter put an end to our imagining and brought us into the reality of her life on the farm.

> Though unbearably hot and humid here yesterday, today is unbearably windy and in the 50's. Tonight will drop to the 30's. Perhaps I'll have to get a furnace fire going.

> The corn is all in finally, a tad behind schedule, and this week haying will begin. I don't think I'll be able to help much with haying, but I did help Lance in planting two or three fields. He rode the big Allis Chalmers complete with stereo and air conditioning, while I rode on the planter, hanging on for dear life, dust in my eyes and black flies swarming. It was not fun, but working alongside Lance isn't something we get to enjoy enough, so I did it readily.

> Fella killed a groundhog this spring, and Mama and Sis, with three kittens still left, are always on the hunt— mostly chipmunks, mice, and unfortunately, birds. The cows are all healthy and happy. Our hired man has been with us at least five months now. Lance can trust all the milking to him and concentrate on field work.

> Soon I'll be swimming in Unity Lake and hopefully getting our canoe down there. Meanwhile my concentration is on the lawn. Lance and I will cut down two more of those low branches on the weeping willow. We planted another pear tree in the back yard.

I have a lot more flowers this year—portulacas, petunias, and three different types of marigolds. And our garden is much better this year. I cut it in half, landscaped it all out. We have oats (for looks) in the empty half. In neat, straight rows we also have two types of peas, beets, radishes, parsnip, carrots, onions, corn, lettuce, and spinach. All these are beautiful and healthy. However, there are four withered and weary-looking tomato plants that I don't think will make it. Oh, well, we don't like them that much anyhow.

I feel fine!

Love,

Allison

Those last five words freed us to believe that Allison was healing and enjoying life to the fullest. I decided to invite myself for a long weekend on the farm as soon as school ended, and Allison happily agreed.

The visit began with another house tour showing how she had renovated Lance's bachelor pad with its brown walls and utilitarian furniture.

"Oh, Allison, how great to get rid of those depressing dark colors in favor of this white interior! Must've taken gallons of paint."

I teared, momentarily, at the sight of a new electronic piano in the living room. Those lessons we had made her take as a child bore fruit now as she gave me a quick recital. On the music stand were sheets of current tunes she had almost mastered, but she began with her favorite, *Für Elise*, learned a decade ago. Again I brushed back the tears remembering those carefree days. How could I stop this damned weeping!

Fortunately I found no more time to cry. Next we crossed the road to the barns, and I geared up for the goose patrol.

"What gives with the geese, Allison? They don't seem as fierce as they used to be."

"Oh, I guess we didn't tell you. One of the males got run over by a car. It was real sad watching the other one wandering down the road looking for him. Anyway, one day a female showed up, pretty

soon they got to be friends, and now they're a twosome—not nearly as feisty as the first pair. In fact, Mom, she's had a rather calming, softening effect on him. Funny how nature works, isn't it?"

"Sure is," I replied, thinking more about human nature and Allison's healing transformation from suburban to country mouse. My musings were cut short by none other than Lance who hugged me warmly, putting to rest my qualms over whether or not he welcomed my visit. Soon he launched into a description of plans for the new milk parlor, tearing down the old tie-up, and putting in a free stall barn. My eyes must have widened with surprise to hear him tell how he and his "boys" would not have to shovel so much manure. With the new free stalls, they could shovel it out by bucket loader. I nodded with enthusiastic, if confused, approval.

"Just think, Mom, we'll have a computerized barn! It'll have a gate automatically open to let in the cows by way of a signal from a tag on each cow's ear." The good part meant more time for overworked Lance and a general modernizing of the Carson Hill Farm.

I felt my enthusiasm waning over a lunch of Lance's favorite casserole, a mixture of the worst old cow meat I have ever tasted and macaroni. This he washed down with a swallow of coffee-flavored brandy in preparation for his daily nap.

If the day had not offered enough experience, the night brought even more. Allison and I talked for hours, releasing blocked, unspoken thoughts we had stored up for too long. First, about Lance, I should not think of him as a jock or snob at all. No, he's real smart and a real hard worker. "Mom, he's so fair-minded, gentle, and real rugged. He loves science and music, appreciates fine machinery, and has had his own share of knocks in life, too. I know the more you get to know him, the more you'll like him." I assured her of our support, and that, honest Injun, whoever made her happy suited us fine. It was enough of a gift seeing her the happiest she had been in years.

I remember thinking, "She's already lived deeply enough for one lifetime," when I asked about some incidents that had worried me.

"Oh, don't fret, really, but a couple months ago I ran Lance's truck into the barn. Thought I'd help him pull in the tractor, but I didn't anticipate that its weight affected my driving the truck. Anyway, I tried to brake, but couldn't stop in time, so the front bumper went through the other side of the barn. Luckily it didn't hurt me, but I

felt awful about doing it. Lance wasn't too bent out of shape—more concerned for my safety than anything else."

"Lord, Allison, you've got to be careful around this place. You can't expect to always work as his hired hand. Neither of you can count on that, as I see it."

"Well, Mom, sometimes those things just have to be done around here. There's no time to get anyone else, so you just pitch in and do it yourself."

"What else haven't you told me about, sweetheart?" I might have known her most heart-rending accounts involved animals.

"I don't know if you understand, Mom, but dairy cows can sometimes be pretty dumb animals."

"Why, of course, I remember back in Arizona, Daddy milked two cows every day and he used to squirt streams of warm milk right into the cats' faces. They loved it!"

She smiled patiently enough to clue me I had better skip the nostalgia and grasp her real-life existence.

"You know, the emergencies around here have cropped up about two in the morning lately. Last week some weird noises woke us up, so Lance went out to find a calf stuck in the barbed wire fence. Poor thing couldn't go one way or the other for being cut, and Lance saw some coyotes circling around ready to make an early breakfast of him. So he used some wire cutters to free him and herd him back to the barn."

"You didn't go out and help him, did you?"

"Not that time, but I just had to help him a couple weeks ago—nobody else to do it when a cow went into labor for too long. Some instinct got Lance up around midnight to check, and he found her in real trouble rolling around and mooing because the calf wasn't coming out. Anyway, Lance came and got me up, and, as we were looking at her behind, her water broke, gushing out over everything and soaking both of us. What a mess! But the calf still wasn't coming out.

"So I washed my hands and arms, and since they're smaller than Lance's, I had to reach in and try to find out why the calf was blocked. Turns out he was in a breech position coming out butt first and not moving at all. Most births are with the calf's front hooves and head first.

192

"Anyway, Lance said we'd have to hurry so the little guy didn't choke to death on the placenta fluids still in there. Well, I could feel a hind leg folded back and binding the delivery, so Lance told me to pull out the hind legs so they fit under the calf's rump. I finally figured out what to do, and as soon as his little legs stuck out, the mother pushed real hard, we pulled, and out he came—like toothpaste out of a tube. Both of them lived through it, but I tell you, Mom, you've never seen a worse mess in all your life. I'll show you the calf. He's as frisky as can be, and now my favorite, of course."

"God, Allison, that's awful! Is this what it's like living on a farm—getting by from emergency to emergency?"

"No, Mom, really, most of the time it's not like that. You know, going through that experience of helping bring a life into the world, even that little calf, was so wonderful. And seeing that mother licking life into him was a sight I'll never forget. I can see why someone would want to be a veterinarian. I do love it here, you know, and this's where I belong."

"That's wonderful, sweetheart. Takes some people lots longer than you have to find their niche in life." I breathed a quick prayer of thanks that this "niche" was prolonging her life, and, as we talked, I detected a reprise of her life-is-so-precious theme.

"Mom, one thing that really ticks me off up here is the way that some of the stupid macho hunters kill deer, even out of deer hunting season. These jerks drive their trucks around at night looking for deer alongside the road. When they spot one, they shine their headlights on him—they call it "shining"—and the deer just freezes, standing there staring at the lights. Quietly they get out of their trucks, not making any noise that'll make the deer bolt. Then they take aim with their rifles and shoot him. Pretty hard to miss that way! Then they just drive up and load him in the truck. That kind of killing really pisses me off, but Lance doesn't seem to care."

"That's terrible, Allison. I never heard of such a thing. Guess it's like a lot of injustices in this world that we can't do much about. Lord knows you're taking on your share of caring for animals right here on the farm."

I gathered her up in my arms and declared, "I really do love your sharing so much of your life with me, sweetheart, and I'm so proud

of everything you're doing." It felt like Christmas in July listening to all that Allison told me that night.

During the next year, life was beautiful for Allison. Although to me she had been a total individual from birth, now she seemed to be working out her special destiny. Her growing confidence led to earning extra spending money by doing part-time accounting for her friend Patty. Now Ken and I more easily visualized her life on the farm, with the weather furnishing reminders that Allison and Lance could seldom rest. With winter came blizzards, followed by March's mud season, leading to May's torrent of black flies.

Allison's joy in farm life spills over in a letter to Kent:

> Dear Kent,
>
> Well, how are you? I know you're busy these days, but remember, if you ever want to take a vacation, you're always welcome here. We have two extra bedrooms and lots of cats for your liking. Right now there are four calves in the cellar, because we're having so many girl babies there's not enough room in the barn. But we need them.
>
> We've got a new barn that Lance built with trees cut from the property and sawed right at the barn site. He bought a new computer program that's designed to simplify feeding the cows. It's made life a whole lot simpler!
>
> Kent, you really ought to see this place. I know you'd love it, and besides you might as well start considering this as your sister's home because I plan on staying here and making this my life.
>
> And you haven't seen country and back roads until you've spent time in Maine.
>
> I love you.

Allison's birthday that year, February 6, 1988, proved memorable for more reasons than beginning her twenty-fourth year of jam-packed living; on that same day her best friend Dede was married, with Allison her single maid of honor. She felt as overjoyed and nervous as if she, too, had been a bride that day.

Allison had helped Dede in dressing, calmed her frazzled nerves, and carried out the expected maid-of-honor responsibilities, but she also managed to hold up the ceremony. Friends and family were seated and the key players waited in varying degrees of readiness to begin the small at-home service. The flower girls, ring bearer, and best man proceeded down the staircase with all the dignity at their command, destined for the living room where the minister waited in front of a crackling fireplace. Allison made it to the bottom of the staircase and stopped, frozen in place, suddenly remembering her primary role as keeper of the groom's ring. Bride, groom, wedding party, and expectant guests waited while Allison returned to an upstairs bedroom where she had stashed the all-important symbol. She quickly returned, the wedding took place, and the couple lived happily ever after.

The Kindness of Strangers

Happiness is a how, not a what; a talent, not an object.

Collected Letters, I., 1895-1921
—Herman Hesse

I never knew whether the family's attitude toward my extracurricular activities spelled resignation ("Oh, let her have her fun— she's going to anyway.") or admiration ("Isn't it great all Mom does for those students!") But I did know that my priorities—1. the family; 2. teaching school; 3. advising my American Field Service Club—added up to a busier life than we had anticipated. Each year we hosted foreign and domestic students at the house and I chaperoned students in weeklong stays each year around the nation.

This year I had mixed motivation in deciding on the place for a student exchange; out of all fifty states, I chose Maine. We hosted their group in the fall at our school, and now in planning to visit their community, I prayed that I could see Allison, if the Lord would forgive my monstrous manipulation. One night I bit the bullet and called her. Starting with small talk, I finally broached the subject with casualness probably transparent to her.

"Say, Allison, it's time for our AFS'ers to visit the Oxford Hills (Maine) group."

"Oh, when?"

"Well, we're scheduled for April fifteenth until the twenty-first."

"That's great, Mom! Can you come see us, too!"

"Gee, I'd love to, Allison, but Mrs. Williams, the Maine chaperone, and I are the adults in charge, and I'm afraid it'd be hard to get away. They've got lots of stuff planned for us."

"Hmmmm. Too bad."

"Yeah, but I'll tell you what—they're taking us on a shopping trip to L.L. Bean's on Saturday. Is there any way you could get down to Freeport?"

"Sure!"

"How?"

"I'll ask Patty to come with me. She'd love to."

"Oh, that'll be great, Allison! Are you sure you guys can make it?"

"Positive. We'll change off in driving."

"Wonderful. Call her, and let me know as soon as you can."

"Okay, Mom. It'll be good to see you."

"You too, Allison. I love you!"

My days of planning and chaperoning that student exchange were only prologue to the minute I spotted Allison that Saturday morning in Freeport, threading her way through the crowds of shoppers, walking with the help of a sturdy wooden cane. Slightly hunched over, she gauged her steps for sure footing and balance. Our eyes met, and I ran to her, trying to remember to be gentle in hugging her.

"Oh, Allison, how wonderful to see you! Hi, Patty. How're you doing? But, Allison, what's happened? Did you get hurt? Why the cane?"

"Oh, Mom, it's nothing, really. This right leg's been giving me some problems again—something about the circulation. It'll be all right—really it will."

"But, sweetheart, does it hurt? Have you been to a doctor?"

"No, I just thought a cane might help in walking around today. Where d'ya want to go first?"

"You name it, Allison. What can I get for you? What do you need?"

That day Allison improved her penchant for staking out benches, low walls, and shopping displays for sitting and resting when the need arose. My one purchase for her—at L.L. Bean's, for old time's sake—amounted to a pair of work boots that she believed would make life easier on the farm. She confided that maybe they would help her keep up the farm chores and deflect Lance's impatience.

She mentioned that he had been "on my case about not carrying my load like I used to." I bit my tongue hard on that one and instead dredged up images from her childhood years when she had collected sequined dancing slippers.

We skirted around serious matters over lunch, and I knew I had better not break down in front of Patty. But as my deadline neared in turning back into a student chaperone, I blurted out, "Allison, it looks to me like you've lost some weight! Please, please, won't you get yourself to a doctor?"

"I will, Mom. Don't look so tragic. I've had a busy time of it these last few months what with Dede getting married—by the way, she's pregnant, isn't that great?—and the building of the new barn and all."

"I know, I know, but this is about your life and your future, Allison. You want to come back home and be examined?"

"No, Mom. I promise I'll call up Dutch—you remember that doctor in Portland who helped me so much—and see what he says."

I trust the Lord would have forgiven me had I tried to kidnap Allison, scooping her up in my arms to take her home and make her well again. Instead she parented me near the last, assuring me that we would get together again soon and that I really shouldn't cry. Talk about contrast! I had come to Maine a resourceful chaperone of other people's children and climbed aboard the bus in Freeport that afternoon an unstrung mother for reasons that remained incomprehensible to my charges.

True to her promise, Allison consulted a local doctor who confessed to being "perplexed" about her pain, chalked it up to muscle scarring, and suggested she consult a pain clinic. Next she appealed to Dutch who came to the rescue as four years before and referred her to the Dana Farber Cancer Institute in Boston. All this took some getting used to: Allison taking on the sole management of her own case in this way. Then I remembered her talking to me about doctors one time and—as only Allison could do—lumping them into three categories.

She had found that most doctors confine themselves to the here and now. No use trying to trick, cajole, or bamboozle them into speculating about the future. Then she had discovered some doctors willing to explore eventualities and conjecture about the future.

They could anticipate her pointed questions, but ruled out, for example, experimental protocols involving sophisticated drugs. The third type of doctor climbed out on a very long limb, maintaining that ultimately she would win her battle against cancer. Such a doctor made her case his own personal crusade, assuring her that "throwing in the towel" remained out of his realm of possibility.

Probably only God could have led Allison to a doctor who qualified for her third category, and this man, Dr. Lloyd, examined her at the Dana Farber Cancer Institute in Boston. Only fragments of our overnight stay come back to me: the relief of our being in a hotel near the hospital especially designated for patients and loved ones; the stolen ecstasy of our shopping expedition at the Harvard Coop; Allison's report on Dr. Lloyd's initial findings.

Dr. Lloyd seemed to deeply and personally understand rather than minimize or dismiss her pain. He had listened to her with the concentration of his entire personality. For her, their conversations became an answer to prayer and a partial, if temporary, release from the pain itself. In mysterious ways, he had succeeded in validating her very worth and self. Before, she had felt that even Ken and I could not fathom the depth, power, and pervasiveness of her pain. Now, with time, her earlier memories of not being believed by most people when the tumors were as yet undiagnosed were fading.

Soon Allison called us, relaying Dr. Lloyd's findings. The minute I heard her voice over the telephone, I could tell she had good news. I wrote down most of what she said in jumbled notes:

6-19-88

"Everything in the past done correctly—J.B. did the right thing—Dr. L. basically agrees with the surgery done—concerned about pain, so she should go to a pain clinic—overdue for a CT scan—he's found some enlarged uterine cysts—return in a month for findings of their Tumor Board. P.S. She can probably have children!"

Ken and I churned out a letter to friends and relatives relaying the news. Over the years we had learned to gauge within a hair's breadth our emotional tolerance for describing Allison's condition. Sometimes we would stretch the limits of courage to merely mutter, "I can't talk about it right now." At other times we recounted in

monotones and dreamlike state sufficient details to satisfy the questioner. This time we spontaneously declared Allison well—not without pain, but on the way to normal health—and we happily ended with those last five words, "She can probably have children!"

If we three felt peaks of joy and valleys of despair before, both occurred three weeks later, after her next appointment with Dr. Lloyd. As she emerged from the hospital and approached the car that steamy July afternoon, almost eight years to the day after her surgery to remove the cancer, she looked fatigued and still hunched over. I studied her expression as she got into the back seat, loving that trait in her that solved the immediate concern first. Dr. Lloyd had prescribed codeine for her pain. "How much codeine? In what form? What will the effects be? Where do we get it?"

We drove to the nearest pharmacy, and while waiting for the prescription to be filled, Ken and I almost willed the chemicals to circulate throughout her body and bring her release. She remained the calmest of the three of us. On the return trip to Maine, we stopped at an IHOP and reveled in seeing her consume an entire serving of banana pancakes.

But new surprises issued from the back seat when she reported more that the doctor had said. He had found a "mass" causing the pain in the back left part of her stomach and suggested chemotherapy. The frantic side of me inwardly screamed, "Ah ha! That proves it! That damned stuff is coming back in four-year cycles!" while the rational part listened to her practical, steady planning: She would take the treatments at a nearby clinic. Patty would drive her, as Lance could not leave the farm and animals for the time required for chemotherapy. She would be given only four cycles, maximum over four months' time.

And so it went, with Allison's telephone conversations describing the treatments, often with almost scientific precision and thoroughness. It called to my mind that biology had been her favorite subject in high school. At other times, however, she shielded us to the point we could only guess at the reality behind what she did not describe.

Then, in the mail, came a rare picture of her that gave us renewed hope. Lance took the photograph on a gloriously bright afternoon in Boston Harbor, a day that turned out to be one of a kind for several

reasons. One of his friends invited them aboard his boat. Lance actually turned over the farm chores to the hired man. They both were so happy that her expression says it all. We cherished that picture not only that summer but forever after as revealing the essence of her spirit.

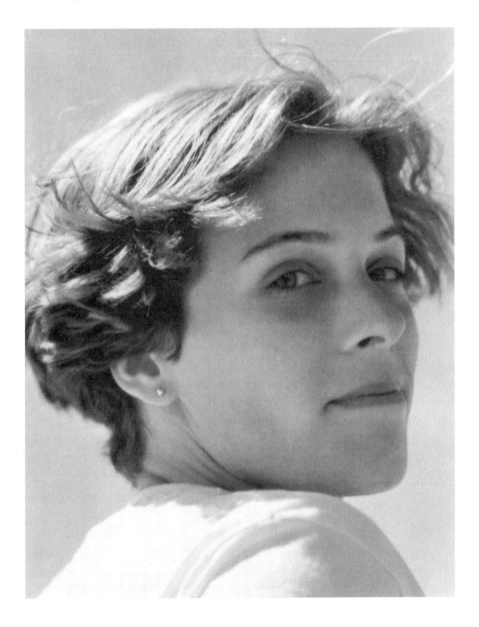

Random Harvest

*Freedom is not worth having if it does not include
the freedom to make mistakes.*

—Mahatma Ghandi

*E*arly that September afternoon, I checked my watch at 4:15,
pleased over having returned all my customer phone calls, and I
decided to give Allison a jingle. She might be in, as Lance had started
his second milking by now. Sure enough, two rings brought her
sweet voice.

"Carson Hill Farm."

"Hi, Allison. It's Dad."

"Hi, Popsie. How're you doing?"

"Fine, Just thought I'd call to say hello and catch up on any news."

"Have you heard from Kent lately?"

"Yes. He's going to school over at Rockland Community College,
has a part-time job, keeps busy with his buddies, and dating differ-
ent girls. Nothing serious though."

"How's Mom?"

I smelled a rat; Allison didn't usually begin our conversations
with this many questions.

"Oh, she's just fine—started back teaching this week."

"She really loves it, doesn't she, Dad."

"Yes, she does, Allison. She sure does. She's so conscientious
about those high school kids—wants them all to learn that English.
But enough said about us. I called to see how you're doing, sweetie."
Maybe now I would find out what she was avoiding.

"I'm feeling great, Dad. Just a little pain in the back, per usual. Doesn't bother me in doing the chores though. I keep it to myself. But Lance just can't seem to realize I've got a problem."

"Why can't he see that you're not a full-time hired hand?"

"I don't know, Dad."

Look out, I said to myself, *before you go negative on their relationship,* a gut feeling I fought hard to hide. Instead I shifted to, "Allison, you look fantastic in that picture you sent us."

"Yeah, that was a great day we had!"

"Must've been." How happy to know they had taken a day off from shoveling cow dung!

"Oh, uh, there's something else, Dad. And please don't get mad," she added sheepishly.

"Don't worry, I won't. What is it?"

"Well, you remember a while back when we talked about smoking marijuana, and I asked if you thought it might help me after chemo?"

"Sure, honey, in July, as I recall." I tried to keep the alarm out of my voice, remembering how awful she had felt after her first two treatments of this regimen. She had asked me about using pot to try to lessen the effects of the nausea. I had agreed with false enthusiasm, but had to bite my tongue to keep from telling her I abhorred the idea of using pot in general. My drug of choice was a double Scotch. Recently I had heard some doctors had found pot helpful in post-chemo recovery. God knows I would not deny her whatever relief she could possibly find.

"I guess you've been using it anyway, Allison," I stated rather than asked.

"Yes, Dad, and it helps, believe me!"

I stifled the urge to ask whether or not she also used it recreationally, and was caught by surprise with her next comment.

"You know, Dad, I even planted a pot seed in my garden this year. It grew into a nice big bush, but two weeks ago the sheriff came by in his car and spotted it. I planted it on the edge of the garden near the road. Maybe not too smart, I admit."

She took such pride in that garden, with its squash, beans, and corn, why wouldn't she grow a healthy cannabis too?

"So what happened then, Allison?"

"Now, understand, Dad, that Lance agreed to my planting it in the first place. Anyway, the officer was friendly enough when he pulled it up, but Lance told him that the garden was strictly my responsibility. So I, not Lance, got a summons and yesterday I had to appear in court before the local judge all by myself.

"When I went in, it's funny, Dad, I wasn't scared a bit. After all, I figured, what've I got to lose? I'd rehearsed my little speech explaining to the judge that I've got cancer and used pot to help counteract the effects of chemo. Thank heavens he was understanding, but he still said that raising it was a no-no, and he warned me never to do that again."

"Gee, Allison, I'm glad it turned out the way it did. Consider yourself fortunate. Some places you'd go straight to jail. You know Lance's one of the good ole boys in the community and his status probably had an influence on the outcome. That's probably why he didn't get the summons himself. My heart goes out to you, sugarplum. The real crime's that you have to take that damned chemo in the first place. If we could only arrest cancer! But I know you're trying hard, honey, and I'm glad you told me about it. If you want to use pot, I've got no problem with it. Goodness knows there's lots of it being grown up there, so you shouldn't have any trouble finding some."

"Oh, I'm glad you feel that way, Dad. I feel better telling you what happened."

"Allison, you know Mom and I are behind you all the way. Whatever it takes to get you well and make you feel better—that's the whole point."

"Thanks again, Dad. Give my love to Mom. Love to you."

"Thank you, honey. Love you too."

"The Heart has its Reasons..."

People change and forget to tell each other.

Toys in the Attic, 1960
—Lillian Hellman

Meanwhile life around Allison and her friend Dede became enriched by the arrival of one small boy. Dede herself tells it best.

> I'll never forget how excited Allison was when I told her I was expecting. She was even present in the labor room, and she stayed there all night with us! Unfortunately, she had to leave at 7:00 A.M. to go to another hospital for chemotherapy. Jamie wasn't born until 11:00 A.M. Allison was disappointed to have missed the actual event, but it was great having her there.

Allison's calm delivery of the next news reminded me of a book she had asked that I send her, Gilda Radner's *It's Always Something!* Another Boston doctor had recommended removal of a cyst on her ovary. After three operations, damaging radiation that had toasted some of her innards, and numerous cycles of chemotherapy, I thought, "Surely, Allison, you've had enough for a lifetime." She assured me there would be no complications, he would survey the "landscape" checking for any possible tumors, and her still persistent pain would subside. In short, we should prepare for surgery the end of May. She would spend some time with Lisa at her apartment in Boston and meet us at the airport.

On the appointed day, I would have treasured more time spent with Allison beforehand rather than the ghastly efficiency of the three of us going from the airport to Brigham and Women's Hospital, but those were her wishes. By now we sized up hospitals

as travel agents rate hotels by their services, ambiance, personnel, and food. One improvement here struck me right off: eight private patient rooms centered around a nurses' station—cozier and more accessible.

Our settling in went smoother this time, as Allison's stay would be, at the most, only two days. We had the TV turned on, Allison nestled into bed with her pet teddy bear, and soon we were all chatting with two charming nurses recently arrived from Ireland. Then came reminders of our immediate purpose: Allison's getting prepared for surgery. The nurse hooked up the IV and asked her to drink two liters of a yucky green solution to clear out her system. She had weathered discomforts before and followed orders with unstinting determination. This time, however, a new note crept into her conversation: she confessed she was afraid. "Afraid of what?" we asked. She certainly had a right to feel that way, but considering all that she had conquered before, this operation should be a breeze.

Shortly after, when a female doctor came in to interview Allison, my secret uneasiness took a roller coaster ride from the top of the summit. The doctor talked on at great length about the forthcoming surgery. Then as Allison signed the required legal release, the doctor offered additional information better left unsaid. In a brief aside, she muttered that if anything went wrong, then Allison could have a colostomy. "What's a colostomy?" Allison demanded. "It's an operation on the colon." "Why—what are the results?" Allison persevered. "Oh, nothing, really," the doctor replied, "they give you a colostomy bag and you go to the bathroom that way." It took all our resources, white lies, and psychological twists to undo those few remarks and calm Allison's active imagination.

I did not like leaving her that night, but remembered one of my motherly bromides that a good night's sleep remedied many problems. With the hefty doses of sedatives given her, Allison began to snooze. I should have remembered that her one hundred-pound frame required much more sedation than most people took. Only later did she confide that she had stayed up for a TV movie whose plot could not have been more inappropriate: one graphic prolonged scene showed a lovely young woman dying.

The next morning we returned to Allison's bedside to see her off to surgery. We walked on each side of her gurney down the hall, up

in the elevator, and as far as the doors announcing "NO ADMITTANCE." Clutching her teddy bear, crying despite herself, and repeating her fears, Allison listened to our assurances that soon the surgery would be over and she would return better than new. Inwardly we wondered why the pre-operative tranquilizers were not doing the job. Fortunately, early that morning Lance had called to wish her well.

Back in her room, we sought that mental set I can best describe as prayerful meditation. I smoothed down the bed sheets and picked up my needlepoint while Ken tried to concentrate on reading. She had left at nine o'clock and we knew we were in for a long wait. Right now this was the place we most wanted to be—as near as we could be to her so as to help pull her through.

In a little over a half an hour, an abnormal stirring in the hall interrupted the quiet. Then we heard intense conversations and unusual activity coming from the nurses' station. Suddenly a nurse rushed into the room announcing, "She's coming back! She's on her way down!" and vanished before we could ask, "But why? How can it be? Is the surgery over? What's happened? What's gone wrong?" Next came Allison being wheeled on a gurney, appearing more dazed than before, but with a slight sheepishness and an expression smacking of guilt. Always out of love for her, we had tried to keep our negative, confused feelings in check. Then, her doctor, still in surgical gown, appeared for a gurney-side consultation: he on one side; we on the other. Even while subject to the gamut of emotions, we empathized with the young doctor in relaying the details with sensitivity and without judgment.

They had done more prepping her for surgery and moved her from gurney to operating table. Nurses, surgeon, assistant surgeon, and anesthetist—all were in readiness. At the moment when the anesthetist had begun to place the mask over her face to administer anesthetic, Allison sat bolt upright, announcing to the doctor, "I don't want to go through with it!" I can only presume that the good doctor had never in his entire career seen such a last-minute change of heart, so he followed his basic instincts and replied, "Okay, then, Allison, we'll not do it." In all the resulting confusion, shock, and alarm, I remember his direct gaze as he said, "It takes the patient's full cooperation for an operation to be a success, you know, and I'll

need that from Allison. She can be discharged today—no need to stay. Call me next week, Allison, and we'll reschedule."

For anyone counting, the tab for that change of heart cost $7,500.

The operation was rescheduled for two weeks later. The second time around, we three stayed together on the night preceding hospitalization, browsed at the Harvard Coop, and savored a fish dinner. Ken and I staved off any déjà vu qualms, and Allison's refusal of surgery did not recur. We proclaimed the results to relatives and friends.

July 13, 1989

Dear loved ones,

We have great news! Allison just went through another operation where there was a distinct fear that cancer had recurred in the area of her female organs. Fortunately, after brief surgery, the doctor found only benign endometriosis on both ovaries, and, although he had to remove one, she appears to be home free, with no signs of the old tumors in the areas he explored.

He's confident that at present she'll do well with a regimen of physical therapy to minimize her pain, stemming from scar tissue due to radiation, chemotherapy, and past surgeries.

The truly "great news" did not percolate in us at the time. In initially announcing, "I don't want to go through with it!" Allison had thumbed her nose at death itself.

I'll tell you, I loved our telephone conversations the next few months when we shared everyday tidbits of living as most mothers and daughters do. I confess to sometimes working around our chats to what concerned me: her relationship with Lance, for instance. I had detected some warning signals such as, "Would you believe, Mom, he calls me his 'poor little rich girl,'" and "I feel like I don't have any of my own things around here, except my clothes and my lap desk. Even though Lance thinks it's strange, I've still got my *Pinkie* picture up in our bedroom." Happy for the pleasure that her cherished copy of Gainsborough's portrait gave her, I still knew, woman-to-woman, that their conflict went deeper.

Allison's fourth operation had added one more scar to her lithe, sturdy body. Lance continued to deny the seriousness of her condition, although she now walked with a decided limp and became less able to help out on the farm. His loyalty was waning, and, despite Allison's trying to shield him from much of her suffering, he could not permit himself the emotional and physical commitment needed in continuing to be with her. Again the time came for Ken and me to rescue her; we waited in the wings to pick up the pieces.

Luckily, Allison, as with most children, had tucked in her memory advice that I had not remembered delivering. She recalled being on the receiving end of one of my lectures on the topic of how to leave a partner, even though "breaking up is hard to do." I had said that if she were ever to decide to leave beyond any turning back, the decision ought to be premeditated, resolutely carried out, and irrevocable. Now, years later, she was processing that information in deciding when and where to go. We suggested returning home, but her heart belonged to Maine.

Fate intervened when Ken overheard a conversation about very sick people under certain circumstances being entitled to Medicaid benefits. We did not know anything about Medicaid, but he suggested Allison give it a try, what with her now being technically destitute. If we resisted such a label, her achieving such status turned out to be not all that simple. Bottom line, Allison did not want to leave Lance, the farm, and the animals, did not want to fill out endless Medicaid questionnaires and forms, and, most of all, did not want to "beg" for help. Eventually, the Medicaid people advised she would be entitled to a monthly stipend and housing. Wonder of wonders, a new apartment complex had just opened up in Unity.

Once Allison decided to move, I credit her with not looking back. Her ubiquitous lists of "Things to Do" gained greater urgency and practicality, as she secured a new roof over her head, made down payments on rent and utilities, and purchased furniture to sit and sleep on—all in one week's time.

The new roof over her head, a ground-floor one-bedroom apartment represented a taste of heaven; the place was as opposite from her former surroundings as her new life was from the old one. Indeed it gave her new life. Reading between the lines of our telephone conversations, I suspected that her zest for cleaning reached

fanatic proportions in contrast to handling the grime and chaos of farm life. Now her days took on an orderliness, a calmness, and an independence she had never known before. She awoke in her sunny new bedroom with a startled, instantaneous, pervasive rush of joy, remembering the source of her happiness: her most precious Apt. 1-C, Unity Family Housing.

One day a letter came from her that made me realize she had discovered a new medicine to extend her life, the responsibility of another mouth to feed:

Dear Mom and Dad,

Hello. It's sunny and warm and beautiful today. I'm out and about getting things done.

Had a great time last night and brought home a stray kitty because a few weeks ago I found out I was allowed to have one. I was going to wait until after visiting you, but I just couldn't. I wanted one so badly, especially for company. It'll do me good.

Love,

Allison.

Gwenifur, as Allison named her, became her alarm clock. Each morning this loving, grateful stray gently walked up her chest, pressing her moist nose against Allison's face. The light pressure never failed to awaken her.

Besides a return to normal health, we knew that one more item would make Allison's life complete: owning a dependable car to drive over the vast distances required in the state of Maine. Although her ancient yellow station wagon had performed double duty on the farm both for pleasure and hauling, its days were numbered. We enticed her to come home with the offer of a new car and she was thrilled. Ken had co-signed for a car for Kent, who was recently out of the Navy, and now she and her brother could compare cars.

Given Allison's definite tastes, I prepared for a grueling selection process while Ken anticipated car shopping with great gusto. His instincts proved truer. After two days of hunting, they narrowed the candidate to either a Plymouth or a Dodge that Ken knew were the same model with different labels. He preferred the muted green

Dodge for its cruise control to ease the stress on Allison's back and leg. But Allison fell in love with the blue four-door Plymouth Sundance, and it was hers.

She gave personhood to that Plymouth Sundance in naming it "Blue" and agreed to test-drive it to Chatham, Massachusetts, so we two could spend a few days together, but not before the family sat for another portrait. This time we were five, including Kent's dog, Beaufort. We gathered on a day ironically more filled with joy than on any of our former portraits

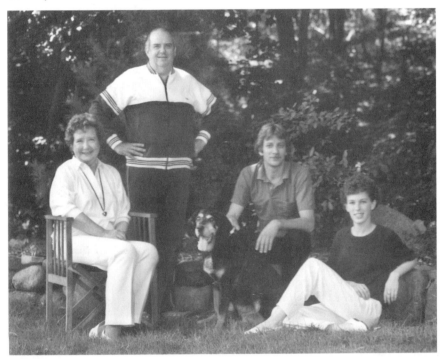

Not only did Blue pass the test, Allison and I passed muster in my coaching her in driving. She grew more confident with each passing hour of the six-hour drive. In Chatham we sought out the old haunts from a decade ago, but her greatest thrill remained Blue. I awoke with a start one morning, sensing her absence, and looked out in the parking lot to find her, car manual in hand, intently studying Blue's engine. She is the only person I have ever known who completely read through and took notes on her new car manual.

Allison yearned to be back in Apt. 1-C, and after careful rehearsals about her return route, she left me at the Boston airport for my

commuter flight home. Rather than reckoning the summer by my three trips to that airport, I mentally accompanied her home: "Now she's putsying north along I-95; she's stopped at the Howard Johnson's in Portsmouth for a bite to eat; she's on the Maine Turnpike, past Augusta, Waterville and finally Unity. She's 'home free'"—a phrase applicable to her in more ways than one. Only later did we reckon that summer by its two rites of passage: Allison's acquiring her first new apartment and her first new car.

"...That Reason Knows Not Of"

*The hardest times have been when it looks as though
nothing is happening or, worse, when it looks as
though something is definitely wrong in my life. 'It's
not working,' I say to myself.*

*Then I remember the scrap pile filled with pieces
of material of those early quilters. Nothing was
wasted. Out came those glorious quilts.*

*I have to keep reminding myself that nothing I am
doing is wasted time. I may not understand or like
what is happening, but I can begin to appreciate that
the impasse is another marker on the way.*

Plain and Simple: A Woman's Journey to the Amish
—Sue Bender

When Allison declared that nothing in her life seemed to be
happening, I reminded her that she had freed herself of the
daily and nightly emergencies of farm life, cultivated many new and
varied friends, and managed her own finances and a new lifestyle for
several months. Former friends returned to the fold: muscular, ener-
getic pioneer woman Kathy whose fun in life was living in a tent;
dainty, intellectual Lisa studying for the law in Boston; Dede, busy
mother but still available to gossip; Willy Kelly, favorite band leader
at the Unity Student Center and one of three men who composed a
song for Allison; Jeff, her upstairs neighbor who wrote:

> I remember one time I was planning on going out to a
> dance club. Being a typical bachelor, I had no idea which
> shirt matched which pants. I asked Allison if she would
> help me coordinate myself. She seemed delighted to. She

213

came up and had me try on a few different things and then picked out my clothes for the evening. I really don't remember what it was that I wore that night, but what I do remember is sharing a good time with a good friend. She lived her life as normally as she could, doing what she was physically able to and accepting the rest.

She was the most open person I've ever met. I think that she knew her time was short, and, as a result, she made sure she got done what she needed to. When we discussed anything, she didn't beat around the bush; she said it like it was and expected the same in return. We spent a lot of time talking. Now that I think back on it, it amazed me that after all she had been through she didn't spend her time feeling sorry for herself. Our conversations were not about how unfair life was to her, as one might expect when talking with someone who is terminally ill. Instead we talked as any two good friends would talk, not necessarily of anything in particular, but just whatever came up at the time.

If Allison again got by on the kindness of strangers, they were legion: the accommodating postmistress, the kindly grocer, the helpful pharmacist, the cooperative bank manager, and the friendly florist. Buster, the apartments' maintenance man, faithfully plowed them out after each snowfall and periodically checked on Allison's safety. Closest of all were the warmhearted waitresses of the Homestead Restaurant, conveniently located down the street, who would one day furnish her much-needed Meals on Wheels.

Trusty Blue helped extend Allison's frontiers in shopping trips to nearby towns and appointments with Dr. Hirsch, now her attending physician in Bangor forty-five miles away. She proclaimed him "the nicest doctor I've ever met" and his oncology unit at Eastern Maine Medical Center (EMMC) "paradise!" She reasoned, "You don't have to see any normal people there—everything's for cancer patients."

Ken and I had no sooner flown to Bangor for a long October weekend than she drove us by EMMC, nestled next to the Penobscot River, and then pointed out the Ronald McDonald House across the street. Gazing at the hospital set off a confusing mixture of both

denial and curiosity in me, and I inwardly railed, *"But, Allison, why're you bringing us here? Let's think about anything but hospitals!"* Fortunately, I politely glanced at the buildings; Allison was preparing us for what lay ahead. Next she showed us another Bangor landmark, Stephen King's eerie Victorian house bordered by a magnificent iron fence decorated with creepy spiders and bats.

Shortly after that weekend visit, Allison's life focused on EMMC in unexpected ways. She had heard that they needed volunteers to work with children with cancer, ones she had easily recognized by their "chemo cuts." She eagerly signed up to serve on Mondays and Wednesdays, and her natural affinity for children resurfaced. I remembered times we had been in supermarkets, for instance, when she had stopped motionless, practically devouring with her eyes a toddler or baby in its mother's arms. In the past, babysitting had been her most satisfying job, and she had often expressed her desire to have her own children.

When the time came to be interviewed at the hospital, Allison over prepared, sensing that the rather daunting supervisor might hesitate in accepting her. The night before the interview, she called us, mulling over what to wear, how she could feel stronger, what creative projects she would suggest, and how to calm her opening night jitters. Allison's eagerness and intensity must have tipped the supervisor's decision in her favor.

On her first morning of volunteering, Allison's uncertainties evaporated as she immersed herself in what appeared to be an ordinary pre-school, but with a difference. For nearly two months, she delighted in telling stories to the children, playing games and doing crafts with them, and lifting them above their tragic plights to function as normally healthy children do. They became her surrogate children; their unity in all being victims of cancer became incidental.

And then they fired Allison. Only the barest of details emerged months later when, with a bittersweet pride, Allison took me on a tour of the rooms where she had so lovingly helped her charges. Apparently the supervisor had noted the close attachments Allison had established with the children, and they with her. This was not to be the rule of the day. Instead, those in charge preferred greater detachment, an impossible requirement for Allison, given their mutual emotional needs. The rationale given Allison was that they

wished to spare her additional emotional pain. For whatever reasons, Allison's work with the young cancer victims at EMMC turned out to be her only and final such effort. She was heartbroken, as were the children. At Christmas, one lad managed to make contact in sending her his handmade card, noting, "Allison, we miss you. Merry Christmas and love, Dan." Take note, Supervisor Ratched. Love is what it's all about!

The following months marked the way to further complications. Dr. Hirsch, at Allison's request, wrote us: "She clearly has a local recurrence with involvement in the right psoas muscle...It was not felt that she has surgically removable disease... I discussed all of this with Allison, and she is quite reluctant to take further chemotherapy, but would be willing to do so if it is strongly recommended. I think she has a good understanding of what is now going on. She knows that she is not curable... She was obviously quite upset with all of this news... I offered to talk to you. She will probably have you call me tomorrow."

When we called, Ken quickly cut to the chase with, "Doctor, no offense intended, but your report is basically an ultimatum. If she doesn't start the chemo, she'll be facing a rapid deterioration. Do I have that right?'

"Yes, that's pretty much the case, Mr. Hall. More surgery or other protocols are out of the question, as I see it."

"Will she show any improvement from the treatment, doctor?"

"Can't really predict. She's shown tumor reduction from past treatments, so we have reason to hope for the same this time. Can't be unrealistic, but right now this chemo is the best we have to offer. By the way, there'll be an additional chemical in the mixture that's designed to cut down on the nausea. Understand, folks, we'll be treating her with very strong chemicals," he added.

Before I could ask about the "very strong chemicals," Dr. Hirsch said, "I hope you two can influence her to take the treatments. Frankly, with no chemo she'll probably have only a couple of months. It's really imperative. I'm sorry, Mr. and Mrs. Hall, but I really must go now. Thank you for your call."

"Thank you, doctor," I squeezed in before he quietly hung up.

We sat there, horrified that this might be Allison's last chance for effective medical help. Here she faced "salvage"—I hated the

term!—chemotherapy, the most aggressive treatment they could administer, and even then there was a slim chance it would cure her. I heard Ken slam down the receiver, screaming, "Fuck this world! God, all she wants to do is live!" Then he went to the kitchen to settle his nerves with a double Scotch. We called her that night, telling her that this chemo really was the only alternative now.

There followed two more weeks while we waited on tenterhooks for Allison's decision while she wisely lived life. Another of Dr. Hirsch's reports pointed the way.

"I had a long discussion with Allison today concerning her illness. We went over chemotherapy and other options. I told her that surgery is not an option at this point. We proposed chemotherapy and she is interested in this. She will need placement of a permanent catheter in her chest inserted directly into her artery enabling the chemicals during chemotherapy to more efficiently enter her blood stream. I will look into arranging for this and for admission following Thanksgiving."

With Allison's next telephone call, I knew she had more than the usual grip on reality when she announced, "Well, it's all set. How about you guys coming up here for Thanksgiving and then I'll go into the hospital on the following Monday?"

"Fine with us. I'll bring up a turkey and all the fixings. How're you feeling?"

"Not that great, but Dr. Hirsch says to keep up with the pain pills. I'll be going in for chemo for about five days in a row every three or four weeks for who knows how long. It's going to lower my blood count, so there's risk of infection."

"What'll you do then, sweetheart?"

"He says if I have a temp. of 100-101, then get to the emergency room pronto."

"Anything we can do?"

"Thanks, Mom, not right now. Bottom line is he told me I'd know by the pain level when I have to get back for more chemo."

Holidays have a remarkable way of regulating our lives, and, despite Allison's forthcoming surgery and chemo, we remember our Thanksgiving celebration in Apt. 1-C above all the others. The tru-

ism applies that it did not matter about the surroundings or the quality of the meal; instead, what counted was that the four of us—Ken, Kent, Allison, and I—were together. Kent had to return to his job Saturday, so we dropped him off at the Bangor Airport.

The weekend whizzed by with Kent taking Allison on visits to her many friends while Ken and I tackled an unexpected task: reconciling medical bills that she had uncharacteristically ignored. For months they had arrived daily from three states at her tiny post office box, along with claim forms from three insurance companies. The total by now had reached what seemed to us astronomical proportions—$12,000. As we neared the end of the paperwork maze, she innocently dropped another bombshell: she would like to briefly see Lance, the farm, and the animals before being hospitalized the next day.

Although Lance and Allison had physically separated, their relationship had not ended. He had telephoned and visited both literally and figuratively with hat in hand on her own turf. His carping tone began to place a postscript on their years together: milk prices had dropped; the co-op had refused last week's milk production; the hired man had quit. The frustration of their meetings echoed the old patterns when Lance yearned to be mothered and comforted in the face of the stings and burdens of his life. She described to me with only mild impatience a person she considered an otherwise strong man now whining. Still she heard him out about how unjust the world had been to him, never mentioning the depth of the genuine injustice she had experienced for nearly half of her life.

That evening as snow began to fall, Ken and I succumbed to that human trait of concentrating on the details of a plan, Allison's farm visit, rather than questioning the wisdom of the plan itself. Since the increasing weakness of her right leg now prevented Allison from driving, we decided to drive Blue to the hospital the next morning while she would go by ambulance to the hospital, returning when the treatments had enabled her to drive again. As a result, Ken begrudgingly deposited Allison at Lance's doorstep for an evening none of us would ever forget.

Back at her apartment with all the medical bills in manageable categories, much to our and her creditors' relief, we called Allison at the farm telling her we were going to the nearest motel twenty miles

away for a good night's sleep. Ken noticed a certain tension in her voice but chalked it up to her usual habit of trying to shield us from worry. We could hear in the background Lance's unusually strident Maine accents. Evidently more than the accustomed quantity of his favorite coffee brandy had heightened his mood. Nonetheless, Allison assured us that he would bring her home, we would see her at EMMC in the morning, and all would go well.

As Ken and I drove through the bleak countryside—Ken, in our car; I, in Blue—we noticed that the snowfall had increased. We checked into the "luxury" motel by the town's standards, but for us it might as well have been the Bates Motel for all our foreboding. Reading by their sixty-watt light bulb, I ticked off the time by half hours (it was now nine o'clock) until we called Allison's apartment to assure ourselves of her safety. No response. Forty-five minutes later, we called again, but still there was no answer.

Then a call to the farm brought Lance's gruff retort, "She's left! She went down the road!" How could she make her way over the five miles to her apartment clothed in the filmy gauze dress and ballerina slippers she had been wearing? Our instincts visualized her in such danger that this means of escape had probably been the lesser of two terrible evils.

Later we learned that Lance had offered to photograph Allison before Dr. Hirsch's knife inserted the catheter, forever scarring her frail chest. Ironically, the photographs of her complete with leather cap covering her tousle of curls more resembled a cyclist's moll than a tempting seductress. The pictures projected emaciation rather than sexuality; the facial expressions, frustration rather than animation. Her eyes seemed to say, "This isn't my real self that you see before you."

What transpired after the picture-taking session can only be left to the imagination; both that evening and ever after, Ken and I did not probe. Suffice it to say, they quarreled.

Either Lance ushered her out or Allison found it intolerable to remain and slammed that rickety porch door on Lance and the farm forever. She had given all the love she could to that relationship.

Luckily, Allison's Heavenly Father, her own father, and the Unity Police Department never shut her out. We frantically called the

police with cries of "missing person" and "domestic violence" tumbling one after another. We fervently begged the soul on the other end of the line to search for Allison somewhere along the Carson Hill Road, warning that he might find either a body struggling to survive or one literally fallen by the wayside.

Time seemed interminable that Sunday night, and our imaginations ran wild. Had Allison strayed from the road into even greater danger? Had Lance pursued her until complete exhaustion brought her down? Or had she decided to spend the night outdoors in the snow in what seemed to her the safest nest, nature itself, with the Maine woods to cradle her?

About thirty minutes later, the policeman discovered Allison in a swirl of snow stumbling down Carson Hill Road. As he approached, she bolted like a frightened animal, and he gave chase, telling her she had done nothing wrong and he only wanted to take her to her apartment. Her resistance waned and turned to embarrassment when she recognized her rescuer as a former Unity College student whom she had often seen on campus. Allison returned to lonely but safe Apt. 1-C, but remained shaken, angry, and terrified, sensing that the night had ended a relationship that nearly proved her undoing.

Crossing her emotional Rubicon freed Allison to fight for her life in a different arena. Although her struggles remained solitary, she allowed us in as closer allies and accepted our love more completely. We no longer felt we were on the sidelines but instead were members of a threesome combating a formidable enemy. Never had Ken and I been quite so relieved to see her resting in a hospital bed as on that Monday morning, November 27, 1989, in Eastern Maine Medical Center, Bangor, Maine.

Houses that Love Built

A cluster of malignant cells is a disorganized autonomous mob of maladjusted adolescents, raging against the society from which it sprang. It is a street gang intent on mayhem. If we cannot help its members grow up, anything we can do to arrest them, remove them from our midst, or induce their demise—anything that accomplishes one of those aims—is praiseworthy

How We Die
—Sherwin B. Nuland

A sign at the main entrance to the EMMC announces to all that "This is a smoke-free environment," a notice generally accepted, but not by Allison. Although I had recently mustered the courage to request a three-week leave from teaching to be with her while Ken returned to New Jersey, I could not ask her to leave her smokes at home. Instead, I studied various nurses' reactions to the unmistakable odor of smoke wafting from the direction of her bathroom. Some stiffened upon getting a whiff of her forbidden pleasure; others studiously ignored the telltale aroma to busy themselves with other responsibilities.

Then one day a nurse won her over with a simply stated bargain. "Okay, Allison, I'll allow you one more cigarette, and then I'd like you to give me the pack for safekeeping until you're discharged." Startled Allison quickly complied, enjoying no more cigarettes until one week later when we returned to her apartment.

Allison's praise of EMMC was justified. Its décor transmitted cheerfulness rather than the usual antiseptic sterility. I took therapeutic walks along wide hallways, some lined with floor-to-ceiling

221

glass opening onto breathtaking views of the Penobscot River. After only a few days, the personnel recognized me and eased the way with such tasks as helping me fix snacks, copy letters, and obtain a 'compassion' fare for Ken to fly up soon.

Before long I poured out my worries to a clone of the earlier Mrs. Dawson, this time young, soft-spoken Ms. Bacon who led me through a worst-case scenario involving Allison's possible disablement as the disease progressed. She outlined much that the future actually brought: visiting nurses, Meals on Wheels, and home helpers making their way to her remote apartment in central Maine.

Other key players in our hospital world left a lasting memory. Kathy, a lanky, no-nonsense nurse, handled Allison's post-operative needs and late one night swept into the room with a take-charge air. I sensed more than the usual purpose as she sized up Allison and me for our usefulness in hastening Allison's progress. We had now accepted the "Hickman line" as a permanent part of Allison's chest, but this appendage did not care for itself. Keeping it sterile required flushing every other day so it would be clear for future chemo.

Kathy began the lesson in changing Allison's dressings and irrigating her Hickman line, complete with sterile kits and surgical gloves. Fine, I thought for nurse Kathy to do, but how could this English teacher practice nursing by merely wanting to? How could I be "on duty" for Allison at exactly the prescribed hour? What if I made a mistake? On the other hand, for her sake, I had better rise to the occasion so she would no longer be poked and prodded by laboratory technicians attempting to locate her unusually tiny veins. Allison still hated needles!

Following her demonstration, Kathy suggested that I give it a try, which I did with trembling hands, a 'moment of truth,' triggering my recollection that Mother had wanted to be a nurse. How could nurses ever do this? I sneaked a glance at Allison whose courage exceeded any of ours. Through my swabbing and injecting, I looked to Kathy for assurance, but she observed my long, manicured nails and said they would have to be cut to manage this responsibility.

As Kathy's lesson wound down, I had to admire two teacherly approaches: she instilled in us the confidence that we would succeed and she assigned homework. She produced additional equipment and written instructions so I would be prepared next time.

Each night I would have to practice the procedure, driving back Kathy's chance comment that should an air bubble enter the line and hence Allison's heart, it could mean trouble.

By the end of the week, Allison became infinitely more adept than I at caring for her strange pendants, placed so as not to show through V necklines or sweaters. With her usual aplomb, she displayed her newfound lifeline to male and female friends alike, who accepted her new ally from medical science.

While the Hickman line became a life-giving apparatus, it also affected Allison's mobility. No more spur-of-the-moment overnights at girlfriends' houses or weekend jaunts to Boston without assembling the needed materials. As most of us calculate changes of clothing for trips, so Allison figured intended days' absences and packed the corresponding number of surgical gloves, alcohol wipes, saline solution, and needles.

Again her insights outdistanced ours in reserving a room for me at the Ronald McDonald House, assuring me of its comfort, safety, and convenience—all for "Suggested donation—$8.00"—and described as "Fourteen bedrooms in home-like surroundings built in 1983 by caring and compassionate individuals. With the exception of House Manager and her husband, staffed entirely by volunteers." Well, after the first night, I thought to myself, I'll politely pack my things and find someplace else. Charity was nice, but for now I certainly was not ready for any more hardship!

As I entered the "House that Love Built," Manager Pat greeted me warmly enough, and I got the impression that, at least outwardly, she ran a business like any "normal" motel. She gave me a key, showed me to my room, gave me a list of rules, and then left. Absolutely the best thing Pat could do was to leave me alone to regroup. Somehow she knew!

Those 'RESPONSIBILITIES OF RONALD MCDONALD HOUSE RESIDENTS," she had left, piqued my curiosity:

1. There is no smoking anywhere in the Ronald McDonald House! Offending residents will be asked to leave immediately.

2. Food donations may be provided from time to time, but normally you are expected to provide your own food.

3. Your room was clean and the beds made up with fresh linen when you arrived. You are expected to leave the room ready for the next guests.

4. If your child is a pediatric oncology patient you may schedule your next visit at this time.

As I drifted off to sleep, images of the artwork and wall hangings in the hallways—even the handmade quilts decorating my room—filtered through my consciousness. Must have been a whole lot of caring put into all that handmade stuff!

Morning arrived soon, and, without food stored in my individual cupboard, I decided to brave the dining room anyway and perhaps scrounge for a cup of coffee and a squint at the paper.

I would carefully choose my own space so as not to talk to anyone and hear her sad story. After all, mine took the cake for sadness! My tensions eased when I saw only Pat in the dining room. Perhaps the other "guests" found, as I would, that the truest solace is being next to your loved one's hospital bed.

Over that week, the "House that Love Built" worked its will on me. It became like home where I felt comfortable enough to watch TV, if concentration permitted, in my robe; phone home late at night; be alone on my own terms; be myself. It sustained me so I could help sustain Allison; it eased the way for her by easing my otherwise chaotic existence. I had not needed escape from the Ronald McDonald House but rather surrender to its enveloping, loving arms.

After discharge and a two-day respite in Allison's apartment, we returned to EMMC to check the success of the Hickman line implant and attend to a high fever she had developed. I checked into Ronald McDonald's; she, into a hospital room overlooking the now icy river and rural scenes worthy of Andrew Wyeth himself. We settled in to await developments. While she caught up on her soap operas, I needlepointed the masterpiece I could no longer keep secret, a Christmas stocking just for Allison. The deal was simple: if I could complete it promptly and beautifully enough, then Allison would live out her normal span of years and show her children what their grandmother had made. At least this comprised my current bargain with God.

Then into the room came a kindly, dignified man dressed in a business suit identifying himself as Dr. Reardon, dentist. Fine, I mused, but who needed a checkup at a time like this! They had said Allison's teeth needed work, but clearly Dr. Reardon's call was above and beyond the usual; dentists stayed in offices and practiced there.

Nevertheless, Dr. Reardon drew out his instruments and began with, "Open wide... Uh. Huh!...Hmmmm!" as he probed the lower left quadrant, asking, "Does it hurt here? Well, okay, we'll have to take care of it. We'll be able to slip you in tomorrow." Fine, I thought, but just leave it alone please. We've got our priorities— more than enough on our plate for now, thank you.

Turned out that dental appointment was top priority. Dr. Hirsch confirmed that Allison would not improve without it. Those teeth with their seemingly insignificant infection were responsible for fever, malaise, and overall lack of response to the chemotherapy. She would be temporarily discharged, taken by me to Dr. Reardon, and quickly spirited back again.

I fretted about how she would physically manage and they said they would furnish a wheelchair. But wasn't there danger? No, not much—you're a careful driver, aren't you, Mrs. Hall? We'll give you directions on how to get there—it's not far away on the outskirts of Bangor. See you tomorrow.

The next morning, I drove Allison, bundled up against the December chill, to Dr. Reardon's. In the past we had received curious, often surreptitious stares in doctors' offices, but they were nothing to those delivered in that waiting room that morning. At least all went well with Dr. Reardon's quick, efficient extraction of one tooth and the root canal of another, so we could declare two trouble spots behind us.

Our return to the security of EMMC contained no detours to the local Burger King or Pizza Hut or any other attraction in the outside world. Never before had a hospital room appeared so welcome, where loving nurses had freshened the bed and plumped the pillows in anticipation of Allison's safe return.

The following days brought Allison's slow improvement and me so many "random acts of kindness and senseless displays of beauty" that my purpose on the periphery of her hospital bed became describing them from the Bangor perspective. The florist had found

some lovely pink (her favorite color) carnations along with a vase we could keep and take back to the apartment. A restaurant down the street had cooked up some great soup, so I'd brought her a cup. I had cruised by Stephen King's today hoping he would put in an appearance, but no luck there. I had taken Blue for a thorough cleaning inside and out, lubrication of her neglected joints, and an early oil change. I had exceeded the parking lot's time limit, but the attendant forgave me.

The high point of each day remained Dr. Hirsch's call. I made mental notes of questions to ask him, especially if I chanced to see him outside of Allison's room. Before long I realized he had more answers than I had unanswerable questions. One morning, instead of concentrating on Allison's condition, he gazed over the panoramic river scene outside our window and commented, "You know, they've sighted some flights of bald eagles on the Penobscot recently. Seen any?" We confessed that we hadn't, but throughout Allison's stay, we spent engrossing hours in unscientific and ulti- mately fruitless searching.

Dr. Schwartz, Dr. Hirsch's associate, also furnished surprises when he drew me aside one day in the hallway. He had noticed that Allison had been reading a book on the lives of certain French Impressionist painters, so from their conversation he had learned her favorite painter was Claude Monet. As coincidence would have it, he had spotted in the local bookstore a beautifully illustrated vol- ume on none other than Claude Monet. I raced to get it for her for Christmas.

We celebrated Allison's discharge with a first stop at Burger King, losing ourselves in the ecstasy of juicy Whoppers slathered with extra cheese, bacon, and onions, salty French fries, and a genuine Coca-Cola. Next we shopped for a set of water glasses, a rack to dry dishes on, and groceries. By the time we reached the outskirts of Bangor, Allison decided to drive, as her leg had strengthened con- siderably. I loved those drives with her. Coming down Main Street in Unity (now "Pop.1200"), I remembered Ken and me joking, "Look! They've closed down Unity! Nobody's home!" Sometimes one could look down Main Street for minutes without seeing a per- son or moving object. And from the solitude of Allison's apartment complex, I easily imagined that we two were its only residents.

That December we blossomed where we were planted, as Allison continued to feel better and I cherished the time spent with her. Once we watched a developing blizzard for nearly twelve hours. The snow began to fall in deceptively gentle ways, with tiny, innocent flakes whispering, "Don't be afraid. We're large in numbers, but no threat so far." They continued for several hours until, peering out of Allison's spacious living room windows, we detected a gradual change. As the afternoon temperature rose, the snowflakes increased both in numbers and size until Allison and I decided to outdo each other in describing them.

"Now, Mom, don't they look just like teensy cotton balls, only smashed flat?"

"Nope, sorry, they're more dense than that—sort of like styrofoam balls."

"No way! Actually it's like we're living in a snow globe!"

The moment seemed like a beautiful dream. With an evening wind, the snowflakes began to swirl sideways. I did not want to worry Allison, but by the time we turned in, I could not see across the parking lot to objects or people ten feet away. She reveled in the scene, remembering, "Takes me back to when we used to have snow days off from school and Dad used to get such a kick out of taking us all shopping!" I admitted that as family traditions go, that was a strange one. We drifted off to sleep, awakening the next morning to the sound of Buster's snowplow.

We also awakened to the fact of December 25th fast approaching. Inwardly I worried about what to *do* about Christmas, especially when Ken and Kent would arrive for the few days they could spend for the holiday. How ironic to recall sermons I had heard on the old material-versus-spiritual theme. Congregations could expect warnings not to overdo, not to rush about, not to become overtired and irritable, and in doing so, miss the real meaning of the season.

Our holiday began with a start, when some of Allison's friends forced through the door a Christmas tree, a rather bedraggled Maine balsam just waiting to be festooned with gaudy ornaments. We had exactly one—a nice bulb with angels I had bought for Allison.

Now thrust back on our own ingenuity, Allison relished a "Little House on the Prairie" solution to a downright naked Christmas tree. Soon unusual busyness emanated from her bedroom: Allison

was turning out quantities of brightly colored origami ornaments—a hobby she had learned as a child from a book. She produced graceful birds, cats, and deer, intricate baskets, multi-faceted balls. Surprises coming from her never ceased. Where had she picked up such artistic flair? Next, she set me to fashioning long garlands of cranberries and popcorn. If Dylan Thomas delighted in his Christmas in Wales and Truman Capote, his in Alabama, we savored the best Christmas ever in cozy Apt. 1-C. By the time Ken and Kent came, we had prepared a respectable turkey dinner. On Christmas morning, we exchanged simple gifts, thankful beyond all expression for one more Christmas spent together.

Had we all shared premonitions as we shared our hope, we might have admitted that present circumstances would not prevail. In one week's time, Allison and Dr. Hirsch resumed their battle stations, and he reported:

> The patient returns for admission for second cycle of chemotherapy. Her CT scan demonstrated no actual diminution in the size of the noted masses. However, there is now a component of necrotic (dead) tissue, hopefully representing a response to chemotherapy.

Following Allison's lead, rather than counting misfortunes, we counted our blessings happening in threes: the chemotherapy was working; Allison was coming home to New Jersey for a visit; and she would celebrate her twenty-sixth birthday with us.

The Enemy

Of all the diseases they treat, cancer is the one that surgeons have given the specific designation of 'The Enemy.'

How We Die
—Sherwin B. Nuland

Ken and I were learning in our heads about cancer even as Allison was teaching our hearts how to deal with it. We had read that cancer cells reproduce in uncontrolled numbers yet are born with a death wish, although many do not "have the decency to die when they should." We clung to that "hopeful" sign that Allison's tumors were dying from within.

That first week of January, my usual career and family juggling act seemed to be faltering. I had long felt guilty about working and not being with Allison full time, although she had made clear her desire to live alone and host us only for visits. Make no mistake about it, I loved to teach and felt duty bound to serve my students with all that was in me. The hope that sometime soon Allison would return home to our care bolstered me, and I solved the immediate dilemma by requesting and receiving another week's leave from school.

In early January in northern Maine, darkness comes early. On her second night of chemotherapy, Allison dozed in her hospital bed, weary of boredom and pain. Tumors had gradually absorbed more of her healthy soft tissues so that pain lurked almost constantly in her right leg and sometimes delivered stabs of reminders to her back and side.

For reasons still mysterious to me, I lingered at Allison's bed. The stillness pervading the entire wing made me aware that when I left through EMMC's front door, I would have to ask the night watchman to let me out. Then Pat at Ronald McDonald's would answer the night bell to let me in. Somehow I could not leave, and neither Allison nor I offered either excuses or reasons for my staying. I nestled down in the Barcalounger at the foot of her bed. In her private room I was not inconveniencing anyone. We both dozed; the 11:00 p.m. shift took over; the night nurse perused the chart just outside the door, satisfied that the chemicals were filtering into Allison's veins according to schedule.

Then Allison uttered a primordial shriek, like screams I had heard from her at two weeks of age and again at sixteen. Pierced by these daggers of sound, I leaped to her side to stanch whatever had attacked her. Pain was stopping her from breathing and she drew up more rigid than I imagined her sinewy body could become. I cried out, "Oh, Allison, oh, my precious Allison, try to hold on. What is it? Let me help!" while pushing the buzzer for the nurse and praying she'd come quickly.

Within a minute, the nurse appeared, sizing up the crisis and noting the contents and pace of the IV. She left for only a short time, returning to suggest an old-fashioned backrub, but having obtained permission to administer more powerful painkillers as well. I wondered why she stroked the exact area where the tumors must be growing, but the massage and soothing oils were alleviating the immediate pain. I gripped Allison's hands in mine, and she returned the tightest clenched fists I'd ever known. Taking some unspoken cue from the nurse that pain and tension go together, I stroked Allison's brow over and over again, telling her how much I loved her. As with most mothers, I prayed that I could take on her pain myself.

As the throbbing continued its course but somewhat lessened in intensity, Allison took deeper breaths that I thought might be helped by the rhythm of a chant. I held her close and whispered in repeated iambs, "I hate this pain! I hate this pain! I hate this pain!" over and over and over. She valiantly tried to breathe in time with me. After a while, although the chant managed to direct our energies outward, I couldn't continue to hate with such ferocity, so kept the meter but varied the words, "Go 'way, you pain! Go 'way, you pain! Go 'way,

you pain!" If that was doing the job, why not pull out all the stops with, "Get out, you shit! Get out, you shit! Get out, you shit!" For probably forty-five minutes the pain came back; I could tell by the terrible darkness of her pupils when it was encroaching. We'd return to the old routine until we could almost command, "Stay 'way, you pain! Stay 'way, you pain! Stay 'way, you pain!"

As the remembered waves of pain and after-soreness slowly subsided, we still gazed at each other as do survivors of combat. I remember the nurse asking, "Can you stay the night?" to which I replied, "Oh, yes, can I please?" after which we fell into a fitful sleep. We awakened several times that night, assuring each other that we were still there and that so far we had faced down "The Enemy."

After four straight days of potent chemicals filtering into Allison's body, followed by twenty-four hours of waiting for any reactions, on the day of discharge, we felt like we were making a jailbreak. After fortifying ourselves at Pizza Hut, Allison steered Blue to the shopping mall while I praised the saints in charge of disabled parking spaces for solving plights such as ours.

I cringed at the sight of Allison's determined hobbling across the street until I realized that she had mentally plotted every step of the way. First, she staked out a low wooden display block providing momentary support. Then she zeroed in on a low wall surrounding a circular fountain where most shoppers rest not out of necessity but to people-watch or await companions. Next came a brief rest on a bench just inside the double doors of the department store.

With remarkable efficiency we reached the millinery department where our luck held out in the form of a cooperative, available salesperson. I followed in Allison's wake, half stunned by and half glorying in her whimsy. Three consecutive $21 charges for headgear may appear frivolous to some people, but to Allison those hats provided nourishment for a parched soul. In fact, these were but three-fifths of the morning's purchases there. She spotted the first three berets (pink angora for femininity; gray wool for casual; black cashmere for glamour) and scooped up two more numbers that I purchased for her on the way out of the store.

Having dispensed with millinery, we descended on cosmetics. What luck! The uncrowded counter had stools to perch on. The

Clinique representative herself suggested soft-pressed eye shadow—sunset mauve just above the lash, with twilight mauve feathering outward. Next came "quick corrector" for circles under the eyes, mauve crystal lip gloss, and pink blush for accentuating Allison's high cheekbones. Allison knew the effect she wished to achieve and consulted us only briefly. If at times the representative stole sideways glances at Allison's scarf, she did not reveal her guess that something was seriously amiss here. Allison's eye for color proved unerring; the makeover worked its magic. With the cosmetics purchased, the shopping spree ended as her energies waned. She relinquished the wheel to me for returning to Unity.

Even before we entered, I could see Allison's individual stamp on Apt. 1-C: the old-fashioned braided doormat, colorful window hanging ornaments, leather beanbag chair, and a new supply of pictures on the refrigerator door. I loved cooking for her, spent considerable time at it, and soon noticed along with the pictures, fortune cookie wisdom, and her calendar, a poem front and center on that refrigerator door. "Lemme read it to you, Mom. It's neat. Your friend Barbara gave it to me last summer."

Priorities
By Marion Conger

> I said I could not go
> to lunch tomorrow,
> pleading a previous engagement
> with a dentist. Everyone accepts
> the importance of dental appointments.
>
> The truth would be
> less acceptable socially.
> It is that tomorrow noon
> the tide will be low
> at Newcomb Hollow.
>
> When it's high, the beach narrows,
> shelves steeply from cliffs to water.
> But the receding sea
> leaves peninsulas to walk upon
> and shallow pools in which to wade.

There may be wind tomorrow
blowing spray off the breakers
and sun making rainbows
in the blown spray.
Or there may be heavy fog.

Whatever the weather
I shall be walking at noon
at Newcomb Hollow.
It took many years
to sort out my priorities.
Having finally done so,
I cannot go to lunch.

I muttered something favorable, vaguely sensing still more insights into Allison's complexity. But when I think of the paramount, most joyous, and most life-sustaining image of Allison and me together, it's the two of us in Blue racing over the Maine countryside—two pioneer women together. Sometimes we had immediate destinations: for medicine, for food, for hospital care. Mostly the spontaneous heart-whole-and-fancy-free trips linger: to Belfast for lobster dinners, to Waterville for lunch with a good friend, to Dede's to check on her son Jamie's progress. Our troubles momentarily vanished; the wind blew in our faces; the journey, not the destination, the process, not the results were our goals. Our best arrangement called for Allison to drive, Allison in charge, Allison working out her destiny.

If God forgave my bargains, I hoped He'd forgive my plotting shamelessly on one of our road trips. These were prime opportunities for talking closely. Once more I tiptoed into the many reasons Allison should leave her apartment, return to New Jersey, and live with us. Her reply came more quickly than usual. "No way, Mom, I want to live by myself. You must understand that I want very much to be on my own. And remember, I'm thinking about coming down for a long visit around the end of the month."

A new kind of despair swept over me, knowing that my practical usefulness would end after settling her into her apartment to resume the lifestyle she so desired. At the airport for my return trip, it had become habitual for me to cry my eyes out. A small voice inside whispered, "Why do you have to blubber all over the place

every time you leave her?" to which I whispered back, "'Cause I hate to leave her! I got my rights too, you know!"

Meanwhile a letter to Ken had assured him of her well being.

Dear Dad,

Well, I got home okay thanks to Mom who made me a big bowl of Campbell's Vegetable. I've had my appetite all along this week. Mom and I are having a great time.

Patty came by this morning and turned up the heat for us here in the apartment, and it's all warm and comfy.

I don't feel nauseous at all, but still a little woozy from the chemo.

I'm reading *Star Magazine*, watching the soaps, and filling my mind with all the trash you can imagine!

Hi to Beaufort and Kent,

Love, Allison

Both Dr. Hirsch and we yielded to Allison's inner time clock determining when she wanted to visit home. When she returned for her birthday, she mandated the extent of the celebration: extra low-key with only the four of us present. This time as we observed the usual rituals, my thoughts reached back to Arizona wondering if or how her birth mother might be commemorating the day.

It had been years, literally years, since Ken and I had mustered the courage to talk about finding Allison's birth mother. In fact, to this day I am not sure we did the right thing, went far enough, or if we would repeat what we soon began. We hoped and prayed that possibly finding her birth mother might have a miraculous healing effect on her, so we finally decided to try.

With studied casualness, I asked her, "Hey, Allison, thought any more about finding your birth mother?"

"Nah, not really, Mom." Was she still trying to protect us from hurt? I'd take another tack.

"Well, there must be a way to do it, like looking her up in the Phoenix phone book."

"Oh, there're too many Sawyers in the book. Tell Dad I love him." She was out the door.

Had we taken Allison at her word, we would have assumed that she had lost interest in the search, but we knew better. Ken and I decided on a plan of action of which the first step was looking up the telephone listings for Sawyer. We then drafted a letter.

To whom it may concern:

This is regarding Baby Sawyer who was born in 1964 in Phoenix, Arizona. She has shown a desire to make contact, if mutually agreeable, with any interested parties.

Time is of the essence, as a terminal illness exists.

If there is interest, please respond to:

Baby Sawyer
9 Hiawatha Trail
Centerville, New Jersey

Next we culled from the list of eighty-nine Sawyers a choice forty-eight names almost as one works a Ouija board, arbitrarily deciding, "Let's concentrate on the ones with female first names." Or "No, strike him—he's too far out of town" or "Yes, she sounds like she's the grandmother." I addressed each one of those forty-eight envelopes as if they were angel couriers making their heavenly way to that young mother who, for twenty-six years, had marked each February sixth in her own personal way.

I fantasized that this forty-four-year-old beauty would welcome our outreach and then our love. At first she would question the arrival of a letter from New Jersey, noting with only mild curiosity the "Love" stamp and blank return address. Upon opening the letter, however, the heart-stopping name of "Baby Sawyer" would leap out at her. (Mistakenly or intentionally, the tiny identification band containing the name "Sawyer" had been left on the baby's wrist.) At the "desire to make contact" part, she would respond with overwhelming gratitude that her precious baby, now an equally lovely young woman, forgave and wanted to meet her. She would read the "if mutually agreeable" phrase responding to our sensitivity in giving her the option of accepting or declining. Then she would as quickly sink into despair and panic over the "terminal illness" news. She would rush to reply with all the courage we knew she possessed from having known the quality of Allison's courage.

After her spontaneous, loving reply, we three would fly out where Allison and her birth mother alone would recount the years and come to understand themselves and each other all the more by meeting. In the future, they would become good friends, encouraging rather than making demands on each other. They would enhance rather than overtake what we had established with Allison through the years.

Two weeks later a letter arrived from a well wisher, not the birth mother, saying, "Good luck and best wishes for your endeavor."

The next reply expressed curiosity in wanting "to know more about this, names, etc. before we can volunteer any more information." Ken called the respondent, suspecting that the woman might possibly want to uncover a family skeleton. So, surmising that mention of the birth date might set off alarm bells in the birth mother or other female relative's head, he inquired, "Does the date of February 6, 1964, mean anything to you?" His hunch proved accurate; she replied, "No."

The final response came from a woman whose voice in a telephone conversation correlated more closely to the birth mother's age of forty-four. She seemed inclined to talk, but a stern male voice in the background squelched her willingness to continue. We never heard from her again.

Months later we told Allison most of the story, which she nonchalantly dismissed as a matter of little importance. Finding her birth mother had gained more magnitude in our hearts than in hers. Or so we thought.

Doing Something Right

*That's what being young is all about. You have the
courage and the daring to think you can make a dif-
ference. You're not prone to measure your energies in
time*

Ruby Dee
I Dream a World, (1989)
—Brian Lanker

I have Allison's spirit of adventure to thank for agreeing to spend
that glorious week known as "Spring Break" with me in Arizona
following her third chemotherapy treatment. I hoped she might
gain a little weight, which she needed. Although she still did not
stand up very straight, she walked better unaided and, all in all, was
feeling much improved. I would keep the tut-tutting to a minimum
about her overextending herself and let her be the judge of how
much we ran around. My journal went something like this:

Day 1—Scottsdale

Good flight and hotel. Allison turns down their terrific
breakfast buffet and I practice keeping my mouth shut.
She mostly wants to listen to tapes and get a tan.

Day 2—Scottsdale

We drive twenty miles north to our very own desert
acres and stroll among the mesquite, palo verde, and iron-
wood trees, while recalling the picnics we once enjoyed
here with Mother and Daddy. Allison hams it up for a pic-
ture, leaning against a century-old prickly saguaro cactus.

Day 3—Sedona

We drive two hours north and feel we know each bend of the road in 'Red Rock Country' where we all spent such carefree times with Mother and Daddy in their creekside cabin here. We hurry to the area where they lived, and climb down to Oak Creek, balancing the terror of encountering rattlesnakes against the exhilaration of wading in the clear mountain stream. We choose the latter. Allison and I feel closer to Mother and Daddy here more than anywhere else on earth. We recall the time Mother's practiced aim with a shovel instantly put away a rattler to protect Allison from its slithering advance among the rocks.

Day 4—Sedona

Allison gets stronger every day, both in body and in spirit. She wears me out shopping!

Day 5—Sedona

It's Easter, and we're dressing in the nearest things to Easter outfits we've brought. Allison warns me, "I'll go to church with you, Mom, but I might not be able to sit that long. Remember, this pain in my side never goes away!"

We approached the Presbyterian church with its artful red flagstone entrance. I followed Allison's determined walk in sunshine so brilliant that I squinted. A row of gray-haired elegantly dressed greeters beamed at us, and I thought to myself that one can read everything in a person's eyes. They momentarily met our glances and then took in my tousled hairdo—why was I born with seven cowlicks?—and Allison's tie-dyed scarf so tightly stretched on her head that they guessed at her baldness.

Head up, Doris. Just keep going. We were late, so the ushers gestured to seats in the front. Why, oh why, must we "stand up for Jesus" there? I looked over at Allison literally standing up as we shared the hymnbook and felt she responded to the music most of all. Why did it invariably get to me—those deep tones from the basses marching down the aisle? Now I couldn't start crying right off the bat!

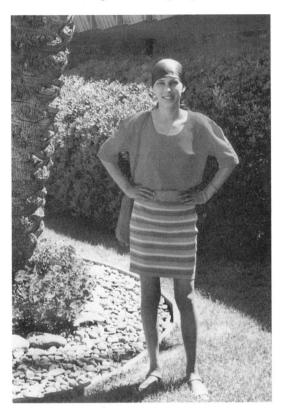

I looked at the cross now stripped of its shroud. Neat symbolism! What classy architecture to place the cross alone against an expanse of clear glass framing even more magnificent red rocks. The rest of that resurrection service passed as if in a dream. I do remember near the end that Allison left the pew to stand by herself in a corner of the foyer.

As I went back to meet her, it came over me that we Halls were living a skewed reality, but that God had given us the love, strength, and understanding to function in it. I made a mental note to keep in closer touch with God. With renewed spirits, Allison and I braved the crowd of Presbyterians savoring the coffee hour. Even with their awkward silences, sidelong glances, and momentary grimaces, we accepted warm welcomes that I knew came from their hearts.

We must leave Sedona. Allison declares that, after Maine, this is where she wants to live.

Days 6 and 7

We persevere in more clothes shopping, and, with admirable thoroughness, Allison chooses fashions and colors far bolder than in the past. She decides on apricot, apple green, and white polka dot cottons—all coordinated with typical artistry. I predict they'll become her favorite ensembles, reminding her of the freedom, health, and vitality of our days in Arizona.

We returned to our separate lives and Allison underwent her fourth cycle of chemotherapy that she had delayed for two months. Afterwards she wrote a letter to herself that cleared her thoughts:

> Because I'm adopted, they (medical records) don't refer to my family's health background. What would it be to find my natural mother? That means every-thing to me. I feel desperate but hopeless in finding her before I die. Just to see what she looks like! See, I have dreams. It's so hard to know I'm probably never going to be married, never have children. All through-out this, I've wanted to meet someone my age in my position. But I never have.
>
> Not until last week when I was in the hospital for another three and one-half days of continuous chemo did I ever share a room with a fellow cancer patient. I was a real puppy and cried a lot to her. She was won-derful to me. We are good people—it certainly hum-bles a person.
>
> Sometimes I think what keeps me going is all the doctors and friends and family believing in me, mar-veling at how strong I am, encouraging me. "Show us more!" My friends and family make me feel real spe-cial and I have to say I'm happy. I have had a good life, but I've got such sadness too. It's like I'm mourn-ing myself. I can't quite grasp it. I want to believe I can keep myself going—just by sheer will. But I know,

I know this is going to get me. It's unbearable at times!

And now that I'm single again—do I get involved? Is that fair? Men find me very attractive—even in my baldness, but why would they set themselves up for grief? I know what love is all about—but people certainly hold themselves back. With all my friends, I am lonely a lot. I feel I'm not getting enough. How can everybody let me live here alone always? But they have their own lives. I get tired of realizing all these things.

I've read all the right books: Simonton's *Getting Well Again* to Bernie Siegel's *Peace, Love, and Healing*. I agree with everything, 'though I persist in doing it my way—without visualization and all that. I must be doing something right, right?

That summer it did not occur to me that Allison's chemotherapy treatments and distractions from them were becoming routine, but the very regularity of those cycles made us squeeze more living into the intervals. After a fifth go-round in late June, Allison drove me through New England to Blue Mountain Lake and our best cabin ever, right on the lake. Had it been an entire decade since that first tentative visit? This time we hiked less and worked more jigsaw puzzles, drove around less and sat on the dock watching the changing hues of the lake, boated less and from our Adirondack chairs on the front porch listened to the call of the loons.

The best month was July, which she spent entirely with us at home in New Jersey.

The summer ended on a bright note when Kent drove up to Maine and took Allison to a *Grateful Dead* concert held in the area. After that reprieve, Dr. Hirsch urged her back for more treatments in August and September. The October treatment prompted a telephone call from Allison to Ken that changed our lives.

Poisons

Listening is being able to be changed by the other person.

—Alan Alda

Gazing out from my home office window that brilliant October afternoon, I feasted my eyes on a forest of maple and oak trees in their full autumn radiance. Their leaves were aflame with brown, gold, orange, and burgundy hues. The scene swept over me, bringing a peace I had seldom felt lately.

At 4:30, a call on the house telephone broke the spell. Hearing Allison's frail voice drained my euphoria, and that knot in my stomach began to tighten again. She sounded as if someone were sitting on her chest; I could tell she was near tears.

"Dad, I'm feeling so awful—worse than ever before. I'm shot! Can't I please stop the treatments?"

Oh, God, I'd forgot. She was back in the hospital for her eighth regimen of intensive chemotherapy.

"Hi, honey," I responded with a tone as lovingly supportive as I could muster.

"Oh, Dad, I'm really having a tough time of it. This stuff's been dripping into me for almost three days now, and I can barely get up, even to go to the bathroom!"

"I can just picture you in that bed, sweetie, feeling like you're in hell. They're going to stop today, aren't they?"

"Yeah, later tonight," she whispered.

"Well, now, you can make it 'til then, honey. You can do it! You're tough, remember?"

"Yeah, I guess so," came her faint reply.

Now's the time for some real fathering, I told myself. This's what fathers are for, even on a bedside telephone.

"Allison, I know it's rough, but you've been through these treatments before, and no matter how bad it gets, you always bounce right back within a few days. You'll do it again this time. Remember, your middle name's 'Resilience.' Besides, everybody so admires that go-get-'em spirit of yours. You inspire all of us, honey, you know that? You really do. And you'll snap back this time too."

God knows she needed all the strength and support we could give her. "Allison, how about coming home right after this treatment so you can recuperate and we can take care of you here? I can get you a plane ticket from Bangor." Why, oh, why wouldn't she come down here for the treatments so we could be at her side through it all? I felt so damned guilty working and not being there for her.

She hesitated momentarily and then, "No, Dad. I'll stay up here. Patty'll give me a ride back to my apartment, and the Homestead will bring me over some Meals on Wheels 'til I'm back on my feet. That new drug they put in the chemo has really helped, so I'm not barfing as much."

"Well, if you think you can get along—at least the doctors say the tumors are shrinking," I added, knowing this was major whistling in the dark. The doctor's findings from the latest CT scan about their shrinking were probably pure speculation. We all knew deep down—but wouldn't discuss or admit to ourselves—that the future appeared bleak, even though Doris and I would never ever convey that fear to Allison or to anyone else for that matter. If we said nothing about death, perhaps it wouldn't take place. We would not give up! Our hope never wavered that the next day would bring prolonged remission or possibly a cure.

"You know, sweetie, you've shown so much courage during these sessions, and now you've only got a couple more to do. The doctors and nurses are all amazed at how well you're getting through the treatments. You just can't give up on them now!"

"I know, the doctors tell me that, too. But the chemo knocks me out so much." Then came a pause and I knew her quick mind had more in store for me. "Dad, could I die from these treatments?"

"Oh, God, no, honey," I shot back.

It dawned on me that she wanted me to be the decision-maker to ease the way for her to discontinue the treatments, so I persisted, "You've just got to carry on and not cop out now, sweetie."

I talked steadily, thinking of every way I could to encourage her to keep on fighting. Couldn't let any triteness or preaching creep in, and, above all, I couldn't give in to my own heartache. My emotions were at the breaking point, with tears swelling, and my voice starting to crack. I had to hold on. Memories of her as my darling, healthy little girl so full of energy and love kept me going.

"You're so strong, sugarplum, the way you've fought your frustration so many times before. Pray to God for extra strength and He'll give it to you. And tomorrow you'll feel much better."

Then I squeaked out a couple of lines from the song *Tomorrow, Tomorrow*. She laughed softly, "Yeah, Dad—*Annie*—I remember when we saw the show!" Probably many of my words hadn't registered, but my love connected.

Then she quietly murmured, "Thanks, Dad, I needed that. I think I feel better already. In another hour they're going to pull the drip. I'm going to make it all right."

"I know you will, honey. You always do. You're the world's most courageous young woman. Allison, please call me tomorrow morning when you're feeling better. Okay?"

"I will, Dad. Thanks for the talk. I love you," she said in a stronger voice, and then, "'Bye," and the phone clicked.

I felt my love connected too, as I slowly laid down the receiver, and the tears I'd held back now came in torrents, followed by uncontrolled sobbing. "Why, God, why?" I again pleaded.

By the time I gained my composure, it was after five o'clock, and I remembered that Doris would be late coming home after her American Field Service meeting at school. Well, I'd just start my cocktail hour without her. After that conversation with Allison, I felt so depressed that I knew a little pick-me-up, a tad of emotional anesthetic would be the answer.

I'd been drinking for over thirty years, but this last year it seemed to be increasing. The drinks were getting stronger: three fingers high over ice, more of them, always straight Scotch; then later, just

fill 'er up to the top. I really savored that smoky flavor of Scotch, though to some people it tasted like medicine. In a sense they were right; it had become my anti-depressant.

The first drink slid right down as I stretched back in my office chair thinking about Allison's plight. A few minutes later I refilled my tumbler while memories of Allison's six years of on-again, off-again battles with chemo resurfaced with full force. I still refused to accept that her type of cancer was basically resistant to all known chemotherapy. The chemo cocktails the doctors were now trying had a new chemical element or two. "Maybe they'll have a positive effect," the doctors had told us. But to me, chemotherapy amounted to an advanced form of torture that was poisoning Allison's system with the intent to kill.

I'd just torn out a newspaper article for Doris to read that said, "In attacking cancer cells, chemotherapy also destroys red blood cells, preventing sufficient oxygen from reaching body tissues. Anemia and subsequent sapping of the patient's strength can result." This was happening to Allison; the strong chemo was bringing her body to a point just above survival. In fact, one doctor had confided in us, "It's a race between which kills the patient first, chemo or cancer." I thought back to Allison's question about dying. That poison had wracked her 95-pound frame for the last three days.

I picked up my glass, and damned if it wasn't empty again. Back to the kitchen to fill 'er up. In returning to the office, I must've bumped the desk because booze spilled over my papers. Mopping up, it occurred to me: you've been doing more and more of this lately—two, three, sometimes four drinks at one sitting. Lookit, you're on your third now, and it hasn't turned you into a happy drunk or even made you tipsy. It's just acted more like a sedative. But that little pool of spilled Scotch on my desk shot down my fantasy that I wasn't tipsy.

Then some heightened awareness triggered another realization: I'll bet you're using booze as a crutch to avoid facing up to reality. Here Allison's dying and you're just drinking more. You're absorbed with self-pity. You wake up at four in the morning with your stomach rolling around like a rowboat in a storm. Remember the other night when you actually saw those beetles coming out of the fireplace? Boy, just like that movie *Lost Weekend*. Was it the DT's or just an overactive imagination? Either way, too close for comfort.

Jesus, then it really hit me! I am one self-indulgent dude, full of selfishness and posturing. Not only that, the booze and God knows what else in me have made me hold back the love and strength my family needs so much. And in the meantime, Allison has to take all those terrible drugs. She's being poisoned to try to cling to life, and I'm poisoning myself to escape real life. I'm pretty mixed up on some fundamental issues here. Allison's the one with the real pain, and she's the one who needs the support.

I looked at my half-empty glass, got up, walked into the kitchen, and poured the remaining drink into the sink. Next I grabbed the remaining bottle of Scotch and started to empty its contents into the drain. Perfect timing. Doris popped in through the kitchen door as the booze gurgled away. Seeing me sending all those dollars down the drain, she asked, "What in the name of time are you doing, Ken?" Her amazement must've brought me to my senses, as I shouted back, "Growing up, dear!" to which she snapped, "Well, it's about time!"

I never drank Scotch again.

When I told Doris about Allison's call, she reverted to a habitual defense in becoming very, very silent when she was sad. I shared with her the miracle that our angel daughter that afternoon had helped pull me back from the abyss of alcohol and that I would regain control of my drinking.

The next morning, feeling more a loving husband and father, I hung around the office waiting for Allison's call.

"Hi, Dad. Just wanted to tell you I'm feeling much better. Oh, and, by the way, I'm going to continue the treatments. Thanks for the pep talk yesterday. I needed that."

"I knew you'd come through, sweetie. Unfortunately, it's got to be. You understand that, and I do too. You'll make it just fine."

"And, you know, Dad, my chemo hangover's not quite as bad as before."

I didn't share with her that my hangover was better, too.

"Why Not Me?"

Nothing is worth more than this day.

Maxims and Reflections, early 19th century
—Goethe

I keep a distinct image of Dr. Hirsch's solemn expression that December night when Ken and I confronted him near the nurses' station in the hallway of EMMC to ask questions we had bottled up for too long. How was Allison doing? What can we (translate: Dr. Hirsch) do next? Can you operate? What does the future hold?

With simplicity and utmost kindness, he replied what doctors, indeed most human beings, must dread saying. Right now she's "holding her own." Surgery would have to be so extensive that she would end up bedridden, so he will continue chemo, even though it did not seem to be shrinking the tumors. Finally he concluded quietly, "You know, there's not much more we can do… It's going to get rough near the end." Mercifully, we were numb to what his words implied.

Over time Allison understood her prognosis with insights only God could have given her. In fact, she wrote about a near-death experience with much less fear than her "cigarette man" dreams had caused. The undated account must have provided release in the absence of a close friend to tell her dreams to.

> I dreamed that I was in my apartment feeling sort of strange, like I was drugged or something. The doorbell rang and my friend Bob Johnson was there. He came to sit down and talk, but I was acting weird while he was trying to talk to me. I leaned up against my bookcase and it fell

over on me, and then all these things were falling off of it onto me. I sort of let myself feel knocked out by it, although I was aware of Bob helping me by pulling things off and making sure I was okay.

When I got up or came to, there was a friend of his there who was trying to talk to me, but I didn't want to listen. Then I noticed Bob had a girlfriend there too. But they all were making so much noise. The other guy got up and started banging on the top of the fallen bookshelf, laughing and really annoying me. I threatened that they all had to leave, but they just laughed.

Then suddenly my girlfriend Dede was sitting there. The others seemed to disappear for the moment. Dede had been at my house that night and left at eleven. I said, "Dede, didn't you leave?" and she said, as if I should have known what she meant, "Well, I got held up by that priest upstairs who always talks to me on my way out."

Then everybody was there again. I got fed up with that guy banging and went to shove him out the door. But, as I was doing so, my phone rang. On the phone (and now I was in a dormitory-like setting), this guy was saying, "Well, I can't say who I am, but there's a cancer meeting happening and you really ought to go. I'm going to be there too. It's very important." I said, "Yes, I read about that, but I'm going to be in New Jersey." He said, "Yes, but you ought to come back up for it. Don't you think it's important to cure yourself and go to this meeting?" By this time I have decided by the voice that it was Bernie Siegel. I got really mad, saying, "But I have survived eleven years. How can you argue that I've not already done what I can?" I got really mad for some reason.

At that point I wanted to try and wake myself up. And I thought I did, because in the next scene I was waking up in my bed and I groped for my cat who was on the bed with me. Although I felt her, I also felt a hand. I was holding onto a hand, and it felt very creepy, so I jumped up, and as I did, instead of flopping back down and landing

on my bed, I kept floating up to my ceiling farther and farther from my bed, and I was looking down on it thinking what's going on. I started to just go with it because it felt sort of fun, but instead of hitting the ceiling, there was none, and suddenly I was floating high in the sky over a dark, illuminated, pretty city. Again I wondered what was going on, and then it occurred to me—well, I wasn't feeling at all well tonight, and I was real warm, like I had a fever—maybe I've died. This must be death. At first, I was curious, but then I panicked, and said this time I better really, really see if I'm sleeping or dreaming, and wake myself up. And, as always happens when I wake myself up, the scene is there and there, and then it sort of explodes.

Well, I was very shaken when I woke up, and I couldn't get over how the last part seemed just like that movie *Flatliners*. I really wondered if I had been dying or something, and, of course, wish I had stayed in the dream to see what would happen next.

Mercifully, we did not know about Allison's dream at the time. Soon she came home to New Jersey with a two-month reprieve from chemo.

Before she left Maine, we began hearing about birthday party preparations that excelled any planning for the holidays. For the first order of business, hiring Willy Kelly's band, she made the call and he agreed: Friday, February 15th at eight o'clock.

Next she mulled over the choice of location. The Unity Student Center? Possibly. The Knights of Columbus Hall? Not available. Of course, the Snowdusters' Clubhouse, long known for its wonderful parties.

By the time she arrived home, plans had reached the shop-for-the-right-dress stage. I accompanied her on this important mission, but, since she had the most success alone, I hovered nearby until needed. She returned in record time, aglow over having discovered an attractive boutique devoted exclusively to eveningwear. We hurried back where the perceptive saleswoman showed us outfits in ascending order of desirability, saving the best for last. It was love at

first sight! A size six black wool, long-sleeved, scoop-necked street length dress with back interest galore! Trimmed in black velvet scallops, the back was open, but ended in a "V" at the waist, culminating in a sassy bow. Matching shoes and her wig with the long curls completed her ensemble.

Kent was home now working and attending a local community college, so we all celebrated the holidays quietly, unaware that this would be our last Christmas with Allison. If the possibility crossed our minds, it proved too heartbreaking to contemplate, so we instead lived in our habitual day-tight compartments.

Allison visited with friends in person and by telephone, mostly resting in the den where she could take in our comings and goings.

For weeks Allison had been revising and expanding her birthday party guest list. She brought with her from Maine supplies for making handmade invitations. Packed among her clothes were notebooks containing multi-colored pages of construction paper, along with jars of sequins, glitter, and glue. For hours, propped on the den sofa and surrounded by supplies, she hand wrote and decorated each invitation, deciding individually which colors and decorations would suit each guest. Her worries about guests' regrets were in vain; the final count came to over eighty celebrants. Her twenty-seventh birthday party would be one to remember! The carefully worded text of the invitations turned out like this:

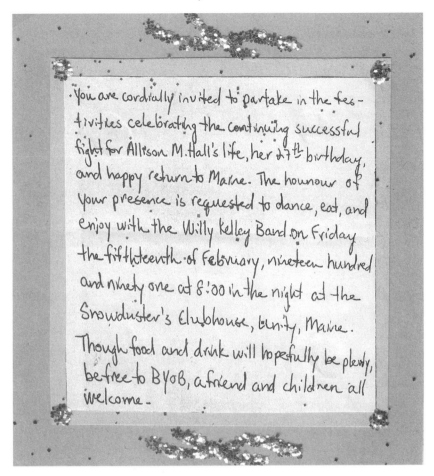

You are cordially invited to partake in the festivities celebrating the continuing successful fight for Allison M. Hall's life, her 27th birthday, and happy return to Maine. The honour of your presence is requested to dance, eat, and enjoy with the Willy Kelley Band on Friday the fiftheenth of February, nineteen hundred and ninety one at 8:00 in the night at the Snowduster's Clubhouse, Unity, Maine. Though food and drink will hopefully be plenty, be free to BYOB, a friend and children all welcome.

All of Allison's friends lucky enough to land an invitation agreed that the party was an outstanding success. Willy Kelly's band played requests and all the old favorites for Allison to dance to as best she could. The invitation's honest wording had set the tone, and guests realized that their hostess had endured beyond anyone they had ever known. At long last she was giving her own party in her own state for her own friends. Even Lance appeared briefly and Kent drove up for the event. A videotape of the party recorded a unique blend of Maine-ers: bearded men in plaid wool shirts, jeans, and boots socializing with sturdy women in their Sunday best. Allison's party even piqued the curiosity of a reporter in Waterville twenty miles away. He decided to call Allison for an interview and his article got to the heart of the matter.

Gerry Boyle

'Why me?
Why not me?'

Like a lot of single people in Central Maine, Allison M. Hall would like to meet somebody nice.

Hall is 27 and lives in Unity. She's very attractive, full of enthusiasm, and wears colorful scarves on her head. She knows tons of people around Unity, including the 75 who showed for her birthday party last month at the Snowdusters clubhouse. But Hall split with a long-time boyfriend more than a year ago and now would like to meet someone else, though she says that someone would have to be very special.

The person would have to be very special because Hall is very sick. And barring a miracle, she isn't going to get better.

Allison Hall has cancer, a rare kind called Leiomyo sarcoma. She's known this since she was 16, growing up in New Jersey, when doctors took a grapefruit-sized tumor out of her back and said she had two to six years left. At 19, she came to Maine to go to Unity College. At 20, the cancer took her right kidney. About a year ago, Hall was told the cancer had spread through her belly.

"They said, 'It's back,' " she said this week. "They said, 'It was always there. I guess you never went into remission. If you don't have chemo, you'll probably only have a couple of months.' That was a year and two months ago."

This was Monday afternoon and Hall, wearing a skirt and orange tights and a purple scarf, said she was feeling pretty good. She'd had the weekend to recover from four days of chemotherapy, her monthly dose at Eastern Maine Medical Center in Bangor. The chemicals, which, at best, are keeping the cancer at bay, are fed into her body through short intravenous tubes inserted in her chest. The tubes stay with her when she comes home to Unity.

For five years, Hall lived with her boyfriend on his dairy farm. Now she lives with her cat in a nice modern apartment. She gets a disability check from Social Security, and spends her days either at home or out visiting friends around Unity. Hall sees a psychologist regularly to talk about her situation, which she flatly described as "pretty awful."

"Do you ever say, 'Why me?' " she was asked.

"No, I never think, 'Why me?' " Hall said. "Sometimes, I think I've had enough pain. I think, 'Why won't this end?' But I do think about it, because I always wanted to get married and I always wanted to have kids and now I'm not going to be able to. But I believe in God and I don't think God's to blame. But it happens to other people, why not me? That's why that 'Why me?' question has always bothered me. Why not me?"

Hall said a couple of things bother her. One is people not knowing whether it's OK to talk about her illness. Another is people who barely know her but feel free to ask about her sickness and then to tell her about cases they've heard about, tell her there's always hope when she knows there isn't.

But the thing that Hall kept coming back to was the fact that she is single and doesn't want to be, not even now, especially not now.

"It's really hard for me to swallow that I'm never going to be married. I'm never going to have kids. All my life, I've had boyfriends. It's just hard to believe that it's over. That doesn't sound desperate, does it?"

Hall said she isn't desperate. The person would have to be very special. But she can't see why someone in her situation should go without that kind of companionship.

"Before you die, you want to find the love of your life, your Prince Charming," Hall said. "I feel like I still have a lot to offer. I don't want to jump into something but . . . somebody to call my boyfriend, somebody steady, a male in my life."

Now, I have to say this isn't what I expected. Someone had told me I should meet Allison Hall because she was strong, beating back cancer with one hand and grabbing for life with the other. I didn't expect someone who not only wants to live what life she has left, but wants to share it with someone else.

But what's so wrong with that?

This is a funny society. We like perfection, or at least the illusion of it. We worship youth, use it to sell cars to the middle-aged, cigarettes to old people. We pat these same old people on the head and don't listen to a thing they say, letting their wisdom fall on deaf ears. On television, in the movies, life in these United States begins at 20 and ends at 35.

"Fortysomething" would never make it to the screen.

But as Allison Hall says, we're all going to die eventually. People who are going to die sooner than that have our sympathy, but not much else.

No, we'd rather not think about it, really. And God forbid that we get involved. What would we say? No, forget it. It would be just too intense to look at those things that are absolutely true.

We don't live forever. Our time with each other is limited, ticking off by the seconds. There are no guarantees. Most things are easier to take if you're not alone.

"Why not me?" Hall says.

It's a good question.

Choices

Job endured everything—until his
friends came to comfort him, then he
grew impatient

Journal, 1849
—Soren Kierkegaard

Who would have guessed that Mr. Boyle's article would have
inspired the telephone calls, letters, and expressions of love
that deluged Allison! If "the shortest distance between a human
being and the truth is a story, "Allison's story tapped a direct line to
the best in many human beings. Some extended gentle lifelines:
"You remind me of my dear wife, not only for your courage and per-
sistence, but for your still hopeful attitude... In the event you'd
sometime like a shoulder to lean or cry on, you are welcome to
phone or write me." Many were deeply affected: "I've been doing a
lot of thinking about you lately. Your story really touched me, so I
wanted to let you know that someone out there heard you."

Two cancer patients showed that they cared, one commenting, "I
hope you do find someone. You sound like a lonely person. Don't
give up." The other included lyrical descriptions of his travels in
Egypt, mixing denial ("I try not to think too much about anything.")
with Islam ("Their Koran says disease is considered a test in this life
by God, so you are touched by God, as I have been chosen also.")
with simple wisdom ("If you say 'Why not me?' it stresses quality
time, so one realizes how best to use it.")

Others who fancied themselves potential Prince Charmings
called, wrote, and sent snapshots of themselves and even of their
houses. One felt "an incredibly strong connection," despite envi-
sioning "dozens of people, including some nice eligible men, all

vying for your attention and offering their support right now," and concluded, "I'm not afraid of you or your disease." Another wrote, "At a time when it would be so easy to just give up and blame everything on God, you haven't. You must be one special lady. When I get down, I remember the trial you are going through, and that tells me to smarten up. So I guess, even though I've never met or talked to you, you have been a great inspiration to me."

Allison's connectedness to these outpourings found expression in random paragraphs she jotted down on the legal pad next to her bed:

> My whole life has been and is full of things to be thankful for. I am rich because I know so many good and interesting people. I am rich because I live in Maine where there are quiet country roads to drive on, forests and mountains every way you turn, beautiful sunsets and rises and Northern Lights. But my illness has denied me just as much. I'll never have children; most definitely never marry; I will not grow old or even see middle age. I'll not know what it's like to be full of energy and in good health. I'll not be everything I could have been.

With equally realistic insight, she wrote about another discovery.

> Maybe I have an idealistic view of friendships. It's sad that we've such a generation of self-centered people that, when we're all filled up with what we need and want, if there's any that spills over, maybe it will spill over on me.

I wondered at the implication when she sent us a puzzling cartoon.

*"O.K., who else has experienced the best-friend
relationship as inadequate?"*

© The New Yorker Collection 1991 Mischa Richter from cartoonbank.com. All Rights Reserved.

Lately she had not sounded like the genuine Allison. Then we heard from Patty:

Allison is okay.

She is not speaking to me, but she basically told me to go away, so I know she was home. I told her to phone you because you were worried.

I love your daughter and am very sorry for your grief. I have truly done my best. Call or fax anytime.

I still was not prepared for the closing off of her other friendships. Most friends found it easier to write than talk directly, and they echoed the same desperate theme.

From Jennifer:

"We've been through so much together, and now that we're both in such need of friendship, we seem to be so far away from each other."

From Marla:

"Whatever happened at the end of our friendship, I'm sorry for. When I can't deal with things, I run away from them and simply don't deal. Anyway, I want you to know that I love you very much and want to see you when you come back to New Jersey."

From Dede:

I hope this isn't the end of our friendship and that you'll remember the good parts of our relationship. We seem to be seeing things differently lately, and I'm sorry if I let you down. I honestly wanted to be a supportive and positive part of your life. I understand your need to remove all bad vibes and the things causing them, but please try to remember how much I care about you and always will.

Two friends outlasted the others. One, Virginia, periodically walked by Allison's apartment window to check on her. Sometimes she would try to signal or talk briefly, but if she saw her asleep, she too could rest knowing that Allison was still coping. Seldom had compromise been forced on Allison as now in maintaining her self-reliance, guarding her waning energies, and saying silent goodbyes to friends.

The second individual, Linda, describes a friendship that enriched them both.

The telephone rang one afternoon and to my surprise I heard Allison's weak but cheerful voice say, "Linda, you're probably wondering why I'm calling you."

"Yes, I am, Allison, but I'm happy to hear from you. What can I do to help?" I knew from other people that her cancer was worse.

Allison got right to the point. "Linda, I've heard that recently you became a born-again Christian. Well, I was wondering if you'd be willing to come over and talk with me about the Bible and what it says about death and the afterlife."

I was so touched that Allison would want to talk about such serious life issues with me, and I wasn't sure that I even knew enough to be able to help her. Anyway, I went

to her apartment and she welcomed me at the door, hugged me, and thanked me for coming over so quickly, confiding,

"Linda, I've been reading the Bible some, and I really want to have someone I know and am comfortable with talk about it with me. I've heard that you're going through your own hell, what with your husband's alcoholism and your separation from him and all."

So I showed her the passage in the book of Isaiah, Chapter 40, Verse 31, that had so changed me and set me free from all the anger and hate that I was feeling. Allison and I read together: "Those who hope in the Lord will renew their strength. They will soar on wings as eagles; they will run and not grow weary; they will walk and not be faint." And then she exclaimed, "I love those words!" And she kept on reading for a while longer.

We kept on talking about other things in the Bible and how they related to our lives, and it all seemed very much to strike near to her heart. When it was time for me to go home, we hugged again, and I told her to call me if she needed anything at all, or if she just wanted to talk.

I admit to some sleepless nights worrying about Allison's brief fling with alternative methods of treatment. She had somewhat loosened up our thinking years before when she gave us the book *Choices* that encourages patients to seek alternative treatment. First she had described an acupuncture procedure that did not diminish her pain. Next she had contacted an astrologer who advised that certain planets were lined up in an unusual scheme. More recently she had begun a macrobiotics diet.

An eleventh-hour network of macrobiotic enthusiasts materialized to teach her about detoxification, Oriental diagnosis, yin and yang, and cravings. They crowded into Apt. 1-C to brew foul-smelling stews in enormous caldrons, sell her cookbooks, and issue earnest instructions on menus. Now the local movement's most exciting disciple, Allison bravely attempted to follow the dull, exotic diet, but soon found that she was not up to cooking much less eating their strange concoctions. Once again the Homestead Restaurant came to the rescue with daily Meals on Wheels.

With Allison's next call, her unerring sense of timing told me she had reached a turning point. I scribbled down what she said: The tumors are growing and the chemo is not working anymore. Dr. Hirsch mentioned some experimental protocols, but she just does not want any more hospital time. He does not know why her pain has changed. And then: "Mom, do you think you could stay next week? I'm scared it's the beginning of the end. I'm down to ninety-one pounds."

I had been waiting for that invitation. Within two days, I managed to get to her bedside, where she had been spending more and more of her time. That first Monday in April could not come too soon when we decided to throw ourselves at Dr. Hirsch to beg for relief.

Little did I know at the time why the scene imprinted itself on my memory. Dr. Hirsch listened intently to Allison, asked few questions, and had already decided on a course of action. With a deeply emotional quality in his expression and a trembling in his voice, he quietly conceded, "Perhaps we'd better start you on a morphine pump, Allison."

With a subtext here we were not grasping, what struck me most was Dr. Hirsch's deference to whether or not we would agree. When I flinched at the word "morphine," he calmed our fears and reassured us that it would not transform sensible Allison into a crazy. As she agreed, he noted that for the record, told us he would set it up, and the meeting ended. We returned home to wait for morning.

The next day, nurse Wanda breezed in and with a practiced eye took in the cozy, neat apartment, the macrobiotic leftovers, Allison's weakened condition, and my probable coping ability. She calmed us with neutral topics—her trip from Bangor, a fondness for cats, the weather forecast—and then got down to business, asking that Allison relate from the first the history of her illness. With typical accuracy and attention to detail, Allison recounted the nearly eleven years, ending with the troubling conclusions, "the chemo was making my heart weak" and "I've already had more than my lifetime dose of radiation." Wanda pursed her lips at that.

Wanda went right to work showing Allison how the battery-operated pump about the size of a small portable radio and a bag of liquid morphine should be worn at her waist. She then hooked

it to the Hickman line still in Allison's chest, demonstrating its adjustable timer that regulated the flow rate of morphine as needed. As Wanda explained how Allison could monitor her pain, decide on giving herself a dose, and call a nurse at any time of the day or night, I felt like shouting, "Let's do it!" She gave Allison the first dose. *Please, God, no more of those overwhelming "waves of pain,"* I silently prayed.

I could feel the tension easing as we all chatted like long lost friends and Wanda looked for signs that her pain was diminishing. The last I remember of the evening were Wanda's parting commands, "Now, Allison, I want you to stay out of bed more starting tomorrow" and "Hey, Allison, now that your mom's here, I want you to start eating better meals!" She had spoken to just the right twosome: Allison prepared to stay out of bed and I prepared to cook.

We reckoned the days of that week by Allison's progress and could report when Wanda returned that the pain was mostly at a "4" level and below, that Allison slept for longer periods at night and awoke refreshed, that we had taken brief forays out, that her appetite had returned, and that once again we had hope. As the dreaded time came for me to leave, we decided to treat ourselves to a movie, dinner, and overnight stay in Bangor. I marked those precious hours with mental notes: look at how she is so active and talkative; thank God she has rediscovered pizza; that pump is helping no end; how can I get her to come home.

The day before, I had rehearsed my plea about her coming home: how we, the doctors, and visiting nurses could take good care of her, how desperately we wanted her home with us, how we would do everything in our power to make her happy. Back came her quiet reply, "No, Mom, I'll be okay just where I am. My place is right here in Maine, and I can manage on my own. I'll let you know when I'm ready to come home."

A week later Linda recalls another telephone call received from Allison who sounded even more weak and tired.

> She said that the morphine was really doing a number on her, and that when I got there I should knock on her door really loud just in case she fell asleep. When I got to her apartment, I did what she asked and banged on the door loudly, but after a couple of minutes, there was still

no answer. So I went to the outside bedroom window and could see that she was asleep on her bed. As I banged on the window repeatedly to no avail, I couldn't help but sense a bit of panic welling up in my heart. She looked so still and thin to me, and I wondered if she had fallen asleep forever.

I ran back to the inside apartment door and started to almost wail on it, feeling the tears in my eyes starting to build. Then I went looking for someone to help me, and found a man who said he had a key and would unlock her door for me. Just then her door flew open and she stood there looking at the two of us with a slightly amused look, saying, "I'm sorry. Did you knock very long?" When I said yes, she half-joked, "You poor thing. You must have thought I was dead." When I admitted to her that the thought had crossed my mind, she really apologized for scaring me like that. Once again, I was amazed at her consideration for my feelings, when all I could think of was how hard it must be at that point for her to even stand up and breathe.

We sat down on her couch and she said she knew that the cancer was consuming her and that she needed to be cared for all the time. She mentioned that not too many people had been coming to see her now—almost as if people had abandoned her when she needed them the most. I told her I knew what that felt like; not too many of my friends came around anymore since I'd separated from my husband. We could only surmise that when a person is lonely, heartbroken, and even suffering, people would just rather avoid you than deal with the reality of what is happening—kind of like the sickness of denial. Maybe it's because they feel too inadequate at saying something to help, but sometimes it's better that no words are even spoken.

I asked Allison if she'd been able to read any more in the Bible, and she said she'd read a little, but fell asleep easily lately. She mentioned that passage that she liked so much in Isaiah: "All the people are like grass, their glory like the

flower of the field. The grass withers and the flower falls, but the word of our God stands forever." I believe she knew that she was that falling flower and that her time on earth was drawing to a close, but she no longer appeared to fear her impending death.

Our visit this time was much shorter because she was so tired. As we said our goodbyes, I told Allison that of all the people I had ever met in my life, she was the bravest one I had known. She was a hero to me. Allison looked at me with that beautiful and mysterious smile on her face and said, "No way, Linda. You are my hero. The trial that you are enduring is much more painful than mine. Mine is drawing to a close, but yours will last your entire life. I admire your courage."

I cried all the way back to my house, not only because I knew I would never see my friend again on this earth, but I cried because I knew that if this world had a lot more people like Allison in it, it wouldn't be such a hard place to live in. Every person needs an Allison for their friend, and I know that heaven is full of them.

By this time Ken and I were candidates for nervous breakdowns. Now in mid-April, Easter was over and my superstitions about calamities occurring around holidays had waned.

Then came Allison's call and her admission in crestfallen tones that the pain had returned and she was having trouble preparing meals. She uttered the words we had waited to hear, "Mom, I'm ready to come home now."

Home

It is utterly natural that we should fear death and everything that begins to become a reminder of death. There are two ways to deal with that fear. The common way is to put it out of our mind, limit our awareness of it, try not to think about it. The smart way is to face death as early as possible. . . For people who learn to do this, the prospect of death becomes a magnificent stimulus for their psychological and spiritual growth. "Since I am going to die anyway," they think, "what's the point of preserving this attachment I have to my silly old self?" And so they set forth on a journey toward selflessness.

Again and again all of the great religions tell us that the path away from narcissism is the path toward meaning in life. And this is their central message: Learn how to die

The Road Less Traveled and Beyond
—M. Scott Peck

Those seven words, "Mom, I'm ready to come home now" prompted my taking the next plane to Bangor. Those same words echoed in my head as Allison's friend Diana drove me to Allison's apartment and as I ran to her arms, letting go my pent-up tears.

The next two days with Allison taught me all over again the lesson for life that love will see you through. Love will see you through when you feel paralyzed inside with grief and fear that you will botch the job of moving your daughter out of her apartment for the

262

last time. Love took over with grace and efficiency as Allison suggested which clothes to pack, where to find a cage for transporting the durable Gwenifur, and that I should clear out the fridge—all in preparation for Allison's going home "for just a little while." Love also helped us shield each other from the reality that Allison was saying goodbye to her beloved Maine forever.

Several friends stopped by. Buster, the apartments' maintenance man who had seen her through blizzards, dead car batteries, and power outages, did not want to see her go. Jeff, the upstairs neighbor, promised to watch over things. Dede gratefully accepted the gift of some of Allison's books and furnishings. Diana, ten years Allison's senior and always ready to help in both personal and practical ways, drove us to the Bangor airport. What a sight it was to see suitcases, cat, and three women crowding into Blue to start the journey.

As we flew over the state of Maine, Allison gazed wistfully out the window, pointing out EMMC, Waterville, and landmarks so familiar after her nearly eight years there. Upon our arrival in Newark, however, two scenes spelled T-R-O-U-B-L-E to me while the world rushed by unaware. The wheelchair requested for Allison was nowhere in sight, so she led the planeful of passengers and me up two flights of stairs to find it at the counter. Next, we retrieved the shaken Gwenifur whose terror-stricken expression told me she had traveled uncomfortably close to the racket of the turbo-prop's engines and hoped that this first flight would be her last.

To ease the way, Dr. Hirsch wrote a letter to Allison's New Jersey doctor that mercifully we did not read at the time.

> Allison is returning home to live with her parents. I believe she will be spending the rest of her life there. Again, she is interested in pursuing further treatment, although she understands her very poor prognosis. I appreciate your seeing her again.

Although I do not recall the exact words, time, or place, we three agreed that Allison would not spend one more night in a hospital; she had experienced enough and too much already in her twenty-seven years. So Ken put together a bed with a sturdy

wooden headboard for pillows to rest on and foam cover over a mattress for her frail body to lie on. He set it up in our den just a few steps from a bathroom, next to the kitchen, and in the center of family activity.

With mixed relief and exhaustion, Allison sank down on the sofa and then slipped into bed while I unpacked her belongings and Ken produced a nightstand complete with a glass of ice chips, flowers fresh from the garden, a telephone, and her beloved legal pad. As my head hit the pillow that night I wanted to yell out, "Thank you, thank you, thank you, God, that finally we're all together again sleeping under one roof. Please, please let her get better!"

In a letter to her friend Willy, Allison confided her thoughts about the transition.

April 30

When my mom got to my place I was so happy and relieved to see her. The first thing I said as I hugged her hello was that I just wanted to get out of there... I'm scared because I'm down to eighty-four pounds, but now that I'm here with my parents, I'm determined to put on some weight. The last couple of days in Unity were hard, and I left without saying goodbye to many, many people.

Meanwhile, nature put on another seasonal spectacular in New Jersey. Never mind shades of green rivaling those of Ireland, tulips and daffodils welcomed Allison home while magnolia and apple trees joined in with their pink sprays. During that first week in May, they provided fitting backdrop for Allison's many activities. In amazement, we saw her disappear out the door to go on shopping expeditions with her friend Marla, followed by lengthy dinners at their local hangout.

Allison's return gave us cause for celebrating, so on the next Saturday night, the eleventh, Don and Birgit whom she had last seen at their Seder, joined us for dinner. Allison, in rare form that night at a game of pool, astounded her opponents, Don and Ken. To make one particularly difficult shot, Allison stood on tiptoe, hoisted one leg onto the edge of the table, and sank two striped balls with

that single shot. That night she went to bed, not to rise again unaided, with one exception.

Subsequent days brought more dependence on nurses with varying degrees of competence and sensitivity, courageous and caring Hospice ladies, morphine monitors learning on the job, and the "relaxation" lady with her supply of audiotapes that Allison valiantly tried to follow. I learned the meaning of 'being there' when loving friends brought food without asking us to explain the unexplainable about Allison. Faithful Marla joined us to watch family movies of Allison's early years in Arizona.

Despite our "No more hospitals!" pact, Allison agreed to go in on two separate days for blood transfusions to give her needed strength. And indeed they did. One lasting memory I sort out from those days came from a nurse, coincidentally also named Doris Marie, who drew me aside saying, "Never give up hope, Doris! Do you understand me? Never give up!"

These days Gwenifur's coping skills were also being tested, especially with our unfortunate timing in having a central air conditioning system installed. She had clearly reached her limits one day as Ken and I sat in the den while Allison apparently dozed. Suddenly Allison raised herself almost out of bed, pointed to the ceiling, and screamed, "Look at that!" We turned to see an upside down devilish-looking furry being peering down at us through a hole in the den ceiling cut for the ductwork. Either Allison was hallucinating or we could almost believe with her that Gwenifur had preceded her to heaven.

Luckily we identified the adventuresome Gwenifur whom Jack, the exasperated air conditioning contractor, had earlier coaxed down from a tree. Life in Gwenifur's new home was taking some getting used to. Later Jack's irritation gave way to sensitivity to what we were all enduring as he prepared to close up all the ductwork and attach the registers. "Now, folks, let's find your cat! I don't want to seal up another one in the ductwork like we did on a job last week!"

I admit to considerable shock when Ken suggested that Allison "get her affairs in order" by writing out her will. But the very act helped her face the inevitable.

May 16, 1991

I, Allison M. Hall, bequeath all things unto said persons upon my passing:

Blue 1989 Plymouth Sundance: Dad
All my books: Dede
Gold sapphire & diamond ring: Mom
All my tapes, Walkman, radio/tape player: Kent
Sofa and tall lamp: Dede
Electric piano: Jennifer
Large and small bookcases: Mom and Dad
Wall hangings, posters, and wreaths: Patty
All my dolls and stuffed animals: Mom
All remaining items: Mom and Dad

As Allison's wisdom had led us almost every step of the way through these eleven years, so the writing of her will told us the end was near. She said as much one afternoon, had I had ears to hear her message. Looking over at me on the sofa, she asked, "Still keeping a stiff upper lip, Mom?" and I merely agreed. How many things I might have said: "Yes, Allison, but now you can go in peace with the assurance that somehow we'll be okay," or "Yes, sweetheart, and my philosophy's not working anymore. It's you who's had the courage all along!" or "I know it's a crazy way to cope, sweetheart, but just remember that you're the most precious thing on earth to us!"

Allison had been away from Maine for over three weeks now that the weekend approached and wanted to reach out by calling her friends there—Willy, Patty, Dede, Jeff, Lance (who was out working)—to say that soon she would be "checking out." Most did not fathom the nuance of her words. With equal purpose and fulfillment, she had a rare and animated final conversation on her last night with Kent when they reminisced about better days—dancing at the Chatham Bandstand, tricking camp counselors into wild goose chases, exploring New York City with special friends.

In moments of lucidness, Allison asked God, "When am I going to go? I wish it would hurry!" even though her physical pain had left by now. But among the memories that crowd in of her last day remains one when Ken and I sat on either side of her bed holding her frail hands. She looked up at us declaring, "You guys really have

loved me!" Numbed with grief and exhaustion, we could only mumble our agreement.

I can still see the exact place in the den where Allison uttered her last words to me. I had been helping her back to bed, but she lingered for a moment, sitting on the stone ledge in front of the fireplace. As she leaned toward me, we faced each other so closely that our noses almost touched. She looked at me so intently as if she were recording my features forever and said, "I love you, Mom. I love you! I love you! I love you!" Her tone was almost tinged with frustration, and well it might have been with death so near. I answered back, "And, Allison, you know I love you and that I always will." After that she fell into a deep sleep, unable to take any food or liquid.

Ken and I were at her side that night still quietly expressing our love to her when, at about 11:15, her breathing became more irregular. At 11:45 she struggled to take her last breath and peacefully expired. Momentarily Gwenifur jumped up on the bed, again walked up on Allison's chest, and gave her a farewell kiss.

More Kindness of Strangers

The souls in the hereafter tell us constantly that love is what survives of our physical bodies on earth, and it is a gift that cannot be taken away. No matter what divides us on the earth, our spiritual bond is permanent and enduring

<div align="right">

Lessons from the Light
—George Anderson

</div>

*E*arly the next Friday morning, both Doris and Kent had fallen asleep as I drove over the Tappan Zee Bridge on our way to Unity. Our purpose: to close up Allison's apartment, but, more importantly, to hold a memorial service so her many friends could say goodbye.

As we entered Connecticut, my thoughts began to review Allison's last hours. Everlasting in my mind will be that last morning when she raised herself from her bed and stood at the end of the room so radiantly beautiful. Then, as quickly, she returned to bed, losing her beauty and regaining her skeletal form. I am certain I was given a glimpse of her spiritual being.

Then I recalled the moments of her passing, with Doris and me holding her hands as she struggled with her final breath. Doris spoke softly, "Ken, she's going," while I just sat there holding her hand. I looked toward the ceiling—as if she were there—as she had described in her near-death experience, thinking, "I know your spirit's still here and you must be looking down at us. I love you, Allison. Please come back!"

Much later, Doris placed her hand on my shoulder, whispering, "You'd best call the funeral man." He arrived shortly and carried her frail body away for cremation.

Still driving in a trance, I recalled last night when I'd called Chris to tell him of her passing. He'd reacted with immediate shock.

"When did she die?"

"Tuesday night, Chris."

"Oh, no! That's the night I had a dream about her. Allison was standing at the top of a driveway wearing only socks, and I was at the bottom of the driveway wearing only socks. We weren't talking—just staring at each other, and she was waving goodbye to me.

"And you know, Mr. Hall, I've felt her presence ever since that night. I got a kind of a 'ding' from her. It was a warm and wonderful feeling.

"Then I woke up early this morning and said to myself, 'Something's wrong. I'm 100 percent sure something's wrong, and I don't know what it is.' I've never had a feeling like this before about anybody. I just had chills running all up and down my spine, and then you called me. Oh, I'm so shocked! I've never had an experience like this before, and I'm so upset with myself.

"Before, Allison and I had talked about me being there to hold her hand when, she, well, when it happened. But, you see, we had this stupid little disagreement—an argument or misunderstanding. I wanted to reconcile with her, but we just weren't communicating then. Oh, I feel so bad! I'll have to live with this for the rest of my life! I know we were made for each other, Mr. Hall. I just can't believe she's gone!"

It took many minutes of conversation before Chris's grief momentarily waned.

I pleaded with him, "You've got no reason, Chris, to have to live with this guilt. Both you and Allison made independent decisions. Each of you chose separate paths in recent years. So please, please don't carry these feelings with you, Chris! With all the confusion of her last days, we just didn't think to call you. I'm sorry."

More missed opportunities, I thought, like another *Romeo and Juliet* tragedy!

Suddenly reawakening to the traffic around me, I found myself passing a car, even as I mused about Chris, "Yes, you'd have made a great son-in-law!"

We arrived at Unity in the late afternoon, and, walking into Allison's apartment, we reeled again at the shock of her absence. We carefully, sadly packed some of her possessions into Blue for Kent to drive home the next morning.

Then came time for Allison's memorial service with organ music, a small choir, a minister's words of solace, and my eulogy.

Allison came to our house four days after she was born; she liked what she saw and she stayed. We were overjoyed!

From the very start she was a parent's dream—even sleeping through the night in less than three week's time. Active, happy, positive, she resembled a sprite who chased the day's cares away.

She was also an individual who "marches to the beat of a different drummer" and at age eleven wrote, "My whole family loves mashed potatoes, but I can't stand them! I feel like an oddball."

At that age she also wrote an essay about being different in which she said, "In the cafeteria I happen to like one of the cafeterians named Nellie. We've never seen each other before, but we've become really good friends, like she always says, 'Thank you,' and I say, 'You're welcome.' And when I'm giving her my money, we stop to talk to each other. People call her a crab and stupid and mean, but I like her very much."

Allison's love of people and her idealism often put her at temporary odds with the world to the point that Doris and I wondered, "Was she too good for this world?"

One of her proudest achievements was her ability to run in track and field where she set new records and one year became 'Most Valuable Player.' But, like a class racehorse, she was forced to accept too large a handicap in her race of life: the three-year-overdue diagnosis of cancer—at the sweet age of sixteen.

Allison was nurtured to love the outdoors and fostered this love at Unity College in Maine, which is geared for people who will be spending much of their careers in the outdoors.

At one time in her life, Allison considered becoming a minister. We feel that she must have listened to that "still small voice within," as revealed in this writing: "I have learned to listen to myself, for when I do, my goals and aspirations become clear. My life has been difficult. Fortunately the experiences I've encountered have enabled me to recognize an inner strength and conviction in my beliefs. Over my twenty-three years I've realized that this recognition is my most valuable asset. I've been happiest and most positive when I've put my faith in my instincts and acted on them accordingly."

With her intuitive understanding both of people and problems, she could get to the heart of challenges and solve them—all but one!

A million times Doris and I have asked, "Why?" The Buddhists teach that existence itself is pain and that man's hope is in escaping from existence through a series of rebirths. Maybe that explains in part eleven years of suffering. However, Christianity isn't that pessimistic. Of course, we experience suffering, but we're also given hope through Jesus' resurrection.

Maybe Allison and a newspaper columnist, Mr. Gerry Boyle of Maine's *Morning Sentinel*, hit on it. In an article written about her in March of this year, Mr. Boyle asked, "Do you ever say, 'Why me?'" "I never used to think, 'Why me?' Allison said. 'Sometimes I think I've had enough pain, and I think, 'Why won't this end?' But now I do think about it because I always wanted to get married and I always wanted to have kids and now I'm not going to be able to. But I believe in God and I don't think God's to blame. But it happens to other people, why not me? That's why that, 'Why me?' question has always bothered me. Why not me?'"

Doris and I offer our philosophy regarding its causation this way: life can be cruel and the plight that attacked Allison's mortal body was probably due to random selection. The devil that Allison confronted was probably a single mutated cell.

During our last days with Allison at home, she struggled to achieve peace but was grateful to be surrounded by the love of family and friends. The wisdom beyond her years that she'd formerly shown seemed to increase all the more. We think she'd like me to say: 'Go and live for today. Give of your love today.'

We'd hoped that Lance would come, but he did not attend the service. The next day, friends came by the apartment to gratefully receive mementos she had willed to them or possessions we chose to give: her bed, her sofa, her bookcase, and a closet-full of clothes. Still it hurt, even though we knew we must relinquish her personal belongings.

Late that afternoon, we closed the door to Apt. 1-C for the last time, dropped off her key at the real estate office, and headed for home.

One hundred and twenty long miles down I-95 and too emotionally exhausted to continue, we spotted a sign to Kennebunkport. We made the turn. A night by the sea might give us a measure of peace. Entering the hotel area, the discouraging "No Vacancy" signs reminded us it was the Memorial Day weekend. But we pulled into the driveway of a big gray hotel, somehow missing their "No Vacancy" sign.

I lingered at the front desk only a few moments to hear the desk clerk say, "We have no rooms available. Sorry." I must have been in such a state of grief that I stood there addressing no one in particular confessing that we'd just come from a memorial weekend for our daughter. The words no sooner left my lips than I headed for the front steps and the car. By the time I reached the bottom step, I heard a man's voice,

"Sir, may I talk with you?"

Overhearing my remark, the hotel manager had urged the clerk, "Go get him!"

As I returned to the top step, he asked, "You say you've just lost a loved one?"

"Yes, our daughter"

"I'm sorry to hear that. Our manager lost a child, and, uh, she overheard you just now. Why don't you come back in, sir, and let's see if we can find you a room."

And he did—a small, odd-shaped, but quiet room with a soothing view of the river leading to the bay. Besides that, he helped us take in our few belongings, including the two large bouquets of flowers we'd kept from Allison's memorial service.

While entering our room, I'd heard voices from down the corridor. After the kind desk clerk left us, tired as I was, I still decided to check out the source of the talking. I went down the corridor, turned into a small hallway, and to my surprise confronted two military automatic rifles leaning against the wall. Next to the opposite wall stood a table piled high with olive drab electronic communication equipment. Two no-nonsense U.S. Marines sat by the table and were kind enough to answer my puzzled look.

"President Bush's in town, sir, and this hotel is the staff headquarters. We're security."

"Thank you, gentlemen," I replied, and I returned to our room. That night we slept sad but secure.

Before leaving the hotel the following morning, we called Lisa in Boston, Allison's roommate during her breaking away phase, whose sentiments amazed us.

"You know, Mr. and Mrs. Hall, I really believe Allison came to instruct us about living. Though she had such a gentle demeanor, her understanding was so advanced—so knowing! When we lived together, her conversations and poetry and writing were so important to me. I'd never experienced anything like that. Sometimes people like Allison who're so advanced come to instruct, and when their work is done, they leave us earlier than others."

After that week, we held a second memorial service at our church where the minister who'd helped Allison in her last days spoke. Debbie, her friend and church school mentor, organized the service and supplied the music. As a professional musician, she played on her guitar Allison's favorites, *Morning Has Broken* and *Amazing Grace*. I shared the eulogy with a heartwarming turnout of friends.

In the days that followed, almost anyone who asked about Allison could prompt more tears. As quickly as they welled up, we'd wipe

them away and concentrate on anything that would stop the flow. But that same flash flow washed away the moment's anxiety, broke the tension, and allowed us to talk normally. Some people noticed; others didn't.

Thank God most people left unasked the question uppermost in their minds: How do you manage to keep your faith through all this? A good offense was the best defense, and we'd lessen the tension and tears by launching into the subject ourselves with the quiet confession, "It's hard to keep the faith." We'd all agree that the passing of one's child remains the greatest tragedy a parent can experience.

One notable exception among the people who questioned us was our old friend Gerry Boyle, newspaperman and friend of Allison, who showed such depth of understanding in a follow-up article entitled *Between Here and Heaven.*

> "'Before you die, you want to find the love of your life, your Prince Charming. I feel like I still have a lot to offer. I don't want to jump into something but... somebody to call my boyfriend, somebody steady, a male in my life." (Allison M. Hall, March 5, 1991)
>
> It was a long shot and Allison Hall knew it, but then she'd been banking on long shots for so long—and winning—that no one could blame her for trying.
>
> Allison never got her boyfriend, though she did get a few phone calls after her thoughts were put in the newspaper, almost three months ago.
>
> But no, Allison didn't find her Prince Charming. In the end, the male in her life was her father, Kenneth. Her father was the "somebody steady," too, along with her mother, Doris. They were at their daughter's bedside when she died, shortly before midnight, May 21.
>
> Three weeks before, Allison had decided that it was time to leave Unity, where she'd lived since coming to Maine at age 19 to go to Unity College.
>
> It was the pain that did it, that made her decide that after a dozen years she could no longer stand up to her illness alone. The cancer was spreading through her

abdomen and the pain was unrelenting. Allison was attached to a morphine pump that she could hit when the agony was more than she could stand. For the last weeks of her life, that was most of the time.

Allison was very tough and very honest and refused to give in to self-pity. She didn't want to be alone with her sickness but she didn't run from it, either.

I'd like to be able to report that, as a reward for her courage, Allison's last weeks were a respite but they weren't.

"It wasn't the movie kind of passing," her father said, "It was like the girl had to be picked on until the last minute....But those who knew her personally found in her an inner beauty, an inner strength... She would have wanted to tell us that we should 'give of our love today' and not wait for tomorrow.

Sometimes we call it love but it's really toughness. The toughness it takes to keep from feeling sorry for yourself and your plight, the toughness it takes to live every day like Allison lived her last years, the strength people need when the world seems to be caving in like some kind of a black hole.

Allison's passing brought home the statistic that cancer or AIDS touches one in four persons in our land. Add to that the accidental and premature death of children, and you can understand how a hell does exist here on earth. We overcame our personal hell when two important people entered our lives. They gave us understanding that turned our tears of sorrow into tears of joy.

"I Would Have Chosen You."

Vast aspects of human behavior are determined by our genes, but much of how that genetic material will be expressed is critically determined by the environment.

—Dr. Jean Roiphe

*F*ive years after Allison's passing, the indelible scent of the Pacific wafted over us from the nearby shore and the sun's rays warmed us that June afternoon in Santa Barbara. The towering palms, magenta bougainvillea, and giant birds of paradise provided a lush backdrop for the start of the twenty-fourth annual Santa Barbara Writers Conference where Ken and I gathered for a week of inspiration and learning.

After renewing friendships at an introductory party, we returned to our room exhilarated. Out of habit, Ken picked up the telephone to take down any messages from home, and, curiously enough, one came from a Phoenix area code. It had been nearly thirty years since we lived there, and I stifled momentary alarm that such a call brought either an energy-draining emergency or opportunity—nothing in between. Ken called the number as one more duty to put behind us.

The caller, Mrs. Scott, introduced herself, inquiring, "Do you remember us, Mr. Hall? We bought your house here twenty-eight years ago."

"Wow! It slipped my mind," he quipped.

"Well, anyway, the other day an attractive fiftyish woman named Frances stopped by the house wondering if we knew how to get in

276

touch with you folks. Says she's your daughter Allison's birth mother and she's been searching for you for eight years!"

The color drained from Ken's face, as he covered the receiver, whispering, "It's about Allison's birth mother!" Ending the conversation as quickly as he could, he promised to call Mrs. Scott as soon as we'd talked it over. He repeated to me everything Mrs. Scott had said, and we clung to each other tighter than we had in months, talking into the night. We puzzled over Frances's asking Mrs. Scott to call, perhaps winning her over with her intensity and the poignancy of her story. We suspected that our first reactions were not necessarily the truest, but Ken's defenses told him that Frances might steal away his reservoir of love and memories of his relationship with Allison. I grieved afresh, knowing that not even Frances could fill the void of the daughter we had lost. Frances's entry into our lives would bring back not only the happiness that Allison gave us but also the agony of losing her. On the other hand, getting to know Frances could turn into an adventure.

To understand our turmoil, remember, if you will, the high points of your life: a marriage proposal, receiving a promotion or coveted award; being told you had failed in school or at work; a pregnancy or childbirth, the death of a loved one. The poet W.H. Auden reminds us that at the same time trauma shakes one person to the core, the rest of the world goes on about its daily routine.

> About suffering they were never wrong.
> The Old Masters: how well they understood
> Its human position: how it takes place
> While someone else is eating or opening a window
> Or just walking dully along.
>
> (Musée des Beaux Arts)

Our "human position" for the next week turned into a dual existence with our inner and outer lives utterly fractured at first, but then slowly integrating. We sought physical release in morning walks and emotional outlets in writing—thousands of words streamed from us intended for each other's eyes only. We probed each other's minds asking: Why had Frances contacted us? Why had she persisted in her search? What did she want from us? What were we willing to grant her? What had God wrought?

But W.H.Auden also wrote, "Even the dreadful martyrdom must run its course," *(Musée des Beaux Arts)* and we knew we must soon respond to Frances. Fearing we would never call back, she had called our home leaving a message confessing her eagerness to talk to us about *"my* daughter."

Still recoiling from the shock of her contact, we bolstered ourselves in remembering that for twenty-seven years we had parented Allison with all the love, wisdom, and courage we were capable of. In a second call to Mrs. Scott, Ken made two promises: 1. Without fail, we would ultimately contact Frances, and 2. Of necessity, this contact would have to be made in our own good time. Within two weeks we wrote to Frances saying we would like to talk, and she replied with a letter ending with seven words of considerable understatement, "I look forward to hearing from you."

Then both Ken and I faced the inevitable, making that telephone call, while we rode roller coasters of emotions but tackled different issues. Ken dreaded reliving our initial anxiety over Allison's adoption, sorrow that he had long repressed. He wanted to shout out, "Understand that she'll always be mine and nobody else's!" At first I steeled myself against the heartache of hearing Allison's soft, feminine tones echoing in Frances's voice. Then my more rational side kicked into gear as I tried to find meaning in France's entry into our lives and to decide the nature versus nurture theory of human influences that not even great thinkers have settled. Mercifully enough, Frances's voice did not echo Allison's, but the similarity of their thinking patterns played havoc with my heart and mind.

Had Allison's spirit overheard that hour-long conversation, she would have been overjoyed at this remarkable reconnection between the two women who gave her life. At long last, two of Allison's life threads were being united. I venture that Allison must have smiled on that first conversation, because we comparative strangers quickly felt mutual trust and began to share long-held intimacies.

Without our asking, Frances satisfied our curiosity in telling us that within a year of Allison's birth, she met and married, eventually bearing three children.

"So Allison had two stepbrothers and a stepsister!" I declared, adding, "You know, when she was nine, Allison drew a picture, fantasizing about her 'real' family." Then I asked a question uppermost

in my mind and, I confess, ambivalent in my heart. "Tell us, Frances, how did you ever manage to find us?"

As Frances spent the next fifteen minutes eagerly recounting the highlights of her long search for us, I knew how Allison had come by her penchant for detail.

"I always knew I'd find Allison. People told me that eventually I'd forget, but I never did. The most important thing I wanted to know was if she was all right and how her life had been. Also, I had many issues of my own to resolve—I guess I needed some validation that I'd done what was best for her.

"Finally, encouraged by some birth organizations and my family, I decided to start the search, first through Mr. Phillips and Dr. Schmidt, but both refused to release any information. Believe me, it took a lot of letter-writing, help from other people, searching through records, and many years. Sometimes my life would get in the way of searching, and I'd have to put certain investigations on hold. And sometimes I just kept hitting dead ends, so I'd stop until I could gather the courage to begin again.

"I guess the biggest breakthrough was getting the non-identifying information from the state giving hers and your names. I'll never forget the day I stumbled across her name in the Social Security Death Index at the Mormon Library, put all the facts together, and found out that she'd died, but didn't know the circumstances."

Our next conversation took place on February sixth, Allison's birthday, and almost before I picked up the telephone, I knew who was calling and why. Frances recounted her years of longing and wondering as that day approached, culminating in what she called her "ritual." Said she'd try to visualize what Allison looked like and what her life was probably like at that moment. Then she'd send mental messages that she loved Allison and was thinking of her.

That did it! I made up my mind that we should meet, and meet we did one month later on a trip to Phoenix.

We chose the corner of a quiet hotel lobby where, fortunately, I spotted Frances first—one of my life's unforgettable moments when memories of Allison came floating back. To me, that turn of head was Allison's while to Ken her petite stature and beauty brought her back. Had anyone observed that first meeting, he'd have thought us

old friends musing over photographs—the birth father resembled James Dean!—and tearing over shared stories.

Frances recalled Duane, the birth father, at the time nineteen and a year older than she, with brown curly hair, sky blue eyes, and 5'6". He traveled the local rodeos and worked just enough so he could make it to the next rodeo. He rode bulls, loving the excitement and danger of it. Her voice trailed off as she confided, "I could have married him, but it wouldn't have worked out... Haven't had any contact with him in all these years... Last I heard he was working as a livestock inspector—he loved animals so."

Then came more information I was little prepared for. Frances's mother, and maternal aunt and uncle were victims of a type of cancer that doctors feel is passed genetically through the family on the mother's side. I could only gaze down at the beautiful, single red rose she had brought me for our first meeting.

"You know," she added, "I've kept a journal for years, and in it is a letter to Allison I'd like to share with you." I mustered the wits to assure her I would treasure the letter.

Dear Allison,

Thank you for coming into my life. I'm proud of you and what you became, and I'm happy that you had the kind of life I wanted for you. I believe I made the right decision for both of us.

I made the decision to place you for adoption myself. It wasn't a snap decision and I worried over it for nearly nine months, trying to do the best thing for you.

I was three months pregnant when my friend Judy took me to her gynecologist for a consultation. I was sure everyone in the waiting room knew I was pregnant with no husband and no wedding ring. It seemed an eternity before the nurse called my name. The doctor examined me, asked me questions and talked to me for a long time. I cried the whole time I was so ashamed. He described how hard it would be for me and for a child. How would I pay for all his charges and the hospital expenses? Who would take care of us when we came home from the hospital? Who would take care of you when I went back to work? He reminded me I'd be up with you at night and

tired the next day, sacrificing my plans for an education and having to work two jobs. When would I spend time with a baby or have much of a social life? Besides, if I did meet someone, chances were slim that he'd accept another man's child. He suggested adoption. He told me I could do the right thing and help two people unable to have children of their own who could give you more than I ever could. I went home to think about it.

I was consumed with thoughts of you and whether I was doing the right thing to give you up. No one suggested that I keep you and raise you myself. When I brought up the subject, all I heard were negatives. Surely I wasn't thinking about what was best for my child and I would be selfish to keep you. I hadn't acted very grown up when I got pregnant, so how responsible could I be? I cried more tears than I ever thought I had. I resolved that I could be strong and that giving you up would be the best for you.

After you were born, a nurse brought you in to me. I was so upset, as my doctor had warned me of this, and, it wasn't until much later that I realized the nurse was only giving me the opportunity to see you. Another time, someone from vital statistics came in and announced, "Congratulations on your little girl!" I was in so much pain and shock from the whole ordeal that I just motioned him out of the room and began crying again.

On the day of my scheduled discharge from the hospital, my mother was there to be with me and to take me home. The attorney arrived and a nurse brought you in the room. I don't remember much about the moments that followed, except that I couldn't look at you and was soon openly crying. My mother dressed you in the clothes your new parents provided. The attorney explained that we would all be in the elevator together and then, after the ride down, he would take you to your new parents. It was the longest elevator ride I've ever been on! You were making little noises and I felt as if I were dying inside. I knew this was final and there was no going back on my decision. The attorney stepped out of the elevator with you and you were gone from me forever.

Frances's last words from our initial meeting remain in my memory and became the ultimate reward of her entry into our lives.

"Let me say this, Mr. and Mrs. Hall. From the information I've gleaned in my search, if I had been able to choose two parents for Allison, I would have chosen you."

Hello Again

I want people to understand that life is everlasting.

George Anderson
We Don't Die
—Joel Martin and Patricia Romanowski

*T*wo years after meeting Allison's birth mother, we found ourselves in that unadorned room with George Anderson. He has continued to discern messages from Allison. Knowing we are taking part in a once-in-a-lifetime experience, we strive to grasp all that Allison is saying through George.

Now George says, *"I see St. Agatha up here. Usually when she appears that means the person has an illness like cancer. It's a symbol for me that your daughter had some form of cancer; apparently it started spreading. Also I keep seeing scenes from the movie "Terms of Endearment," so you know why she's showing it to me—about a young daughter who passes on from a form of cancer. But she keeps telling me she is walking fine. Apparently it affected the leg, but she says she's walking fine and she's back to her old self."*

Oh, thank God, Allison's freed of those years with her leg problem!

She admits she suffered in silence a great deal, more concerned about what you all were going through than what she was enduring.

She's speaking of children and she says she worked with children?

"Yes," I assure him.

"On the earth?"

"Yes," I repeat, remembering all her babysitting jobs.

She says she works with children in the hereafter, and she's telling me to tell you this so you can know that her life is going on as it was here.

Of course, no matter what, you'd still like to have your daughter back, but she knows that as long as you know she's all right and at peace, alive, and going on with her life, it's going to make it a little bit easier for you to deal with. And she says that when you have your bad days, say to yourself,' My daughter is alive, but has moved somewhere else to go on with her life.' She says in this manner she's a lot closer to you than you can imagine!

"*She says she worked with animals, also?*"

"Yes," I hasten to answer.

Yeah, she says—this may not be much comfort to you—but she says she couldn't be in a happier place because she's working with animals and children.

I wonder if your daughter wanted to become a veterinarian or something like that, because she says to me that she's doing the work over there of what we would understand as a veterinarian. That's also to show, to impress you that her life is going on. There was a time when you might think her life was cut out before she got a chance. She got sick and look what happened. But this is her fulfillment.

Oh, that's exactly what she'd have wanted, I mused. She'd told us once that she'd wanted to be a veterinarian. But now George was hearing more details.

She says she particularly works with animals who come over who have died from abuse—like if they've been used in experiments or things like this. Says she helps them find out how to trust and be loved again. She must've been a compassionate soul, particularly to animals. She jokes that she has her own Humane Society over there where she can take care of all the animals she wants and where there's enough room for everybody.

She says that she also works with young children who come over that were abused and this is how you should know she's in a heavenly existence. She's doing exactly what she always wanted to do here on the earth. Since she's fine and back to her old self, there's nothing to stop her. She must have been a busy young lady on earth,

because she claims over there her time is filled with complete love, harmony, and fulfillment.

Suddenly came surprises of a different sort.

She also thanks for the memorial.

"Yes," I said to everyone in general, proud all over again of the Allison M. Hall Welcome Center at Unity College.

And the planting. Two different things.

"The trees," I offered, thinking about the landscaping they'd done around it.

And it seems there's funding with it. Because I see money being exchanged in front of me like in a scholarship or a funding of some sort, and this is what she's talking about.

"Yes," I reply, as Ken and I cast knowing looks at each other about the Allison M. Hall Scholarship Fund we established.

You obviously pray for her, yes?

"Yes," Ken replies.

She thanks you for praying, asks that you please continue, and she doesn't want you to think you were let down in praying for a cure that didn't work out. As your daughter states, it's not that your prayers weren't heard; sometimes God has to say no, because as a part of the soul's personal fulfillment, they can't interfere.

I see Christ coming to you in compassion. Have you prayed to Christ on her behalf?

"Yes," we both reply.

Okay, because I keep seeing Jesus appearing between the two of you, so apparently you've prayed to him on your daughter's behalf. Certainly that's been heard.

Now with the instantaneous shifts of thought we were still trying to fathom, George turned to me, asking, "Have your folks passed on?"

"Yes."

Two people want to be acknowledged because even though your daughter has said all her grandparents are there, your parents haven't acknowledged themselves strongly. And again your daughter is with your parents also—just so you know she's not alone. But pointedly your daughter is very independent.

"Huh!" comes Ken's involuntary cry of affirmation.

She makes friends and has a job in ten minutes. She's the last person you have to worry about adapting anywhere. She kids me, she could go to Mongolia and find a way to fit in. So the thing is, over there, she's fine. If anything, she's more worried from over there about the two of you dealing with her passing than you should be worried about her being okay. She says, 'I should be the least of your worries.' Even when she was on the earth, she seemed like the type of gal who had it all together, and that will not change because of her state. Her physical body died, yes, but you didn't love her body, you loved her, and the essence of her has moved on somewhere else.

She states that you're going to see her again, because eventually you gotta show up there. So she says you have that to look forward to so that when your time as a unique individual is fulfilled here—for whatever purpose—you'll move on, and guess who'll be waiting for you? She says that for you the wait may seem long, but for her it's like you're coming tomorrow because there's no conception of time there.

She also says she hopes that her messages will bring comfort to you, that the two of you can go home and have a good night's rest with your minds at peace about her.

She had siblings?

"Yes," I volunteered, glad that maybe she might be greeting Kent, but still unprepared for more that was to come.

Why does she say there are two? Counting her, you have two children? Or no, there's more. Don't say anything—let her straighten it out if I've done something wrong. Wait a minute. She speaks about another loss. Did you lose two children?

"I had a miscarriage," I confided with hardly enough time for those memories to resurface before George reported,

Yes, I think you would have had a girl. She speaks about having a sister in the hereafter who continues the cycle of birth there, so maybe that's why she's telling me there's two. But she does have siblings on the earth, yes?

"Yes."

She's calling out. 'Tell them they've heard from me.' She also congratulates—it feels like a brother—him on some kind of happy news

because your daughter extends white roses to mean congratulations. She tells me he's graduating, but she may mean graduating up in career, because I don't feel it's a cap and gown graduation.

"Yes," was all I responded, but so pleased that she knew about Kent's receiving his Journeyman's rating in the electrical union.

Also a name Julie?

"Yes." I was shocked that Allison would be calling out to Kent's wife Julie whom she had never met.

Apparently your daughter knows her from the hereafter, although they never met on earth, and she realizes she's her sister-in-law. And she's aware that she's an aunt because she speaks about knowing the child or children. One was named in her memory?

"Yes." How proud I was that they had named our first granddaughter Elizabeth Marie after Allison Marie.

She says she's aware that she's been reborn in the sense of the name. She extends thanksgiving to her brother and sister-in-law for naming the child in her memory because she claims she's around the child as a guardian angel. That makes the link of 'I should be there for her.'

Is there also a Debbie? Anybody your daughter would have known?

"Yes," I reply, so glad for her calling out to her church mentor Debbie who had organized her funeral service.

Yeah, Debbie was a friend of hers and she calls out to her in appreciation. Then she shows me a tremendous show-up at her funeral and wake, so this is somebody who paid her respects. You know, it may have been something that just came into her head that she called out to, even if it wasn't someone uniquely close.

Is there a Katherine? Is there a Kathy living?

"Yes!" It's our other granddaughter!

So your daughter would know her from over there?

"Yes."

And, again, she's connected with family.

Are you devout with Christ?" George asks Ken.

"Yes."

Yeah, because he keeps appearing behind you. This is the third time I've seen him, and I wanted to keep abreast of everything I'm seeing. And, as a Christian, you've prayed to Christ a great deal for your daughter. You've consecrated her to Christ, and she says she's with the Lord in the hereafter... But Jesus is also appearing to you to let you know that he didn't let you down, because you probably were praying to him on your daughter's behalf, and again it's a ful-fillment of her soul's growth.

Even as the Son of God, he can't interfere. Like your daughter says, you don't like somebody telling you what to do in your life, so they don't do it from over there either. They let us find our own way, even if it's a difficult path, as we see it.

I heard the name Daniel, and then he kinda disappeared. Does that mean anything?

"My father's father!" I blurted out.

Don't say anything. Just say 'Yes' if you can. I feel better if I tell you. But, in any case, somebody came into the room and said, 'This is Daniel.' That would be your daughter's great grandfather, because she says she's met him in the hereafter. Somebody started singing "Danny Boy" in the room and then they told me to just say 'Daniel,' so apparently he's there as well, because she's met people who have gone over from the generations before... Your daughter lost pets too, yes?

"Yes," I replied, remembering Ben and Fella, the dogs she'd loved so much.

Because she says that the pets she lost are there with her, and she claims that the pets that went on before her welcomed her into the light when she passed on. Because she says she goes over in sleep. Is that true?

"Yes."

She's in a sleep or coma-like state, because she says that the ani-mals woke her up and brought her into the light, so that she knew she was going to a good and happy place. I see St. Joseph appear in the room, and in Catholicism he's the patron saint of departed souls and of a happy death, which shows that your daughter has a happy, peaceful transition into the hereafter.

She says she knows you were there. Were you with her when she passed on? Yeah, 'cause she says that even though she couldn't communicate—she was out of it or in a coma—but she knows you were there, she knows you were holding her hand, she knows you were talking to her, and that she just released. She knows how much you love her, and she loves you. Your telling her how much you love her was like letting her go. She says 'I heard that.' Even though she couldn't communicate back from the physical body, she's communicating it back from here... Someone named Chris?

"Yes." Her first love—how wonderful!

Passed on?

"No."

Your daughter knows? I don't know if it's a guy or a gal... She says it's a guy."

"It is."

So she calls to Chris. 'Tell Chris you heard from me.' She had a lot of friends, yes?

"Yes."

Yeah, because she keeps calling out to her friends in general. I mean, I'd be here all night to get their names. And again so many of her friends have paid respect to her since she passed on—in prayer, in memory, in plantings, and things like this. You can certainly see that she had a fulfilling life here on the earth—that she left her mark here... I also hear the names Lillian or Aunt Lily and Ben and Helen that seem to be more with you this time, Ken. This is all to let you know your daughter's in good company, because this Lillian says that your loss is their gain.

I can see Ken's amazement at the mention of two of his aunts and his grandfather.

Have a little trouble with your back, Ken?

"Yes."

I don't think I'm telling you anything you don't already know, but your daughter's telling you to keep alert to your back.

Ken had just started physical therapy for his back.

You're working still, Doris?

"Yes." I'd started writing a book three years ago.

Yes, she's glad you do, because it's a little on the therapeutic side for you. Because both of you do suffer in silence over the passing. But, as Allison says, it's good that you have your faith. You're more spiritual people than you are religious. It's your spirituality—I see an anchor in front of you—it's the anchor of spirituality that's keeping you going. And, as she says, your daughter was spiritual in her own way. Each of us is a unique individual on his own spiritual odyssey.

She says at times like Christmas when you really miss her, that's when she's the closest. And, she says, think back to this day, so you'll always know she's near. So, she says, when you have your bad days, think back to today, remembering that Allison is very happy in the hereafter. That's your first priority as her parents.

Sometimes, as your daughter says, since you suffer in silence, people may misunderstand that, but they wouldn't trade places with you. So, she says, you deal with it in the way that's right for you. You know that it's between you and her... Quiet all of a sudden... Also, there's an Alfred passed on?

"Yes," amazed all over again that Daddy's brother had appeared.

Somebody just walked into the room and told me their name was Al, and I said, 'Wait a minute, are you Allison again?" and he said, 'No, I'm Alfred.' He's family too?"

"Yes."

He joked that 'He's with the Al's in the hereafter.' Obviously, your daughter, but he's calling out to both of you that this is Alfred... And also an Edward?"

"Yes." It's Daddy himself!

He just walked into the room too. I thought they were going to close me off, and now all of a sudden two more people walk in. So Alfred and Ed—Edward—is here also. They claim they are with your daughter as well. And your daughter is saying you have to take care of yourself, because both of you are still here for a purpose. This is a difficult cross to carry, but you've chosen to carry it, and you can carry it. Otherwise, it wouldn't have happened to you. And someday the cross will be carried to perfection. Trust in her that she knows what she's talking about. You've always trusted in the Lord; continue that way because you have to come there and bring it to fulfillment.

Okay, she tells me she's going to let go with the others. But Allison is embracing both of you with love and to her sibling and her nieces, calling out to the children and the family. Your parents doing the same, Doris, and yours also, Ken.

Allison just wants everybody to know that she's all right, at peace, and going on with her life in a very happy state until we all meet again. But, as she states, continue to pray for her. She's signing off and sends her love. All the others do as well. And just know that they're with Allison. That she's certainly not alone. Oh! Allison calls out to all her friends, "Tell them you've heard from me!"

Epilogue

*T*he story we have just told you is true. We have changed only a few names of the myriad friends who loved our daughter Allison.

Her eleven-year travail and passing tested our religious idealism with its reliance on the outer trappings of faith. The stained glass windows, organ pipes—yes, even the church steeple itself—all came tumbling down in our minds. For years, the more glorious the church music, the harder we fought back tears.

Happily, a friend suggested that we read the book *We Don't Die* about George Anderson who is considered the world's leading psychic medium. From the start, Ken felt in harmony with George's ideas about the afterlife and was convinced that George has the ability to demonstrate that departed souls continue on in another dimension. Eventually some of our grief, skepticism, and helplessness gave way to the next level of our spiritual journey, seeking a private meeting with George. As with many challenges we all face in life, contacting George began in fear and uncertainty, but ended that evening in a leap of faith.

Our seeking and receiving help from a psychic medium may elicit many questions, all of which we cannot purport to answer, especially to the satisfaction of skeptics. However, we declare, without reservation, that it was our daughter Allison who spoke to us in spirit that night through George about issues, feelings, and people important in our lives. The experience strengthened rather than weakened our religious faith, gave us new freedom of thought, and helped us to lead fuller lives.

On the evening we left George's office and started our fifty-mile drive back to New Jersey, we were softly crying with thoughts exploding in our heads. At first, neither of us spoke, and then I said to Ken,

"You know, dear, Allison's just taught us some more lessons—that her life's continuing, that she's fulfilled, and that she's at peace. I tell you, Ken, I'm so dumbfounded by everything we've heard through George tonight that I just can't grasp it all yet. But I do know it's an experience that will change us forever. Everything of value must be about love. It makes me so happy to know that Allison's near to us in spirit. Don't think I'll ever forget tonight!"

"I know what you mean, "Ken answered. "My mind's spinning like a top. And I keep thinking about a Biblical passage that says something about heaven being right here at hand. You know, dear, I think tonight we were just touched by heaven! Maybe Allison's spirit's as close as the air we breathe. Since the spirits can know what we think, our thoughts best be truthful."

The next day and each day thereafter, we start with the conviction, "I believe, Allison, I believe!"

<div align="right">

Doris M. Hall

Kenneth M. Hall

</div>

In her memory

The Allison M. Hall Welcome Center, Unity College,
Unity Maine, 04988

And the Allison M. Hall Scholarship for an upper-class applicant
who has shown perseverance in overcoming adversity in
pursuit of his or her education at Unity College.